H. H. RICHARDSON

EXHIBITION ORGANIZED BY THE
DEPARTMENT OF PRINTING
AND GRAPHIC ARTS
HARVARD COLLEGE LIBRARY

Fogg Art Museum, Harvard University
October 23 — December 8, 1974

Albany Institute of History and Art
January 7 — February 23, 1975

Renwick Gallery, Washington, D. C.
The National Collection of Fine Arts
Smithsonian Institution
March 21 — June 22, 1975

*H.H. Richardson. Photograph ca. 1884 by Marian Hooper
(Mrs. Henry) Adams
(Courtesy Massachusetts Historical Society)*

SELECTED DRAWINGS

H. H. RICHARDSON

AND HIS OFFICE

A CENTENNIAL OF HIS
MOVE TO BOSTON 1874

DEPARTMENT OF PRINTING
AND GRAPHIC ARTS 1974
HARVARD COLLEGE LIBRARY

LC no. 74-80839
ISBN 0-914630-00-8

Publication of this catalogue was assisted in part by
The Graham Foundation for Advanced Studies in the
Fine Arts, the Edgar J. Kaufmann Charitable Foundation
and Philip C. Johnson.

Designed by Larry Webster
Color separated by Techno-Colour, Inc.
Composed in linotype Palatino by Thomas Todd Co.
Printed by Thomas Todd Company, Boston

CONTENTS

THIS CATALOGUE AND EXHIBITION celebrate the centennial, not of the birth nor the death of America's greatest Victorian architect, but the transfer in 1874 of his office, home, family and affairs from New York to Boston — more accurately, Staten Island to Brookline — as a result of his winning the national competition for the design of Trinity Church, to be constructed on the east side of Copley Square in Boston's newly-filled Back Bay. It is with the building of Trinity Church that Henry Hobson Richardson rose to international prominence, and with which one most popularly associates the so-called "Richardson Romanesque." Its pyramidal massing, soaring picturesque towers and centralized plan, today as yesterday, convey the power, dignity and dynamics of a great "color church." From the dim penumbra of its nave there still diffuses a Byzantine glitter and the echoing voice of the preacher-churchman Phillips Brooks.

Richardson, that "colossal man" as Mumford termed him, remains unchallenged as the champion of nineteenth-century American architecture. Of the other contenders, Bulfinch before him was a child of the eighteenth century, while Sullivan after him was a prophet of the twentieth. Among his contemporary rivals, Richard Morris Hunt, who, like Richardson, served his apprenticeship at the École des Beaux-Arts, was essentially an eclectic; Charles McKim and Stanford White, soon to outspan Richardson in the brilliant effects of their own more scholarly eclecticism, were trained in the master's office. As Henry-Russell Hitchcock has remarked, Richardson remains the timeless exponent of later High Victorian architecture, for the range of his work, the personalism of his style and the extraordinary productivity of his brief career.

At his death in 1886 in his forty-ninth year, we have this testimonial in a letter of condolence from the actor, Henry Irving, to the English architect, R. Phené Spiers (Archives of American Art, Charles Rutan Papers):

1, June 1886

My dear Sir:-

It was with very deep regret that I heard of the death of poor Richardson. My acquaintance with him was necessarily limited as our only opportunities of meeting were during my brief stay in Boston, but from the moment we met I am glad to say that we felt as friends. I bear in most pleasing remembrance an afternoon which I spent with him in his delightful home at Brookline. I was much struck with his great energy and grandness of purpose. A few such men in a generation mould the artistic destinies of a country and it seemed to me that he grasped in the hollow of his strong hand two series of facts widely distant — those concerning the needs and those concerning the possibilities of a marvellously growing

FOREWORD

land. He has built monuments of his own power in his Church at Boston in Back Bay which struck me with renewed admiration every time I saw it — of those beautiful arches of the State House at Albany — in his building at Cambridge — and in those colossal works for Pittsburgh in the drawings for which he was engaged when I visited him. But more even than these things was his work for the nation in the school which he was founding by gathering round his own studio the young men of bright promise whom he saw, and whose ability was being moulded to high endeavors by his enthusiasm.

I most sincerely hope that this work will not lapse by his untimely death but that it will be continued — for to my mind its prosperity would be a national good. . . .

Essentially this is an exhibition of selected drawings from Richardson's Brookline office dating from the years of his mature period, 1874 until his death in 1886. They number two hundred ninety-five, described and documented, from the five thousand-odd drawings in the collection of Harvard's Houghton Library, the gift in 1942 of Henry Richardson Shepley, grandson of the architect and a member of the successor firm then called Coolidge, Shepley, Bulfinch and Abbott. While this is the first major exhibition of his drawings, it is not indeed the first showing. In 1936 the Museum of Modern Art, which had just published Professor Hitchcock's critical study of Richardson to mark the fiftieth anniversary of his death, organized a circulating exhibition with seventy-two building projects covering his entire professional career, with drawings and photographs principally drawn from the Richardson corpus then in Mr. Shepley's custody. It would appear from the mimeographed catalogue that some twenty-five drawings from the 1936 exhibition reappear in this Harvard exhibition. Since then only thirty or forty of the drawings have been shown at various times in exhibitions across the country. Some of the furniture designs were shown at the Boston Museum in 1962 in an exhibition organized by Richard H. Randall, Jr.

The importance of the Richardson drawings in the Houghton Library lies not only in their archival value, but also in their current usefulness to architects seeking to preserve some of the buildings here documented. Requests are frequent for drawings of buildings of current concern: Trinity Church, Union Station at New London, the Cheney Building in Hartford, and others.

The preparation of this catalogue, both Introduction and descriptive notes, is the work of James F. O'Gorman, who has emerged as the leading Richardson historian of his generation. His extensive documentation, perceptive remarks and

orderly scholarship have considerably advanced our knowledge of the Brookline period. Future generations will be indebted to him, as are we, for an intelligent appreciation and understanding of these architectural drawings. In his Introduction the author sheds new light on Richardson's method of work, the French atelier-like practice of his office, his catalytic style as a teacher, the role played by his Brookline and Harvard social background in the progress of his commissions, with discussions largely based upon previouly unpublished or unedited documentation, of the origin and evolution of each project and the personnel involved: clients, associated architects, engineers, artists and craftsmen.

The drawings are supplemented by photographs, as far as possible old photographs contemporary with the completed projects, showing them as they were and not as they are, and in so many cases a sad reminder of a now demolished building. Some personal letters, documents like the Trinity Church request, and family memorabilia are included, while, not least of all, are portrait photographs of Richardson himself: the Harvard classbook portrait of 1859, Parisian cartes-de-visite, Marian ("Clover") Adams' sensitive study made in Washington, and the Balzacian or "Richelaisian," as the Adamses playfully expressed it, series of portraits in monk's habit by Cox.

A final section comprises furniture and decorative arts designed by Richardson himself or under his direction for his interiors (including a William Morris rug and a John La Farge stained glass peacock window), lent by the Capitol and Court of Appeals in Albany, the Glessner House in Chicago, the Worcester Art Museum, the Boston Museum of Fine Arts, and the Malden Public Library.

In evaluating this catalogue the following three points must be made. First, the emphasis has been logically placed on the drawings themselves, in describing, illustrating and interpreting them, while the photographs and related documents play a supportive role. The furniture and decorative arts are checklisted, but not fully described, since they too are ancillary, having been for the most part amply catalogued in other exhibitions and are included, as it were, "to take the curse off the flatware," a comment attributed to the late Denman Ross. The second point to emphasize is that this is not a critical catalogue. Value judgments are for the most part avoided. Introduction and catalogue entries developed naturally from the necessity of documenting the drawings, relating them to the graphic evolution, from conception to reality, of specific building projects. This leads us to the third point. The choice of drawings and the length and volume of each catalogue entry should not be correlated to a building's importance or rating in Richardson's oeuvre. The substance of an entry is determined by the

availability to the author of new source material, or his reassessment of published sources on the evidence of the drawings themselves. Drawings were selected for their graphic quality or interest, and to show the whole spectrum of office production, not to defend the merit of the resultant architectural solution. For some important building commissions, drawings are lost, lacking or poorly represented in Harvard's Richardson Collection.

For over a year a selection committee of five members has met periodically to sift through the Richardson Collection and choose the drawings for exhibition. It consisted of James F. O'Gorman, the author; Messrs. James Ford Clapp, Jr. and Jean Paul Carlhian representing the firm of Shepley, Bulfinch, Richardson and Abbott; Eleanor M. Garvey and myself representing Houghton Library. It made for a balanced working team, and though deliberation was often heated, dissenting opinion in the final solution was negligible.

In addition to the collaboration of the above fellow travelers, I wish to warmly acknowledge helpful advice from John Coolidge, and from my colleagues William H. Bond and Roger F. Stoddard. For planning and installation of the exhibition, my thanks to the following at the Fogg Museum: the director Daniel J. Robbins, Suzannah Doeringer, Jane Watts and Larry Doherty; also, to the conservators Marjorie Cohn and Dorothy Warner for the herculean task of restoring and matting the drawings, for which welcome financial assistance has come from the firm of Shepley, Bulfinch, Richardson and Abbott (an additional contribution to that made some years ago towards microfilming and cataloguing). Among graduate students in the School of Design who have rendered useful services in installation, I mention Bent Huld.

Cooperation in arrangements for the exhibition's traveling has come from Norman S. Rice, director of the Albany Institute of History and Art; Lloyd E. Herman, director, Renwick Gallery, Washington, D.C. and Joshua Taylor, director, The National Collection of Fine Arts, Smithsonian Institution.

Towards the expenses of the catalogue, we express our grateful appreciation for grants from the Graham Foundation for Advanced Studies in the Fine Arts and the Edgar J. Kaufmann Charitable Foundation, and a thoughtful contribution from Philip C. Johnson.

Finally, my obligation to my associate Eleanor M. Garvey for tireless laboring in the vineyard.

Peter A. Wick, *Curator*
Department of Printing and
Graphic Arts

I happily thank the following scholars for major research assistance in the preparation of the catalogue: Geoffrey Blodgett, The Charles Warren Center, Harvard University; Robert F. Brown, Archives of American Art; Richard L. Champlin, Redwood Library, Newport, Rhode Island; Marc Friedlaender, The Adams Papers, Massachusetts Historical Society; Henry-Russell Hitchcock, New York; Richard H. Janson, Robert Hull Fleming Museum, University of Vermont; John Maass, Philadelphia; Christopher P. Monkhouse, London; Charles Price, Connecticut College, New London, whose index to the entire Richardson collection made our task a simple one; Herman Sass, Buffalo and Erie County Historical Society; Paul Sprague, University of Illinois, Chicago Circle; Elizabeth Tindall, Missouri Historical Society of St. Louis; James D. Van Trump, Pittsburgh; Richard Guy Wilson, Iowa State University; Cynthia Zaitzevsky, Boston; and especially H. Barbara Weinberg, Queens College, New York. Richard J. Betts, University of Illinois, Champaign-Urbana, and Cervin Robinson, New York, read an early draught of the Introduction with their usual critical skepticism.

The following assisted in the preparation of the catalogue in various important ways: Mrs. Charles F. Batchelder, Milton, Massachusetts; Joan Brown, Manchester, Massachusetts; Jean Paul Carlhian and James Ford Clapp, Jr., of Shepley, Bulfinch, Richardson and Abbott; John Coolidge, Harvard University; Kenneth C. Cramer, Dartmouth College Library; J. Mordaunt Crook, London; Julianne de Vere, New York; John H. Dryfhout, Saint-Gaudens National Historic Site, Cornish, New Hampshire; Claudine Eichholz, Public Library, Crystal City, Missouri; Clark A. Elliott, Harvard University Archives; Jonathan Fairbanks, Museum of Fine Arts, Boston; Anne Farnam, Boston; Maximilian Ferro of Shepley, Bulfinch, Richardson and Abbott; Mary Fisher, Harvard Law School; Margaret Henderson Floyd, Weston, Massachusetts; Susan Fondiler, Cambridge; William Gratwick, Linwood, New York; Christopher Hail, Frances Loeb Library, Harvard University; Esley Hamilton, University City, Missouri; Laurie Hammel, Archives of American Art; Mrs. Frank Harris, Adams National Historic Site, Quincy; Ruth H. Hill, Beverly (Massachusetts) Historical Society; Harley P. Holden, Harvard University Archives; Christopher Hussey, Boston; Jack Jackson, The Boston Athenaeum; Robert M.P. Kennard, Trinity Church, Boston; Walter C. Kidney, Pittsburgh; F. Monroe Labouisse, Jr., New Orleans; Sarah B. Landau, New York; Walter E. Langsam, Kentucky Heritage Commission, Frankfort, Kentucky; Horace Bushnell Learned, Avon, Connecticut; Edward H. Little, West Hartford, Connecticut; Dina G. Malgeri, Malden

ACKNOWLEDGMENTS

xi

Public Library; Mr. and Mrs. John Murray, Prides Crossing, Massachusetts; Mrs. John Norton, The Boston Athenaeum; Jean Baer O'Gorman; Mr. and Mrs. Roger Olcott, Manchester, Connecticut; Duncan B. Oliver, Easton (Massachusetts) Historical Society; Buford Pickens, Washington University, St. Louis; Adolf K. Placzek, Avery Library, Columbia University; the Venerable Charles F. Rehkopf, Episcopal Diocese of St. Louis; Norman S. Rice, The Albany Institute of History and Art; David Richardson, Washington, D.C.; Mr. and Mrs. H.H. Richardson III, Brookline; Joseph P. Richardson, Brookline; Julian Richardson, Beverly Farms, Massachusetts; Leland Roth, Northwestern University; the Rev. Thomas Schellingerhout, Grace Church, Crystal City, Missouri; Dr. and Mrs. Guy Lacy Schless, Philadelphia; Ruth Schoneman, Burnham Library, The Art Institute of Chicago; William Seale, The Smithsonian Institution; Katherine Shea, Manchester (Connecticut) Historical Society; Stuart C. Sherman, John Hay Library, Brown University; Thomas M. Slade, The National Trust for Historic Preservation; and Charles Rutan Strickland, Plymouth and Boston. Finally, whatever grace and clarity the writing possesses is largely due to the editing of Peter A. Wick and Eleanor M. Garvey of the Department of Printing and Graphic Arts in the Houghton Library; the typing of the manuscript and the indexing were done with unfailing patience by Elizabeth Sahatjian.

<div align="right">J.F.O'G.</div>

LIST OF LENDERS

Adams National Historic Site, Quincy

Archives of American Art

Mrs. Charles F. Batchelder

Boston Athenaeum

Boston Museum of Fine Arts

Brown University, John Hay Library

Chicago School of Architecture Foundation, Glessner House

Dartmouth College Library

Harvard Law School Library

Harvard University Archives

Malden Public Library

Massachusetts Historical Society

George R. Mathey

New York State Capitol, Albany, Senate and Court of Appeals

Henry H. Richardson III

Joseph P. Richardson

Julian Richardson

Shepley, Bulfinch, Richardson and Abbott

Charles R. Strickland

Worcester Art Museum

THE MAKING OF A "RICHARDSON BUILDING," 1874-1886

JAMES F. O'GORMAN

An architectural historian should, from time to time, look over the shoulders and under the feet of the conventionally accepted heroes and try to see what went on around them and on what they stood.

Sir John Summerson
The Neurath Lecture, 1973

H.H. Richardson. Harvard class photograph, 1859
(Harvard University Archives)

The "best of people & music," H.H. Richardson called it in a letter to Henry Adams. On Sunday afternoon, April 6, 1884, nearly one hundred clients, relatives, friends and neighbors, all guests of the architect and his landlord Edward W. Hooper, crowded into his office in Brookline, Massachusetts, to hear chamber music played by the Bernhard Listermann String Quartette. The program included Haydn's Quartet in G, "The Mill" and "The Avowal" from Joseph Joachim Raff's *The Miller's Fair Daughter*, the Scherzo from Cherubini's Quartet in E-flat and Beethoven's Quartet in F-major, opus 18, no. 1.[1] Such a musical salon happened more than once. Describing a similar Sunday in the following year, a visiting English architectural student reported that "a large and fashionable assembly . . . in addition to hearing excellent music, finely played . . . had opportunities of seeing many of the illustrations of his works, completed and in progress."[2] Such mingling of business with pleasure in the Brookline setting was characteristic of Richardson's style.

Outstanding among the architect's recently completed works in the spring of 1884 were the Library at Quincy (cat. no. 26), the City Hall at Albany (cat. no. 21), Austin Hall at Harvard University (cat. no. 24), and the Stoughton House in Cambridge. The impressive but unsuccessful competition drawings for the Albany Cathedral must also have been on display (cat. no. 2). Of works in progress there were drawings for the Holyoke and South Framingham Railroad Stations, the Hay and Adams Houses in Washington (cat. no. 8), the Robert Treat Paine House in Waltham and the preliminary studies for the Allegheny County Buildings in Pittsburgh (cat. no. 22).[3] All were mature works by one of the most influential architects in the western world. It is probably safe to assume that most of the assembled guests recognized the significance of the designs on display. How many, we wonder, knew enough about the architectural profession to understand how those designs were created? How many fully understand today?

I BROOKLINE

Henry Hobson Richardson (1838-1886) grew up in New Orleans and later enjoyed four intellectually indifferent but socially promising undergraduate years at Harvard (class of '59), where he belonged to the Hasty Pudding and Porcellian clubs and the Pierian Sodality.[4] He began his architectural career in New York following an extended period of study and work in Paris during the Civil War. In 1867 he married Julia Gorham Hayden, daughter of Dr. John C. Hayden of Cambridge, and until 1874 they lived in a house of his own design on Staten

Island while he commuted to a Manhattan office that he held in partnership with Charles D. Gambrill (1834-1880; Harvard '54). Richardson's practice increasingly centered in upstate New York and New England, so in 1874 he moved his home, as he was eventually to move his office, to Brookline. The immediate reason for the change was the necessity of supervising construction of his design, won in competition in 1872 but not begun for two years, of Trinity Church in Boston (cat. no. 1), his first commission of national significance. But his move to Brookline meant more than that.

His choice of residence was no accident. That area of the Boston suburb lying just west of Jamaica Pond was in the nineteenth century, as it is today, a landscape of rolling hills dotted with large houses inhabited by men of wealth, achievement and influence. Its distinguished residents range in time from George Cabot, Washington's Secretary of the Navy, to former Attorney General Elliot Richardson (no relation to the architect) in our own day. As early as 1888 Brookline could be described as a town which "has long enjoyed the preeminent reputation of being the wealthiest in the United States."[5] Other areas might dispute such a sweeping claim, but mature affluence did make for social self-assurance. Brookline is the location of the first country club in the United States, called to this day, simply, The Country Club. It was founded in 1882.

The undulating land west of Jamaica Pond has long appealed to visitors because of its park-like character. Andrew Jackson Downing, who worked at the estate of Thomas Lee, wrote in 1840 that

> *The whole of this neighborhood of Brookline is a kind of landscape garden, and there is nothing in America, of the sort, so inexpressibly charming as the lanes which lead from one cottage, or villa, to another . . . the open gates, with tempting vistas and glimpses under the pendent boughs, give it quite an Arcadian air of rural freedom and enjoyment . . . there are more hints here for the lover of the picturesque in lanes, than we ever saw assembled together in so small a compass.[6]*

At the end of the century Richardson's biographer Mrs. Schuyler Van Rensselaer echoed Downing:

> *Brookline's site was naturally picturesque—richly wooded, everywhere rolling, in some parts really hilly, and often boldly broken by huge gray ledges of rock. Thus every place has personality, and plays its part in a panorama of perpetually changing charm. But the most beautiful and most interesting of all is Mr. Sargent's.[7]*

H.H. Richardson. Carte de visite *photograph, Paris, 1860-1864*
(Courtesy Adams National Historic Site, Quincy)

3

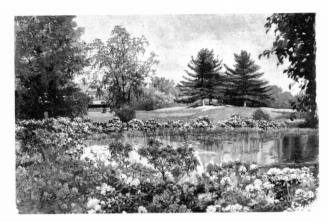

Holm Lea, the Sargent estate in Brookline. Wood-engraving by C. Schwarzburger after Harry Fenn
(The Century Magazine, 1897)

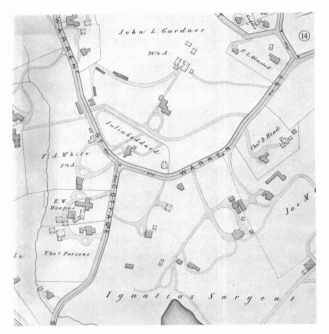

Detail of map showing the Hooper (Richardson), Olmsted and Sargent properties, Brookline
(Atlas of the Town of Brookline, 1884)

If these descriptions sound similar, it is because they both refer to the same location. The twenty-acre estate of Thomas Lee had by 1873 been swallowed up by the vast spread of some one hundred and fifty acres owned by the merchant Ignatius Sargent, but managed by his son, Charles.[8]

Charles Sprague Sargent (1841-1927; Harvard '62), dendrologist and first director of the Arnold Arboretum just south of Jamaica Pond, was one of a large number of prominent men who lived in south Brookline in the post-Civil War period. The group included Francis Parkman (1823-1893; Harvard '44), the historian; Edward S. Philbrick (Harvard '46, A.B. granted '72), engineer of the Hoosac Tunnel and consultant on Boston's Trinity Church; Theodore Lyman (1833-1897; Harvard '55), naturalist and politician; Edward Atkinson (1827-1905), economist and indefatigable pamphleteer for the public weal; Dr. Walter Channing (1849-1921), specialist in mental diseases; and eventually, Frederick Law Olmsted (1822-1903), the landscape architect.[9] All lived within a short walk of Holm Lea, the Sargent estate. All lived in the comfortable large frame houses which crown the hills or nestle in the valleys of this garden suburb, but the estate landscaped by Sargent himself was, as Mrs. Van Rensselaer remarked, the most impressive piece of real estate in an area of rare loveliness.

It is now clear why Richardson chose Brookline. That garden suburb was a very desirable location for a young architect with social and professional aspirations. As P.B. Wight wrote, Richardson "concluded to live in Brookline . . . one of the most picturesque suburbs of Boston, where he was surrounded by the friends of his wife and the refined and cultured society whose association and sympathy he craved."[10] Stimulating and influential neighbors such as Sargent, Atkinson and Olmsted could further his career. No one doubts Richardson's talent, but it was his close ties to his Harvard club-and-classmates and his Brookline neighbors that gave him the opportunities, especially during the years he was establishing his reputation, to exercise that talent.

II HOME-STUDIO

Sargent's Holm Lea was bordered on the south by Cottage Street, one of Downing's picturesque lanes rising sinuously from Jamaica Pond to Warren Street. Across Cottage near Warren stands the Samuel Gardner Perkins house, erected in 1803. A cruciform, frame, two-story structure with elongated service wing stretching to the rear, the house looks out through a portico of widely

spaced, slender piers supporting a low hip roof. It has the look of a southern plantation house, but is in fact simpler than, but similar to, a number of porticoed Federal houses in the area. Situated on a tree-shaded lot of between two and three acres — meager by nineteenth-century neighborhood standards — it commands a vista from the portico across Cottage Street and the former Sargent estate down the hill to the east.[11]

Since 1864 the Perkins house had belonged to Edward William ("Ned") Hooper (1839-1901; Harvard '59; Law School '61). Ned Hooper is now remembered as the Treasurer of Harvard from 1876 to 1898, but he was also a Trustee of the Museum of Fine Arts and the earliest American collector of the art of William Blake. He was a member of that circle of artists, scholars and connoisseurs that included his sisters Ellen and Marian, and their husbands, Professor Ephraim W. Gurney of Harvard and Henry Adams, as well as John La Farge, Augustus Saint-Gaudens and H. H. Richardson.[12] In the spring — probably May[13] — of 1874 Ned Hooper rented the Perkins place to Richardson, and for the next twelve years Cottage Street hummed with architectural activity.

From 1874 to 1878, when the partnership with Gambrill was dissolved, Richardson's preliminary sketches were sent from Brookline to New York to be worked into construction drawings; or assistants such as Stanford White traveled to Brookline for special work. Only the chamber to the right of the entrance in the Perkins house was required for business.[14] After 1878 Richardson brought all his work to Cottage Street, taking over the east parlor for his library. To get from the office-chamber to the parlor-library required crossing the family living room, a situation that became intolerable as Richardson's practice and number of draughtsmen expanded.

Increasing business during the last eight years of his life demanded expanded workspace. Despite the fact that he never owned the Perkins place, Richardson over the years extended a series of additions outward from the parlor-library at the southeast corner of the house. As architecture, the additions were basic: wood, one-story, flat-roofed sheds that appeared designed more for chickens than for draughtsmen. It comes as no surprise to learn they were called "the Coops."

By the time of Richardson's death, the Coops consisted of two ranges of separate draughting alcoves and common office space joined at an obtuse angle. An exhibition and general work area a few steps lower than the alcoves filled in the angle. At the end of each range was an enclosed office or special

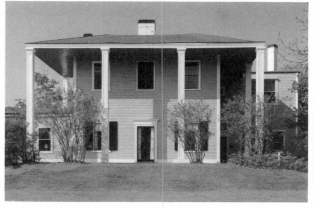

Perkins-Hooper-Richardson house, Cottage Street, Brookline
(Photo: Paul Birnbaum, 1974)

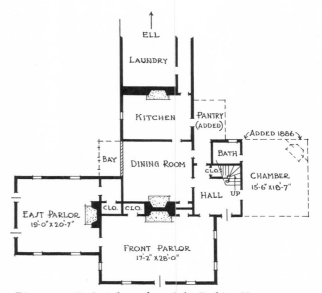

Diagrammatic first floor plan of the Perkins-Hooper-Richardson house
(Nina Fletcher Little, Some Old Brookline Houses, 1949) 5

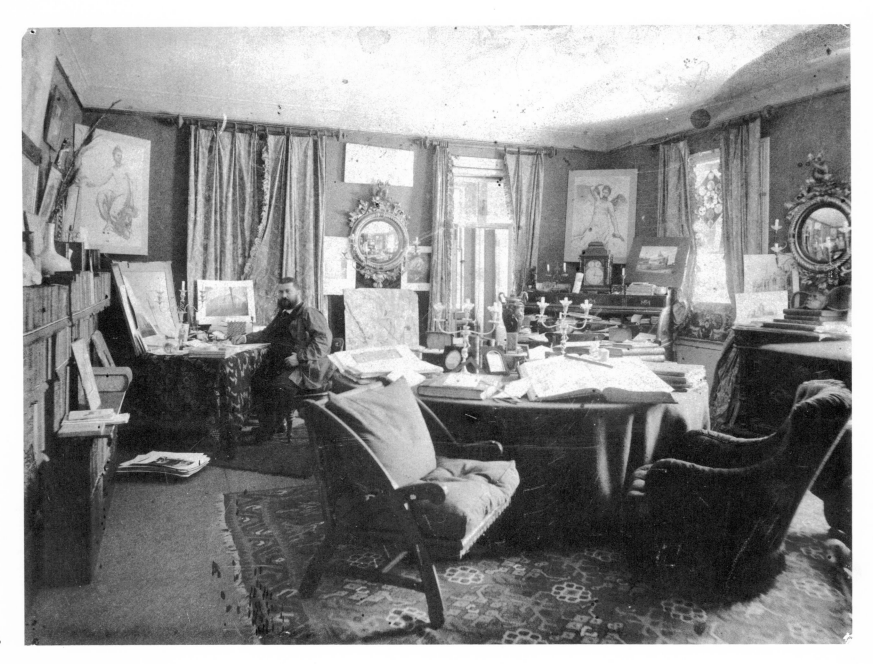

6

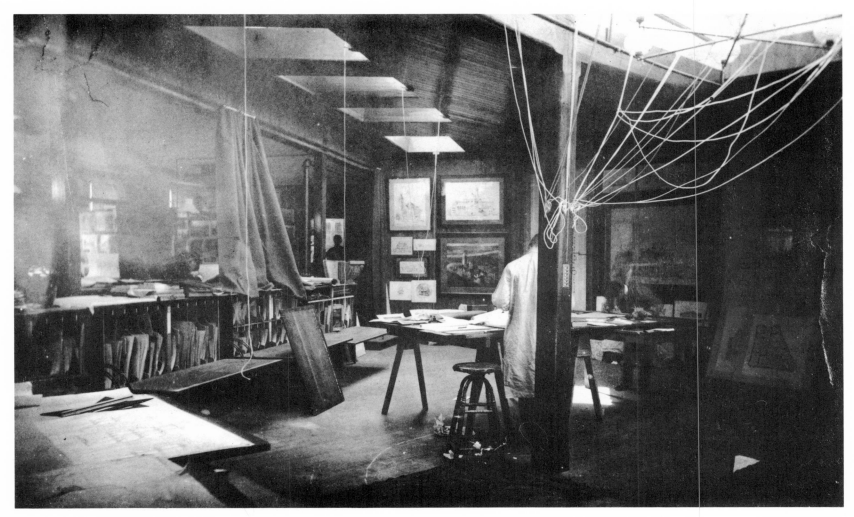

Draughtsmen in HHR's office, ca. 1886
(Harvard College Library)

Left:
HHR in the parlor-library of the Perkins-Hooper-
Richardson house, ca. 1880
(Courtesy Shepley, Bulfinch, Richardson and Abbott)

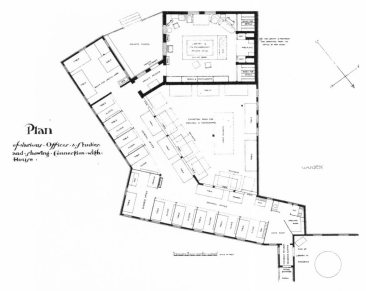

of·various·Offices·&·Studies·
and·showing·Connection·with·
House·

Plan of HHR's office (added to the Perkins-Hooper-
Richardson house; demolished)
(AABN, 1884)

workroom, and at the southernmost extent, a fireproof, masonry structure housing Richardson's study and library. The alcoves held one or two draughtsmen at a table placed at a right angle to windows. They "were separated from each other by low partitions, but all open[ed through curtains] to the general studio. Through the windows the garden could be seen and a glimpse obtained of the tennis-lawn."[15] The intimate coexistence of privacy and community, of inside and outside, and of work and play should be noted.

The sparse efficiency of the skylighted workspaces sharply contrasted with the lush furnishings of what the *American Architect* called Richardson's "private study and library."[16] Reached by a "private passage" that also gave access through a "private entrance" to a sheltered "private piazza," the study was a broad rectangle in plan, some twenty-five by thirty feet, including the deep, curtained recess for the fireplace. One of Richardson's assistants left a detailed description of the room, a description that emphasizes the effect it had upon the visitor. In this "dreamland beyond"

> *The skylight . . . was concealed by a curtain of soft India silk, diffusing its rosy light over the bewildering mass of riches . . . oriental rugs were relieved on a solid ground of deep blue carpets. A huge center table was filled with the rarest volumes, bric-a-brac and choice bits generally; bookcases and couches ranged along the walls; casts and vases showed off beautifully in the subdued light against deep maroon walls; the solid gold ceiling, with its great, sturdy cherry beams, from which were suspended here and there all varieties of oriental lamps of the most intricate metal workmanship — all were overpowering. The wall opposite the entrance was a great old-fashioned crane fireplace, upon whose hearth the cordwood crackled gleefully for the entertainment of the lazy guest who might lie outstretched on luxurious divans. There were stupendous volumes in sumptuous bindings inviting study. Away off in a quiet corner lay some happy pupil in blissful repose, reveling in the resources of the land of plenty. . . . This room was a magic source of inspiration, and in the long winter months it was the retreat for all during noon hours.[17]*

Despite the repetition of the adjective "private" on the plan published in the *American Architect*, the library was in fact open to the office staff during free hours. That is where the study materials were stored, and all accounts stress the educational aspect of work in Richardson's office. "Inspiration is the key-note of Mr. Richardson's idea in the student's training," wrote the *American Architect*. No one emphasized this more than Mrs. Van Rensselaer,

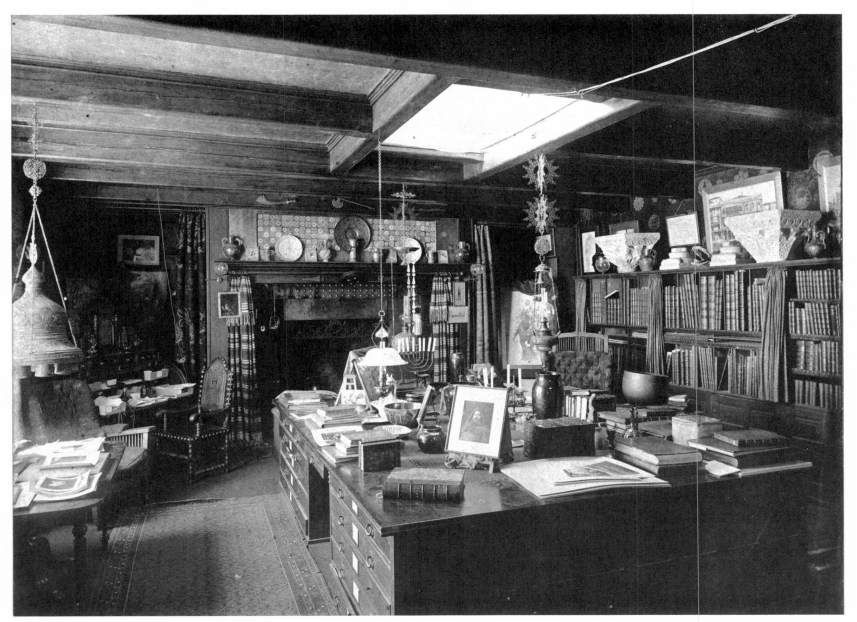

HHR's private study and library, ca. 1886 (Harvard College Library)

9

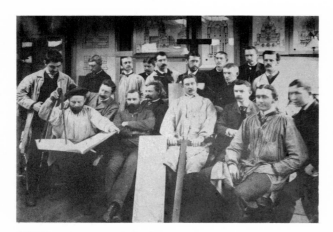

HHR's assistants in his office, ca. 1886
(Courtesy Shepley, Bulfinch, Richardson and Abbott)

whose chapter on the office is entitled "Methods of Teaching." The availability of books, casts, drawings, photographs, but above all, the criticism of the master, a commanding presence whose treatment of his assistants was described as "courtesy itself," made the Brookline office an extension of the formal schools of architecture. The office was, in fact, "one of the prizes striven for by the architectural students at the Massachusetts Institute of Technology."[18] This is not surprising, since their professor was Theodore Minot Clark, himself a product of Richardson's tutelage.[19]

Richardson's office organization paralleled his own educational experience in the *atelier* André of the Ecole des Beaux-Arts in Paris. His *atelier* on Cottage Street was an extension of the *école* at MIT; he was the *patron*, his draughtsman his *élèves*.[20] In following French precedent, his office was not unique in this country. In the late 1850's Richard Morris Hunt, also trained in Paris, had had an *atelier* on Tenth Street in New York City.[21] But there was a difference. Hunt's teaching and his architectural practice seem to have been separate. The familial atmosphere on Cottage Street, the intimate association fundamental to Richardson's professional practice, was unparalleled in this country in the 1870's and 1880's.[22] Yet, though it was without precedent, it did have its progeny. The home-studio of Frank Lloyd Wright in Oak Park, Illinois, founded in the mid-1890's, and later the Taliesin Fellowship at Spring Green, Wisconsin, must owe a debt to Richardson's example.[23]

Even a partial list of Richardson's assistants demonstrates his success as a trainer of architects. Early helpers such as T.M. Clark and Charles H. Rutan were soon joined by Charles F. McKim (from 1870 to 1872), Stanford White (from 1872 to 1878), and the Germans Otto Gruner (1871) and Rudolf Vogel (before 1879).[24] In the 1880's there were a number of outstanding men: Herbert Langford Warren (from about 1880), who was for twenty years head of architectural studies at Harvard; Robert D. Andrews (by 1882) and Herbert Jacques (by 1882), two of the principals in the Boston firm of Andrews, Jacques and Rantoul; Charles A. Coolidge (by 1884) and George F. Shepley (by 1884), who with Rutan formed the successor firm that still exists; Christopher G. La Farge (from 1884), a major New York architect; John Galen Howard (by 1885), head of architectural studies at the University of California; and Welles Bosworth (1885), architect of MIT's Cambridge campus. These men were among the leaders of the next generation of architects.[25]

Studio life was not all work. Besides browsing among the books and photographs,[26] the assistant might also enjoy long strolls in the surrounding land-

scape, "a succession of shaded walks under rows of stately elms," as one of them put it.[27] There were games of ball, lawn tennis or quoits. And there was the inevitable horseplay without which no draughting room would ever be complete. On one occasion, Richardson's unfortunate bulk, celebrated in the portrait by Sir Hubert von Herkomer showing the massive architect seated in the private study just at the end of his life, became the basis for some fun. One of his vests was found unguarded during his absence and promptly became the encompassing garment for a trio of average-sized draughtsmen who "in lockstep paraded the field for the edification of twenty or thirty jolly workers."[28] Unfortunately, the leisurely pace of the studio had to suffer from the increasing demands for Richardson's services. Some two weeks after the above-mentioned matinee concert, on April 23, 1884, the following directive, written in Richardson's own monumental scrawl, appeared in the Coops:

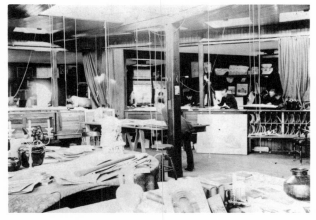

Interior of HHR's office, 1880's
(Courtesy Charles Rutan Strickland)

> *Owing to the pressure of work gentlemen are requested to confine the lunch hour . . . between 12.30 & 1.30. The tennis lawn can only be used during the above mentioned hour. No game or set to last over 30 minutes. . . .*[29]

The grim specter of modern expediency was raised on Cottage Street that day.

Richardson, we can assume, disliked such a stern tone. Congeniality was his more natural temperament. "The Monday-night dinners which in his later years he organized to bring his actual and his former pupils around him," wrote Mrs. Van Rensselaer, "were but the most conspicuous features in an intercourse few moments of which were sterile."[30] The home-studio was a sociable and stimulating place. The appreciation of music made manifest by Richardson's undergraduate membership in the Pierian Sodality continued in the musical Sundays in Brookline; so too, the habits which centered upon the Hasty Pudding and Porcellian clubs at Harvard continued into maturity at the Century in New York, and the Saturday and Wintersnight dining clubs in Boston. These cordial groups utilized the culinary arts as stimulators of good cheer. Charles A. Coolidge's recollection of the menu for the Wintersnight Club, when Richardson called it to order around the black oak table in his blood-red dining room, bears repeating:

> *The wines came from old cellars in New Orleans, the oysters from Baltimore, and the terrapin from Augustin's famous Philadelphia restaurant, with a chef in attendance all the way.*[31]

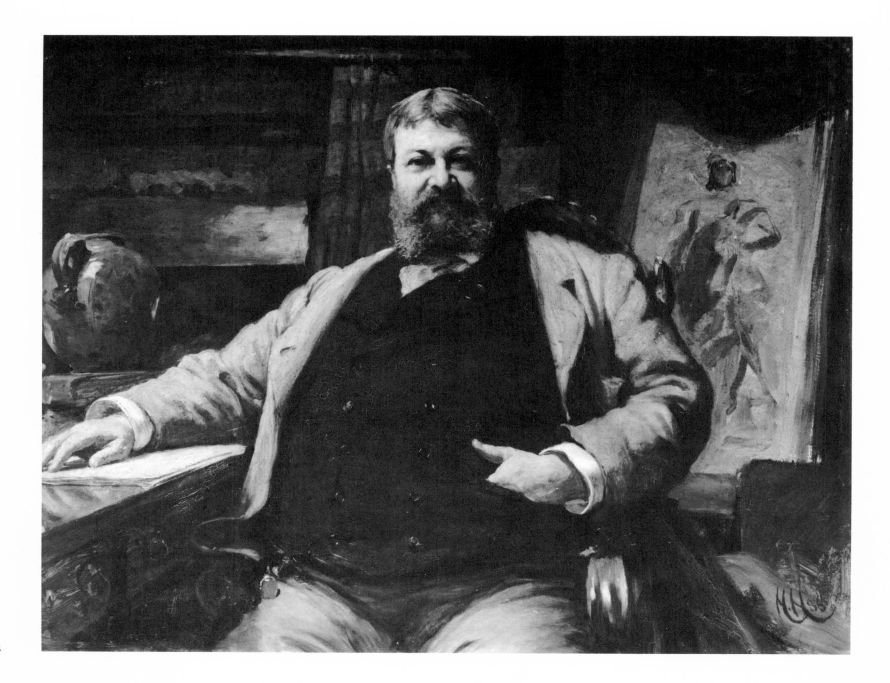

12

Augustus Saint-Gaudens' description of a more average supper, with just one guest, at which cheese and champagne disappeared in large quantities, is too well known to need quotation.[32] Richardson relished the sensuous, and he shared that delight with his colleagues and his assistants.

Such was the congenial, comfortable and fraternal atmosphere of work and play that marked the Brookline office-home during the eighties. In it, the great works of Richardson's last years were designed. The stage having been set, we can now examine more specifically how those works were produced within this stimulating setting.

III THE RICHARDSON DRAWING COLLECTION

The graphic remains of H.H. Richardson's office form a remarkable resource for the study of creative production in a major architectural firm of the post-Civil War era. The collection in the Houghton Library numbers more than five thousand items ranging in date from the late sixties to a period well beyond Richardson's own lifetime (the work of his successors Shepley, Rutan and Coolidge). The collection includes drawings for the majority of executed buildings, as well as sketches for unexecuted projects not otherwise recorded.

The preservation intact of the collection is no less remarkable than its contents. Two factors account for this. First, there is the continued existence of the firm established by Richardson's successors, now the oldest architectural office in the United States. Many of the principals were interrelated or intermarried; throughout its history, its various names have always included a Coolidge, a Shepley or a Richardson.[33] Recognizing the historical value of the drawings, as a consequence of the Museum of Modern Art exhibition and Henry-Russell Hitchcock's scholarship of the mid-1930's, Henry Richardson Shepley of the successor firm, then called Coolidge, Shepley, Bulfinch and Abbott, donated to Harvard in 1942 the bulk of the collection.

But Shepley would not have had the collection to give away were it not for the second factor, one that touches upon the struggle in this country from Benjamin Henry Latrobe onward, to establish the practice of architecture on a professional basis.[34] The main concern was the architect's right to a fee based upon a percentage of the cost of a building, but a related problem dealt with the ownership of drawings. A milestone in the struggle was the case of (Richard Morris) Hunt *versus* (Dr. Eleazer) Parmly heard in Superior Court, New York, in February 1861. Hunt sued Parmly for payment for his

part in the design of the T.P. Rossiter House in New York (1855-1857; Rossiter was Parmly's son-in-law). Hunt won half of his requested five percent fee, thus establishing the architect's right to such a commission. But of more interest here is the following courtroom exchange between the dean of American architects at the time, Richard Upjohn, and the examiner.

Upjohn: . . . *he asked me what I would charge for my [preliminary] sketches [only]; I told him one per cent, he to return the sketches if he did not use them.*

Examiner: *And return the sketches?*

Upjohn: *Yes sir, he to pay me $600 for it. You will understand — the idea.*

Examiner: *One percent for the idea?*

Upjohn: *You as a lawyer, when you give your opinion, do not charge for pen, ink and paper, but for your opinion.*[35]

Upjohn, who was a prime mover and first president of the American Institute of Architects, founded in 1857 to fight for the architect's professional prerogatives, here stated the case in a nutshell. The issue was whether the client engaged an architect to produce drawings, or a concept represented by drawings. If the former, then the client owned the drawings once he had paid the architect's fee. The architect merely sold his skill as a draughtsman. But the architects contended that they provided a *professional service;* they solved the client's building needs. The fact that the solution was conveyed by means of drawings did not make them the client's property. Once the building was erected, the architect expected his drawings to be returned, so that they could not be reused without recognizing his rights to the original concept.[36]

The issue did not disappear after the Civil War; in fact, it turned up over and over again in the pages of the *American Architect.* The problem was discussed at length in the magazine on June 15, 1878, and remained of great concern more than a dozen years later.[37] The *American Architect* pointed out that in common usage the architect retained his originals, but would rarely refuse to provide tracings where records were necessary for the location of structural supports, mechanical equipment and drainage lines. It also recognized that the need for the client to retain such records was greater in public than in private work. As a general rule, it recommended that the architect introduce into the contract with the client a clause concerning ownership of original drawings. Despite the profession's belief, the courts usually favored the client when disputes arose.

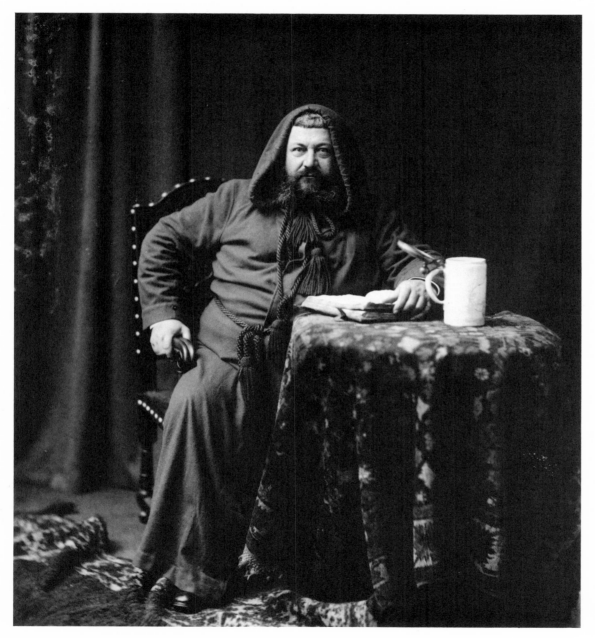

HHR in monk's habit. One of a series of photographs, ca. 1883 by George Collins Cox (Courtesy Joseph P. Richardson)

15

Even without a firm basis in law, the architects frequently managed to follow the opinion of the AIA that they retain ownership of originals. For example, when the Building Committee for Trinity Church, Boston, stipulated in its request for competition designs of March 12, 1872, that all drawings were to become the church's property upon payment of a $300 premium (cat. no. 1a), both Ware and Van Brunt, and Sturgis and Brigham refused to compete. The Committee immediately, and apparently without recorded explanation, canceled that provision.[38]

Although Richardson's "Circular for Intending Clients" does not mention the matter, he agreed with his fellow professionals. On July 30, 1885, he wrote his wife from Cincinnati that he had met with the Building Committee of the Chamber of Commerce "& carried my three points that is drawings to remain the property of the architects perspective drawing at an eighth scale to be allowed in pen & ink & the man . . . whose plan is adopted to have the execution of the work."[39] Many of the drawings have an embossed stamp ordering them TO BE RETURNED TO H.H. RICHARDSON.[40] A drawing by Richardson or his office that is not in the Houghton Library is a rarity,[41] although it is possible to find copies of drawings in the archives of public buildings.[42] The combination of Richardson's attitude toward custody of drawings and the longevity of the firm, which recognized the historical value of these documents, accounts for the preservation of this outstanding collection.

IV DESIGN PROCESS

Traditional art history sees artistic production in terms of individual creativity; architectural history with less justification has followed suit. No building above the level of a hut was ever the product of one man, alone and unaided. The architect cannot function in isolation. He works at the center of a host of interrelated personalities: his staff, his clients (who frequently come through his social network), his suppliers, his builders, and so on. All contribute essentially to his art. His most visible activity, his graphic layout, is only the core of the entire design process.

An architect is hired by a client to give concrete shape to a set of verbally expressed desires that can be fulfilled by building within a specified budget. He takes the client's program (which he may already have helped to formulate) to his draughting board or sketch pad where words such as "room," "vertical transportation," "corporate image," "view," "heating and cooling," are trans-

formed into interrelated geometric shapes. Once the client has approved a design represented by construction drawings, the builder under the architect's supervision translates the graphic symbols into the finished product. The entire process engages three distinct parties: the client (including his financial backers), the architect (including his staff) and the builder (including his suppliers). A visionless client or a slipshod builder can ruin the architect's design as easily as his own limitations.

The process of graphic design falls into a three-stage sequence: preliminary sketches, presentation drawings and construction documents. In the first stage, the architect is communicating primarily with himself or his close assistants, graphically working out his interpretation of the client's desires. Often executed freehand, these early sketches contain the seed from which the final product emerges. These ideograms are usually small, conceptual and useless until tested with a T-square, triangle and scale. The inexperienced designer must struggle to transform sketches into scale drawings; the experienced architect will draw roughly to scale from the start.

Preliminary sketches are turned into preliminary plans, elevations and sections drawn to scale. The shapes, proportions and sizes of openings, roofs, rooms and walls are studied by the architect or his assistant in alternate overlays of tracing paper, until a building emerges satisfying both the client's program and the architect's sense of good design. At this stage, the architect may also test his drawings by building a three-dimensional model. Having communicated up to this point only within his office, he must now "sell" his design to his client. A set of presentation drawings is prepared.

Whether these drawings are for a specific client or represent one entry among many in a design competition, the architect's opportunity to build is decided at this point. Here is where personal and graphic salesmanship are tested. If the architect feels unable himself to produce attractive drawings, he will have in his office, or hire when needed, a professional "renderer," whose job it is to present the design in the best possible light without falsification. The set of presentation drawings will include the usual plans, elevations and sections, and a perspective or model showing the building as a finished product, and something of its place in the environment. These will often be used as promotional material by a satisfied client. When a competition is lost or a client unsatisfied to the point of rejecting the entire design or discharging the architect, the process ends here. The presentation drawings remain unexecuted "project" drawings.

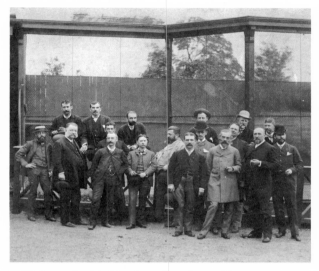

HHR (center) with friends and/or clients (?), ca. 1885 (Courtesy Shepley, Bulfinch, Richardson and Abbott)

If the client is satisfied or requires only inconsequential modifications, the architect is ready to begin the final stage within the office: the preparation of working, contract or construction drawings, and the collateral writing of special instructions or "specifications." These drawings contain all the information that can be shown graphically for the complete erection of the building. For a small house there might be twelve to fifteen sheets; for a large public building, well over one hundred. With the production of these drawings, the architect's graphic work is finished,[43] assuming there will be no major changes during construction, but his real task has just begun. The architect must see that the builder selected to execute his design is the best available, and he must supervise construction to safeguard his client's interest as well as his own reputation. The historian of art should keep in mind what a member of the profession recalled for me recently: "The architect is in the business of making buildings, not drawings."

This three-stage procedure is common to all modern architectural offices, and has been for more than a century. It leaves in the wake of an executed or projected building a mass of graphic material. Some offices systematically destroy what is no longer of value to them; others systematically preserve such records. For the historian they are priceless, since, as the *American Architect* expressed it so well during Richardson's lifetime, they are the architect's "professional autobiography. They record his experience, his development, his aspirations, his failures, and his successes."[44]

V RICHARDSON'S METHOD

The making of a "Richardson building" followed the design process we have outlined above. Although the steps are sequential, all are interdependent. Fully to understand the meaning of each step and the process as a whole, we shall have to shift back and forth among them, accumulating insight as we proceed.

The thousands of drawings in the Houghton Library range from thumbnail sketches by the master himself to huge sheets of working drawings executed by assistants. Few are signed or initialed; fewer are dated. Attribution to a specific hand is usually a matter of guesswork, although a knowledge of Richardson's assistants at any given time is a helpful guide. From 1874 on, the successive names of Stanford White, Langford Warren and Charles Coolidge emerge as chief office assistants, in addition to the faithful Charles Rutan; but

rather than try to assign certain drawings to certain individuals (other than those attributable with some confidence to Richardson himself), we will learn more about Richardson's method if we organize the mass of graphic material according to the design process established in the office. Here we have a wealth of reliable information, but the best source is a brief article on Richardson's office practice during the 1880's written by W.A. Langton.[45]

According to Langton, who is called "my local superintendent" in Washington, in a letter from Richardson to Henry Adams dated July 18, 1884,[46] "Richardson designed, the head draughtsman or draughtsmen executed his design, and the junior draughtsmen made from it the working drawings and specifications. There was, of course, much mutual consultation, criticism and advice. . . ." Mrs. Van Rensselaer put it more inclusively and more succinctly: Richardson's role in the design process was "initiative impulse, constant criticism, and final over-sight."[47]

The process of translating the client's verbal program into a graphic vehicle for construction began in the office with a scribbled ideogram by the master himself (unless, as in the case of the Hay and Adams Houses, the process began earlier, with the client presenting the architect drawings of his own). Richardson's ideograms were

often done in bed, where the state of his health obliged him to spend much of his time. . . . A plan 2 or 3 inches square embodied his idea. The ultimate result of his study was inked in over the mass of soft pencil marks with a quill pen, and sometimes principal dimensions were figured. That was usually the end of his work on paper.

So Langton describes the "initiative impulse."

Langton makes a direct connection between Richardson's graphic work and the state of his health. And rightly so. No real understanding of the architect's career in general or his method of design in particular is possible without a knowledge of his physical disabilities. It is well-known that he died of nephritis, or Bright's Disease, a chronic renal disorder. What has never been properly emphasized, but becomes clear from Richardson's preserved correspondence, is that throughout his professional life he was plagued by a series of debilitating ailments other than the one which killed him. It was apparently in Paris, if I correctly interpret Mrs. Van Rensselaer's genteel allusion, that he suffered the hernia that required him to wear a truss for the rest of his life. As he grew more corpulent, this problem became more acute. On top of that serious complaint, there were constant lesser setbacks. At no time during his

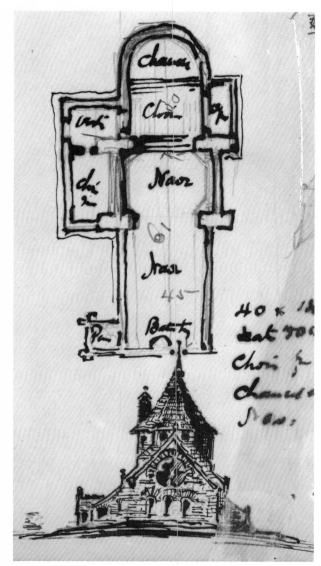

Study for a Church. (Sketchbook, f. 62ʳ [detail]. See Appendix)

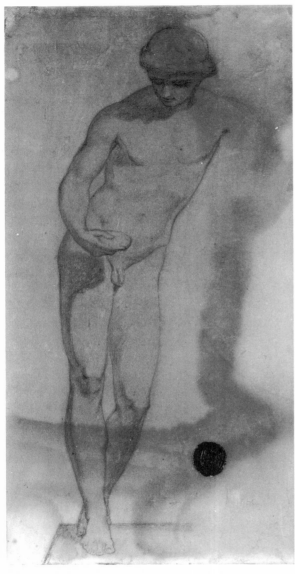

Standing Male Nude by HHR, initialed and dated [18]60
Crayon on paper, 24 x 11⅞ in.
(Courtesy Julian Richardson)

maturity does Richardson seem to have been completely healthy.[48] No wonder his office became an extension of his home.

And his bed became an extension of his office. His daughter recalled that his bedroom "had cork walls, his own idea, on which he could thumbtack photographs and the special subject he was studying at the moment; towers, doorways, windows, bridges, et cetera."[49] He also conducted his business there. John La Farge was "summoned . . . to his bedside," to be told he might be chosen to decorate Trinity Church. Ten years later John Glessner and his wife had a final conference about their house "in his bedroom."[50] The working habits caused by constant ill health had a bearing upon Richardson's style.

Langton's description of Richardson's personal draughtsmanship is precise, and surviving evidence largely agrees with him. We may recognize Richardson's hand in a number of drawings by comparison with those published as holograph by Mrs. Van Rensselaer. They are typically first thoughts jotted down on light blue or buff engraved stationery in the heavy hand so well known from autograph letters. We are told that he demonstrated ability at drawing during his school days, and the one surviving figure drawing shows him to have been competent if not brilliant with a crayon. But Richardson in his maturity drew infrequently and with more individuality than excellence. His line, like his handwriting, has personality, strength and character, but it is usually all business. No drawing from his own hand appears to have been made for the sake of its graphic quality alone. In Richardson's mind, drawings were means to an end, and, as we shall see, not necessarily trusted means.

The studies for the Oliver Ames House project (cat. no. 6), or the Old Colony Railroad Station at North Easton (cat. no. 32) illustrate perfectly Langton's remarks about Richardson's sketches. The Ames House studies, small as they are, capture in a general way all the essentials of the plan as presented to the client. The earlier autograph sheet (cat. no. 6a) shows the cruciform arrangement of halls, rooms and stairs, with the corners filled in with other rooms to make the roughly square perimeter appearing on the final drawing. Notes on room use and basic dimensions are penciled in. The second sketch (cat. no. 6b) is somewhat larger and more articulate. The arrangement is essentially the same. The chosen shape is picked out with ink lines and the basic dimensions given. In its essentials the design is fixed; the drawing is now ready for draughting to scale by the office staff. The same procedure is observed in the case of All Saints Cathedral (cat. no. 2) and the City Hall, Albany (cat. no. 21), the Palmer Station (cat. no. 31) and others.

Langton suggests that elevation studies from Richardson's hand are rare, but the preserved autograph sketches show that to be an underestimate. Certainly Richardson, like any architect (with the exception of pure formalists such as Erich Mendelsohn), first thought of room distribution and organization, but he often initiated the search for silhouette and massing in three dimensions as well. The drawings for the North Easton Station carry the design into elevation and even perspective studies. The problem is investigated first on a small piece of blue stationery in plan and two elevations (cat. no. 32a). The basic arrangement of this simple building is fixed at once. The concern in elevation is with profile; the spreading roof line is emphasized graphically. Evidently, Richardson found it too busy in this first version, especially in side elevation, for in the next set of sketches on tracing paper at a slightly larger size, he characteristically simplified the design by reducing the plan to a basic rectangle (cat. nos. 32b, 32d). This eliminated two reentrant angles and did away with the intermediate roof between the hip of the station proper and the roof of the long sheds spreading out along the trackside (built, but later destroyed, only the main block surviving). This second series of sketches includes a plan showing Richardson's concern with circulation (directional flow patterns are indicated), and a perspective (autograph?) showing the station as built. Ink lines once more firm up the underlying pencil. From this point, the office force could prepare presentation and construction drawings following Richardson's sketches in all essentials. Other examples of silhouette study are for All Saints, Albany (cat. nos. 2d-i) and Austin Hall, Harvard University (drawing not in exhibition).

Following the development from plan to elevation to perspective, there are also in the Houghton Library some rapid preliminary studies of buildings in three dimensions. A critic of the older, aristocratic tradition would assign these without further thought to the master himself, but it is difficult at this stage in our knowledge about the many hands at work on Cottage Street to be certain of the attribution of most drawings. The outstanding example in this category is the breathtakingly vibrant study in limited colors for the early, brick version of the Marshall Field Wholesale Store (cat. no. 19b). Whoever drew this was an artist of the first rank. But it appears to be one of a few brilliant exceptions to the mass of ordinary graphic material produced by the office during Richardson's lifetime.

Richardson's controlling position in the design of buildings that bear his name is unquestioned, but buildings cannot be built from "initiative impulse"

Elevation Study. (Sketchbook, f. 8ʳ [detail]. See Appendix)

21

alone. At this early stage, Richardson's staff intervened for the graphic execution of that impulse. The laborious process of scale and construction drawings had to follow the spirit of his sketches, so his ability to choose assistants capable of following his lead was crucial. His success is measured by the fact that observers from Langton to Charles Price have remarked that even if he did not personally execute all the drawings that came from his office, they were nonetheless in a real sense all his own.[51]

According to Langton again, Richardson's ideograms "were guides for the head draughtsman alone, who made from them small scale sketches for the client." Scale and presentation drawings were made by a Stanford White or a Langford Warren, but not without Richardson's "constant criticism" mentioned by Mrs. Van Rensselaer; for the rough sketch did not exhaust his interest in a building, whether or not he touched it with pencil again. The visible traces of his criticism are preserved on a number of drawings apparently not otherwise from his hand. Perhaps the most interesting are the preliminary scale drawings of the Allegheny County Court House in Pittsburgh (cat. no. 22). The neatly draughted plans have been scrubbed over by the master's pencil. Every room is restudied. In the courtyard of the plan of the third floor is sketched a tentative longitudinal section through the building (cat. no. 22b). At this stage, Richardson had in mind a rather stubby tower set back from the face of the front elevation. The main tower of the Court House grew taller in execution, like that at the Albany City Hall (cat. no. 21), and just the reverse of the shrinking lantern of Trinity Church (cat. no. 1).[52] Nor were handsomely rendered drawings exempt from such revision. Richardson did not hesitate to restudy three-dimensional effects directly on a preliminary plan for the Quincy Library (cat. no. 26b), or presentation perspectives of the Buffalo Civil War Memorial (cat. no. 36a), or Austin Hall (cat. no. 24b). "Constant criticism" meant just what it said.

At this stage too, some buildings were studied by assistants in elevations tinted according to a convention common to the period. Phené Spiers, Richardson's colleague at the Ecole des Beaux-Arts and later an important English architect and author, mentions the practice in his book on architectural drawing, published just after Richardson's death. "The relative effect of an elevation," he wrote, "is better explained when the windows are tinted or blacked-in, and the roof is coloured."[53] The watercolor elevations of the Allegheny County Court House (cat. no. 22d), the Hay-Adams Houses (cat. no. 8e), the Glessner House (cat. nos. 9i-j), the Herkomer House (cat. no. 15) and the Field Store

(cat. no. 19) follow this convention more or less closely. The technique found in drawings from Richardson's office was not especially his own. Spiers' book is filled with parallel practices.[54]

Reference to Spiers and the Ecole des Beaux-Arts recalls the context in which Richardson developed his method. He learned the French system in Paris, and the process we are describing from sketch to scale drawing follows the procedure of the Ecole, as Hitchcock noted long ago, but with one important difference. There, the student was given a day or even half a day to establish a *parti* or schema based upon the program, and present it as an *esquisse*. At a later session he would develop his *parti* in scaled and tinted drawings for criticism by the *patron* of his *atelier*.[55] In his own *atelier* Richardson followed this system, except that his *esquisses* were developed to scale by assistants under his criticism.

The architect also parted with French tradition in the preparation of presentation drawings. While it would be difficult to imagine that a handsome watercolor such as the elevation of Emmanuel Church, Pittsburgh (cat. no. 3) was not shown to the client, as a rule Richardson shied away from elaborate color presentation drawings. Formal renderings prepared during the Brookline years were typically brown ink line drawings on tracing paper or heavy white paper. The perspective of an early design of the Hay House (cat. no. 8a) now at Brown University, for example, is an unshaded outline drawing in brown ink on tracing paper. For larger public commissions, presentation was frequently made by means of an elevation rendered in ink and given a perspective street setting. This is true of the Albany City Hall (cat. nos. 21e-f) and the Allegheny County Court House (cat. no. 22e). Full perspectives, such as those for the Buffalo Memorial Arch (cat. no. 36a), Austin Hall (cat. no. 24) and the Albany Cathedral (cat. no. 2) follow the same technique. As early as 1869, Richardson noted in his Sketchbook that "the greatest fault of the french school is in the great skill of col[oring?;] form is sacrificed to color."[56] As we have already seen, in 1885 he made pen and ink perspectives a condition of his entering the competition for the Cincinnati Chamber of Commerce Building. It would seem that Richardson had a distrust of luscious architectural renderings. His presentations were handsome, but they were simple and direct, permitting the shape of the building and the ordering of its parts to speak for themselves.

With the completion of presentation drawings, the design was more or less established, although Richardson was in the habit of suggesting changes

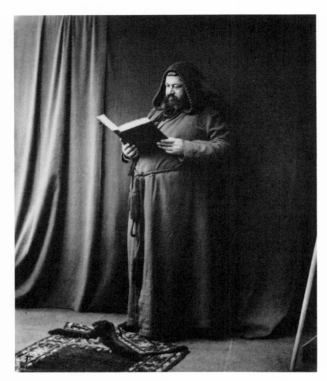

HHR by G.C. Cox, ca. 1883
(Courtesy Joseph P. Richardson)

after this stage. Before we look further, we might pause long enough to ask what this discussion of Richardson's method tells us about his style. Langton says in summation that "Richardson's very method of work had much to do with the ideal character of his design . . . to the idea he devoted himself entirely, and . . . the essentials to its expression that he looked for. . . ." This is why these sketches are of such interest to the historian. As Richard Upjohn pointed out in Hunt's trial, such drawings are the visible manifestations of a concept, and it is the concept that is provided by the architect. It follows ·that the study of Richardson's preliminary jottings brings the historian as close as he will ever come to entering Richardson's mind, to exposing the shape of the "initiative impulse."

That impulse had physical as well as intellectual origins. Richardson was no morbid personality, but he sensed that a long life was beyond his physical capacity.[57] Illness and ambition were key factors in his career. Consequently, patience was not among his virtues. He wrote in his Sketchbook in 1869 that "patience can make a good draughtsman not an architect."[58] The slow, time-consuming working out of alternative details could be left to assistants; the patient waiting for fame could be left to healthier men. The hastily-sketched plans and occasional elevations that issued from his bedroom, and appear to comprise his entire graphic output during his maturity, are evidence of this impatience. Richardson had time and stamina for the main idea only.

His graphic contact with the making of a "Richardson building" consisted almost entirely of thick-lined thumbnail sketches of plans and elevations, or more aptly, silhouette studies. The well-known sketches of overall form for Austin Hall, the Albany Cathedral (cat. no. 2i), or the Quincy Library (cat. no. 26b) show Richardson's prime concern with Ruskin's "Lamp of Power," demanding that the outline of a building be simple and continuous. He seems also to have followed the advice of the English architect William Burges, who, in a talk on architectural drawings to the Royal Institute of British Architects in 1861, observed that "the manner in which a man draws, does and must affect the nature of his design. . . . Thus, if he use strong thick lines, he will, in all probability, be induced to make his design massive and simple, and not give way to the vanities of crockets and pinnacles."[59] *Massive and simple* — what more succinct description of Richardson's mature work is possible? As Langton said, his method left him free to concentrate upon essentials; the drudgery of making these essentials work he left to others.[60] He thought in wholes, not in parts. This led to his most important contribution to the history of late nineteenth-century American

architecture, the control of mass, the discipline of the picturesque that was his basic legacy to Louis Sullivan and Frank Lloyd Wright.[61]

With the presentation or competition drawings accepted by the client, the office was ready to proceed to construction drawings. The drawings completed to date were, again according to Langton,

> *put into the hands of one or more draughtsmen; usually a pair. . . . When the actual work was done many hands might ink and trace. . . . The specification was usually written by the senior of the responsible draughtsmen, and one of this pair often acted as superintendent . . . especially if the work was out of town.*

Drawings such as the elevation of the North Easton Station (cat. no. 32) or of the Bryant House in Cohasset (cat. no. 12) exhibit the mechanical anonymity and precision required of these construction documents. The elevations of Sever Hall at Harvard University (cat. no. 23) bear the signatures of the building committee (E.W. Hooper and J.Q. Adams), fixing their approval of the design, and the signature of Norcross Brothers, the builder. Such drawings are part of the contract entered into by client and builder. All departure from them requires a legal change order or a lawsuit.

With construction drawings completed and contracts signed, Richardson's work was still far from finished. The last third of Mrs. Van Rensselaer's formula, "final over-sight," was probably uppermost in the architect's own mind. Olmsted reported Richardson's attitude toward design to Mrs. Van Rensselaer:

> *Never, never till the thing was in stone beyond recovery, should the slightest indisposition be indulged to review, reconsider, and revise every particle of his [the architect's] work, to throw away his most enjoyed drawing the moment he felt it in him to better its design.*[62]

Such an attitude made Richardson reluctant to commit himself on paper too soon. In the Sketchbook, under date of March 7, 1870, he wrote the following memorandum:

> *To add clause to all specifications . . . that contractors are to call for drawings from the architect only as such drawings are required for the progress of the work — that is that architect shall only be required to furnish drawings (full size) a reasonable time before the building of work set forth in drawings — Architects should not be made the convenience of contractors.*[63]

It was not an attitude to endear him to all builders, or to clients who had to pay for delays caused by hesitation in execution.

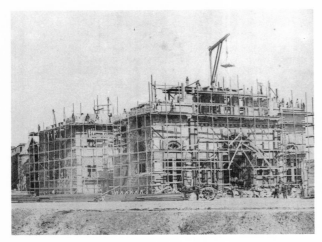

Trinity Church under construction, 1875
(Courtesy Shepley, Bulfinch, Richardson and Abbott)

The evidence points to the fact that Richardson mistrusted drawings. He reserved judgment about the idea contained in his preliminary sketches until the building began to rise. As he told Mrs. Van Rensselaer:

> *The architect . . . acts on his building, but his building reacts on him —*
> *helps to build itself. His work is plastic work, and, like the sculptor's, cannot*
> *be finished in a drawing. It cannot be fully judged except in concrete shape*
> *and color, amid actual lights and shadows and its own particular surround-*
> *ings; and if when it is begun it fails to look as it should, it is not only the*
> *architect's privilege but his duty to alter it in any way he can.*[64]

Richardson's mind leapt directly from ideogram to stone and mortar; he seems to have considered the laborious preparation of detailed drawings as a necessary evil to satisfy legal niceties. It could be left to subordinates, and, ideally at least, the drawings interpreted by the supervising architect, for the moment turned sculptor, at the construction site. Since seductive presentation drawings would fix a design in a client's mind at too early a stage, Richardson's office restricted itself to simple line drawings.[65]

This same attitude must account for the insignificant role models played in Richardson's method. Model-making was an integral part of the Victorian design process, at least in England,[66] but I know of only two models for Richardson buildings. Both are lost. One was of the preliminary scheme for Trinity Church; the other, the final design for the tower of the Allegheny County Court House.[67] Despite Richardson's definition of architecture as "plastic work," he relied almost entirely upon two-dimensional presentation. In fact, many of the presentation drawings from his office show the building itself in elevation and only the scene in perspective. Albany City Hall and the Allegheny County Court House are examples (cat. nos. 21-22). Apparently, Richardson had no difficulty grasping the three-dimensional consequences of geometric projections. And perhaps he felt that a model would fix a design in a client's mind even more firmly than the seductively colored presentation drawings he avoided.

The amount of delay and change Richardson's notable powers of persuasion achieved during construction may be exaggerated. His well-earned reputation for extravagance with his clients' pocketbooks is based principally upon his pre-construction wiles. There is no doubt that he deliberately designed buildings beyond the given budgets in order to whet his clients' appetites, and since, in Charles Coolidge's words, he could "charm a bird out of a bush,"[68] he usually did manage to spend more than was originally intended.[69] Albany City Hall, the Allegheny County Court House and other public commissions do correspond in

the main to the drawings, but where Richardson himself was supervising construction, and where he had a personal rather than a corporate client, the drawings might be ignored and the building erected by change order. After Richardson visited the site of the Gurney house at Prides Crossing, three feet were added to the foundations of the ell (cat. no. 13). But from present knowledge, the best documented and most illuminating case is Trinity Church (cat. no 1). It is true that some deviations from the original design were beyond the architect's control, such as the change in the size and shape of the site after the preparation of competition drawings, and the repeated demands of the engineering consultants that the tower be decreased in height and weight. But documents in Trinity Church Archives prove that there were constant delays caused by Richardson's reluctance to commit himself to paper until the last possible minute, delays for which the Building Committee reimbursed the builder. In one revealing letter of June 2, 1874, Norcross complains about lack of drawings, because "no work can be done economically without knowing what will come up the next week . . . as it can be when everything is decided upon and settled, and we can see . . . the Building from the foundation to the top stone. . . ." Richardson had such a total vision in mind, but wanted to test it stone by stone. After proposing and fighting all along the line for a tall central tower, and seeing it twice cut down by significant dimensions, as the upper stones approached the height finally agreed upon, he begged for, and received, an additional four feet six inches in elevation. Not all at once of course — the first change order was for three feet; the second for eighteen inches. This is situation building! Only a man who has the nerve to mistrust his drawings will do it; only a very convincing salesman will get the opportunity.

VI TEAMWORK

"Final over-sight" of this degree requires, besides indulgent clients, two other essentials. First, Richardson needed assistants who could do more than just draw. His surveillance of a rising building occurred at two levels. Langton tells us that the men who prepared the working drawings superintended construction; that is, acted as the clerk of the works on the site. Above them were Richardson himself and, increasingly as his infirmities grew, his chief assistants, mainly Charles Rutan and George Shepley, who supervised the work. These men visited the site occasionally to maintain overall control. The success of Richardson's career depended not a little upon his ability to pick men he could count on.

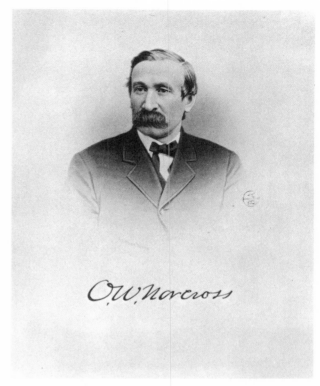

O.W. Norcross (Worcester: Its Past and Present, *1888)*

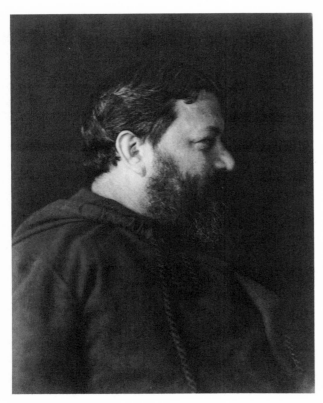

HHR by G.C. Cox, ca. 1883
(Courtesy Joseph P. Richardson)

Secondly, and of far greater importance, the leap from paper to stone required a builder of extraordinary ability if the final product was to be of the highest quality. The architect puts his reputation in his builder's hands, and any architect who relies upon on-site decisions is even more at the builder's mercy. Richardson's method required that his builder be an absolute extension of his soft pencil. And here again he was blessed, for throughout his maturity he could call upon the services of a man of uncommon talent, O.W. Norcross, the active partner in Norcross Brothers of Worcester, Massachusetts.

Orlando Whitney Norcross (1839-1920) was an inventive self-trained engineer who could solve difficult problems of construction. He controlled extensive quarries and millworks and could supply most of the raw and finished material that went into a building. He knew his own business thoroughly, and in the process of building a large portion of Richardson's work over a decade and a half, he came to know exactly what Richardson was after. The firm of Norcross Brothers has been called the "executive arm of Mr. Richardson."[70] In fact, since the firm supplied stone and was consulted early on materials and cost, O.W. Norcross must be considered the collaborator in Richardon's lithic style.[71]

A "Richardson building" was the product of teamwork. The social circles of Harvard and Brookline provided the initial opportunities to build. Richardson supplied the leading motif which his assistants, Charles McKim, Stanford White, Charles Coolidge and others, elaborated into scale drawings and then contract documents. Norcross executed the motif in collaboration with the architect or his representative at the site. For example, take the series of Boston and Albany railroad stations. Charles Sprague Sargent was a director of the line, and James A. Rumrill, with whom Richardson traveled to England after graduation, and whose Springfield house the architect visited with his bride on his wedding trip in 1867,[72] was a vice-president. The stations were sketched by Richardson, laid out by his draughtsmen, erected by Norcross, landscaped by Olmsted, and finally, published by Sargent in his periodical *Garden and Forest*.[73] On other works there were other contributors to the total result: the artist John La Farge provided the decorative program for Trinity Church,[74] and stained glass for the Watts Sherman House and a number of other buildings; the sculptor Augustus Saint-Gaudens contributed portraits for a number of memorial buildings,[75] and the "modeller and carver," John Evans, executed much of the ornamental detail which animates the surfaces of so many of Richardson's works.[76] Richardson conducted this chorus of voices, but the absence of any member of the choir would have produced far different music.

Only one question remains, the most important one. Although the word *idea* has been used to describe Richardson's contribution to his work, Mrs. Van Rensselaer's *impulse,* since it does not suggest premeditation, is probably more accurate. Whence came the *idea* of H.H. Richardson?

Richardson's failure ever to express himself theoretically, his lack of any kind of overarching social program of the type we associate with other major American architects such as Thomas Jefferson and Frank Lloyd Wright, his reluctance to justify his designs except in the most basic terms, suggest that the rationale behind his achievement must be sought elsewhere. He scoffed at theorists.[77] His written work comprises a few booklets accompanying his designs or describing his finished work. Except for the repeated assertion that he sought a "quiet and massive treatment of the wall surfaces,"[78] we have no significant statement of aims from his own pen other than the individual designs themselves. Yet, the associations present in his mature buildings reflect a consistent general outlook. Their abstract natural forms and geological regionalism fit well into the century of the Hudson River School, Transcendentalism and Ruskin, but despite Richardson's large library, he was no thoughtful, bookish man. He thrived on personal contact, and most probably imbibed the theory his work reflects from direct intercourse. It would take space beyond the scope of this introduction to argue the point conclusively, but there is in fact only one possible source for the theory that sustained Richardson's intuition.

Frederick Law Olmsted's first documented contact with Richardson occurred as early as 1868, when the established landscape designer handed on to the aspiring architect a commission for a monument to Alexander Dallas Bache, deceased head of the Coast Survey.[79] The two men were neighbors on Staten Island, where on Olmsted's recommendation, they collaborated with others in the fall of 1870 to produce a report on civic improvement.[80] During the 1880's, they shared the picturesque landscape of Brookline, living and working within a a stone's throw of one another.[81] Many of Richardson's most successful works were designed in concert with Olmsted: the Buffalo State Hospital, the Buffalo Civil War Memorial (a design opportunity that certainly came through Olmsted), the Albany State Capitol, the Boston and Albany stations, the Malden Library, the Robert Treat Paine and John Bryant houses (the latter for Olmsted's son-in-law), the Blake-Hubbard estate in Weston, the Quincy Library, the works at North Easton and the bridges in the Fens. According to Mrs. Van Rensselaer, "Mr. Richardson . . . was constantly turning to Mr. Olmsted for advice, even in those cases where it seemed as though it could have little practical bearing upon

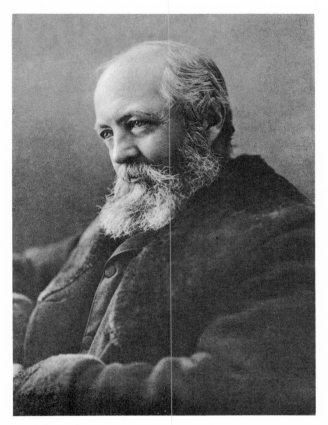

F.L. Olmsted, ca. 1890
Great Exponents Series, *Boston*
(Courtesy Frances L. Loeb Library)

29

his design."[82] And it was Olmsted who begged Mrs. Van Rensselaer to immortalize the architect with a monograph on his work. No two careers could interweave more.

If Richardson never expressed a comprehensive theory of design, Olmsted certainly did. His career lay along the main line of historical development which links Jefferson to A.J. Downing to Frank Lloyd Wright. Olmsted's whole life formed a search for the place of man, especially the democratic American, in the natural order.[83] And he had a reason for everything he did, an articulate explanation of each design decision.[84] Olmsted's environmental projects were justified by his own voluminous writings. His view was comprehensive; like Jefferson before him and Wright after him, his individual designs fit neatly into a broad vision of society. He thought in terms of regions, not isolated parks or structures, and consequently relied upon others to give specific architectural interpretation to aspects of his sweeping concepts. Richardson would seem to have been most favored among the others.[85]

It takes nothing away from Richardson's stature as an architect to envision him as part of a group of interacting individuals who together contributed to the work we for convenience call *his*. His place in the group was central. And his crowning achievement lay in his ability to focus in the most direct and lasting architectural terms the currents of nineteenth-century theory which found broader expression in his lifetime in the panoramic landscape of Olmsted's vision.

Portion of a letter from HHR to his wife, dated Cincinnati, January 27, 1885, with HHR's caricature of himself, George Shepley, and a servant en route for Chicago (Courtesy Shepley, Bulfinch, Richardson and Abbott)

1. HHR to Henry Adams, April 7, 1884 (Massachusetts Historical Society, Dwight Papers).
2. John B. Gass, "American Architecture and Architects," *Journal of the Royal Institute of British Architects*, n.s. III (February 6, 1896), 232. Gass was the R.I.B.A. Godwin Bursar for 1885. Among other foreign guests at the studio was Henry Irving, the English Shakespearian actor.
3. Anyone who writes about Richardson builds upon two monographs, Mariana Griswold Van Rensselaer, *Henry Hobson Richardson and His Works* (Boston, 1888; reprint 1967; Dover paperback, 1969) and Henry-Russell Hitchcock, *The Architecture of H.H. Richardson and His Times* (New York, 1936; 2d ed., Hamden, Conn., 1961; MIT paperback 1966).

Mrs. Van Rensselaer's book was conceived as a tribute to a man who had died at the apex of his career. It was commissioned as a memorial by two of his closest friends and neighbors, Charles Sprague Sargent and Frederick Law Olmsted, and written expressly for a broad rather than professional audience. Highly readable and on the whole still valuable as criticism, it assumes information about the interrelationships between personalities and events that have dimmed with time. With the exception of the Albany Cathedral project, it neglects all discussion of unexecuted works.

Professor Hitchcock's volume is an art-historical monograph in the strict sense. He attempted to trace the development of Richardson's style in detail against the architecture of his time. He studied all existing and available buildings, drawings and documents, although he rarely cited specific sources for specific statements. His critical stance is perhaps more obvious in the mimeographed catalogue of the 1936 exhibition of Richardson's work at the Museum of Modern Art, but it permeates the monograph as well. Hitchcock's criticism grew out of the traditional formal analysis taught by Harvard's Fogg Museum where he was trained, and reflected the bias of the Museum of Modern Art which sponsored his study.

Hitchcock wrote in a period seeking roots for the Modern Movement, which he himself had championed and chronicled. One aim of his analysis was to establish Richardson as the father of the International Style. Since Richardson rarely used metallic construction, this biased approach provided Hitchcock with some embarrassing moments. Although he has in subsequent editions of the monograph and his lecture on *Richardson as a Victorian Architect* (Baltimore, 1966) altered many of the errors and some of the bias found in the writing of the 1930's, *The Architecture of H.H. Richardson* is itself now as much of an historical monument as the works it discusses.

I must assume that anyone interested in Richardson's drawings will have studied both of these earlier works. Unless otherwise noted, mention of either Van Rensselaer or Hitchcock refers to these volumes. I have not thought it necessary to cite chapter and verse in each case.
4. HHR's membership in the Porcellian is common knowledge. On May 18, 1857, he signed a petition to the College faculty as a member of the Pierian Sodality. Among other petitioners were future clients Benjamin A. Crowninshield and James A. Rumrill, as well as Robert Gould Shaw (Harvard University Archives, College Papers, 2d series, XXIV, 1857, pp. 185-187). On April 25, 1866, he wrote "Billy" [his brother William?] from New York that he could not "be present at the next H.P.C. meeting which I regret" (letter in possession SBRA).
5. *Boston and its Suburbs*, Boston, 1888, pp. 103-104.
6. A.J. Downing, *A Treatise on the Theory and Practice of Landscape Gardening*, 6th ed. Henry W. Sargent, ed. (facsimile, New York, 1967), pp. 40-41.
7. M.G. Van Rensselaer, "A Suburban Country Place," *The Century Magazine*, LIV (May 1897), 5.
8. S.D. Sutton, *Charles Sprague Sargent and the Arnold Arboretum*, Cambridge, Mass., 1970.
9. J.G. Curtis, *History of the Town of Brookline*, Boston and New York, 1933, pp. 211, 309 ff.; H.F. Williamson, *Edward Atkinson*, Boston, 1934. Channing's Brookline house (1883) was designed by Richardson; Atkinson put the original project for the Shaw Monument (cat. no.

NOTES

39) in the architect's hands. Other important early supporters not resident in Brookline were James A. Rumrill (see cat. no. 31) and William Dorsheimer (see cat. no. 20). Both were at Harvard with Richardson.

10. Peter B. Wight, obituary of H.H. Richardson, *The Inland Architect and Builder*, VII (May 1886), 59. Wight supervised the American Merchants' Union Express Company building in Chicago for Richardson, 1872-1874, and so must have been in contact with the architect when he made his decision to move.

11. Nina Fletcher Little, *Some Old Brookline Houses*, Brookline, 1949, pp. 63 ff.; *Atlas of Brookline, Mass.*, Philadelphia, 1884.

12. Little, *Some Old Brookline Houses*, p. 65; Edward W. Emerson, "Edward William Hooper," in M.A. DeWolfe Howe, ed., *Later Days of the Saturday Club*, Boston and New York, 1927, pp. 256-261; Harold D. Cater, *Henry Adams and His Friends*, Cambridge, Mass., 1947, pp. lxii-lxiii, 110, n. 4; Ernst Scheyer, *The Circle of Henry Adams: Art & Artists*, Detroit, 1970; Ward Thoron, ed., *The Letters of Mrs. Henry Adams*, Boston, 1936, *passim*, but esp. p. 112; Geoffrey Keynes and Edwin Wolf 2d, *William Blake's Illuminated Books*, New York, 1953, *passim*, and cat. nos. 8, 13, 23-24. Hooper's Blakes are now in HCL.

13. The earliest document I have seen of Richardson's presence in Brookline is a letter addressed from there on June 13, 1874, now in Trinity Church Archives.

14. Little, *Some Old Brookline Houses*, p. 68, makes the chamber an addition of 1886, but it shows on the *Atlas* of 1884, and Mrs. Van Rensselaer is clear about its location.

15. Gass, "American Architecture," p. 231.

16. This was the last room added to the studio. Wight's obituary (see note 10) published in May 1886, calls it two years old. Plans, interior views and a description of the studio were published in *AABN*, XVI (December 27, 1884), 304.

17. A.O. Elzner, "A Reminiscence of Richardson," *Inland Architect*, XX (September 1892), 15; see also Gass, "American Architecture," p. 231. In a letter to Mrs. Van Rensselaer after Richardson's death, Olmsted expressed the hope that this room might be preserved intact in some public place (Olmsted Papers, General Correspondence, Library of Congress, Box 18), but Richardson left his survivors in such financial straits that the contents were sold off, except for the books and photographs. See note 26. Study and Coops were pulled down sometime after Richardson's successors moved the office downtown in 1888. They do not appear in the view of the house published in *AABN*, XLVII (March 30, 1895).

18. Gass, "American Architecture," p. 232; see also W. Bosworth, "I Knew H.H. Richardson," *Journal of the American Institute of Architects*, n.s. XVI (September 1951), 116.

19. T.M. Clark (1845-1909) entered Richardson's New York office in 1869 according to a note in the 1869-1876 Sketchbook (f. 3r, see Appendix), and left sometime after 1877. He superintended construction of Trinity Church, the Cheney Block and the Winn Library. From 1880 to 1888 he was professor of architecture at MIT, then editor of *AABN*. He was the author of numerous books on the practical aspects of building.

20. Cf. Ernest Flagg, "The Ecole des Beaux-Arts," *Architectural Record*, III (1893-1894), 307-313, 419-428; IV (1894-1895), 38-43; also note 55.

21. James F. O'Gorman, *The Architecture of Frank Furness*, Philadelphia Museum of Art, 1973 (exh. cat.), pp. 23 ff.

22. Cf. *AABN*, XVI (December 27, 1884), 304, and *AABN*, XXII (October 1, 1887), 154.

23. James F. O'Gorman, "Henry Hobson Richardson and Frank Lloyd Wright," *The Art Quarterly*, XXXII (Autumn 1969), 308-311.

24. O. Gruner, "Personliche Erinnerungen an Henry Richardson," *Deutsche Bauhütte*, VI (July 17, 1902), 228; A. Lewis, "Hinckeldeyn, Vogel, and American Architecture," *JSAH*, XXXI (December 1972), 276 ff.

25. The list of lesser lights who also worked for Richardson includes William M. Aiken, Frank E. Alden, Francis Bacon, E.R. Benton, H.C. Burdett, John Burrows, E.A. Cameron, C.J. Coffin, Frank I. Cooper, E.F. Ely, A.O. Elzner, A.H. Everett, David C. Hale, A.H. James,

F.A. Kendall, W.W. Kent, W.A. Langton, Alexander W. Longfellow, Jr., E.F. Maher, T. Henry Randall, James S. Rogers, Jr., Frederick A. Russell, Frank E. Rutan, and certainly many more that have not come to my attention.

26. Part of Richardson's library is preserved in the Frances Loeb Library, Gund Hall, Harvard Graduate School of Design, the gift of Henry R. Shepley in 1942.

27. Elzner, "A Reminiscence," p. 15.

28. Elzner, p. 15.

29. Bosworth, "I Knew H.H. Richardson," p. 118.

30. Van Rensselaer, *Richardson*, p. 129.

31. "Henry H. Richardson," in M.A. DeWolfe Howe, ed., *Later Years of the Saturday Club*, pp. 193-200. M.F. Augustin & Son, Restaurateurs, established in 1818, were located at 1105 Walnut Street.

32. A. Saint-Gaudens, *The Reminiscences*, New York, 1913, I, p. 328.

33. J.D. Forbes, "Shepley, Bulfinch, Richardson & Abbott: An Introduction," *JSAH*, XVII (Fall 1958), 19 ff. The complete list of firm names follows:

Gambrill & Richardson, New York	1867 - 1878
H.H. Richardson, Brookline	1878 - 1886
Shepley Rutan and Coolidge, Boston	1886 - 1915
Coolidge and Shattuck	1915 - 1924
Coolidge Shepley Bulfinch and Abbott	1924 - 1952
Shepley Bulfinch Richardson and Abbott	1952 - 1972
Shepley Bulfinch Richardson and Abbott, Inc.	1972 - present

34. Talbot Hamlin, *Benjamin Henry Latrobe*, New York, 1955.

35. *Architects' and Mechanics' Journal*, III (February 1861), 233.

36. Authorship of a design concept was demonstrated by possession of original drawings. This point has become of less significance with the development of cheap means of reproduction beginning about the time of Richardson's death. It is now unnecessary for original drawings to leave the office, and any interested party can obtain a mechanical copy.

37. "The Custody of an Architect's Drawings," *AABN*, III (June 15, 1878), 206-208. A later series of articles on the same subject by Wyatt Papworth in the *Journal of the Royal Institute of British Architects* (n.s. VIII, 1891-1892, 169 ff., 188 ff., 231 ff.; IX, 254 ff.) touched off an international symposium in *AABN*, XXXVI, 33; XXXVIII, 10 ff., 45 ff., 182 ff. The legal history of the problem is too complex to detail here.

38. The relevant documentation is in Trinity Church Archives.

39. Letter in possession of SBRA. The last provision was a guard against the habit of some building committees to pay little for a number of competition designs and then have a hack combine their desirable features in the executed building. This was another concern of the AIA, of which Richardson was an active member.

40. At SBRA are preserved "Drawing Lists" from the 1880's in which outgoing and incoming drawings were logged. These are occasionally cited in the following catalogue.

41. In Richardson's case this may be truer for public structures than for residences. The few original drawings outside HCL that have come to light are preliminary designs for the Hay (cat. no. 8) and Glessner (cat. no. 9) Houses.

42. Tracings exist in the superintendent's office at the Buffalo State Hospital. There is a set of signed drawings in the archives of the Allegheny County Court House. Drawings for Castle Hill Lighthouse should be somewhere in the National Archives (see cat. no. 40).

43. There are also architectural drawings not strictly related to the design process, such as sketches or measured drawings taken from existing buildings, promotional graphics, and so on.

44. *AABN*, III (June 15, 1878), 207.

45. W.A. Langton, "The Method of H.H. Richardson," *The Architect & Contract Reporter*,

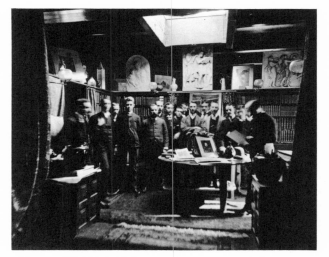

HHR's assistants in his library, ca. 1886
(Courtesy Boston Athenaeum)

Frogs. Study for a Fountain (FOU-D1)

LXIII (March 9, 1900), 156-158. This also appeared in the *Canadian Architect and Builder*, XIII (February 1900). All subsequent Langton quotations are taken from this brief article. Cf. cat. no. 27, for a letter by HHR discussing his method, which came to my attention too late to be discussed here.

46. Massachusetts Historical Society, Dwight Papers.

47. Van Rensselaer, *Richardson*, p. 123.

48. A sampling of letters dealing with Richardson's health includes: HHR to F.L. Olmsted, October 13, 1868 (see note 79); HHR to Charles H. Parker, Chairman of Building Committee, Trinity Church, n.d. (Trinity Church Archives); HHR to Olmsted, May 21, 1876 (see cat. no. 20); HHR to Olmsted, August 23, 1876 (SBRA); Olmsted to Charles Eliot Norton, November 9, 1879 (typescript in Olmsted Papers, Library of Congress); the letters from HHR to wife, summer 1882 (SBRA); and HHR to John Hay, December 31, 1885 (Hay Library, Brown University). Many more could be cited.

49. Julia Richardson (Mrs. George F.) Shepley, "Reminiscences," typescript, n.d., 7 pp. (SBRA).

50. C. Waern, "John La Farge, Artist and Writer," *Portfolio*, 26 (1896), 33; J.J. Glessner, "The Story of a House," unpublished album in two copies prepared for the Glessner children in 1923 (see cat. no. 9).

51. C. Price, "Henry Hobson Richardson: Some Unpublished Drawings," *Perspecta* 9/10 (1965), 200-210.

52. The various heights of the Pittsburgh tower shown in the preserved drawings lend support to the story that Richardson found this a difficult design problem and asked Saint-Gaudens' help in solving it (*Reminiscences*, I, 327). See note 67.

53. R. Phené Spiers, *Architectural Drawing*, London, New York, etc., 1888, p. 19.

54. Spiers, p. 19, para. 23: "In France and Germany it is the practice not only to indicate the materials by tints on the geometrical drawings, but to project the shadows cast at an angle of 45° . . . the object being to emphasize the mass, and to minimise the effect of lines. . . ." Cf. Richardson's sketch plan for Trinity Church (cat. no. 1d). Spiers, p. 20, para. 26: "In plans [in the French system] the covered portions of the buildings are left white, and the courts and surrounding ground (if paved) tinted pale grey; on to these grey grounds a shadow, as it were, of a plinth, 2 ft. in height, is projected. The walls are always tinted jet black; statues, lamps, or balusters in section, are tinted vermilion, to distinguish them from columns." Cf. the presentation plans of the Ames and Higginson houses (cat. nos. 6-7) and again, the sketch plans for Trinity (cat. no. 1d).

55. A brief description of the French system is given in Spiers, p. 33, note. See also note 20.

56. F. 3ʳ, see Appendix.

57. "He was doomed to early death and he knew it. . . ," according to J.J. Glessner's "Story of a House."

58. F. 3ʳ, see Appendix.

59. *Transactions of the Royal Institute of British Architects*, 1861, pp. 15 ff. Richardson's interest in Burges is well known. He visited his house in London during his journey of 1882, unfortunately one year after Burges' death. He owned Burges' *Architectural Drawings*, London, 1870. Nor were Burges' 1861 words forgotten. The quote in the text is also found in Spiers, p. 17, note. Spiers wrote that "A very thick line is sometimes to be condemned . . . and sometime conventionalises the design . . . so that breadth and simplicity are the result." Spiers' paraphrase of Burges fits Richardson's work as well as Burges' original.

60. "While enlarging the scale details to full size, making shop drawings and patterns, I became familiar with the drawings from Richardson's office — was much impressed with their artistic qualities and wondered at his ability in ignoring practical considerations when attaining artistic effects." The writer was clerk of the works for Norcross on the Cheney Block (cat. no. 17); Glenn Brown, *Memories 1860-1930*, Washington, D.C., 1931, pp. 23 ff.

61. O'Gorman, "Henry Hobson Richardson and Frank Lloyd Wright," pp. 302 ff.

62. Van Rensselaer, *Richardson*, pp. 118-119.

63. F. 7ʳ, see Appendix.

64. Van Rensselaer, *Richardson*, p. 119.

65. Cf. John La Farge, *An Artist's Letters From Japan*, New York, 1897, pp. 105-106: "Then, do you think that if he [Richardson] had drawn charming drawings beforehand he would have been able to change them, to keep his building in hand, as so much plastic material? No; the very tenacity needed for carrying out anything large would have forced him to respect his own wish once finally expressed, while the careful studies of his assistants were only a ground to inquire into, and, lastly, to choose from."

66. See the chapter on "The Architectural Model During the Victorian Period," in J. Physick and M. Darby, *Marble Halls,* London, V. and A. Museum, 1973 (exh. cat.), pp. 13-16.

67. See cat. no. 1 for Trinity; the model of the tower appears in the library in the photograph of Richardson's assistants published here. No other models show up in other photographs of the studio. The use of models in Victorian America remains unstudied. Certainly they were made (i.e., Thomas Fuller's for the New York State Capitol; John McArthur's for the Philadelphia City Hall, etc.), but they may not have played a significant role in the design process. There is no important discussion of them in *AABN* between 1876 and 1893.

68. See note 31.

69. Trinity Church (see Introduction and cat. no. 1), the Hay-Adams Houses (cat. no. 8), the Higginson House (cat. no. 7), the Billings Library (cat. no. 27), and Austin Hall (cat. no. 24) may all serve as examples.

70. "A Great Building Firm," critical supplement to the *Architectural Record*, 1896, pp. 104-105.

71. James F. O'Gorman, "O.W. Norcross, Richardson's 'Master Builder,'" *JSAH*, XXXII (May 1973), 104-113. To the information about Norcross-built Richardson projects given there in notes 13-14, I can now add the following information. Norcross did *not* build Emmanuel Church, the New London Railroad Station, or the houses for Gurney, Bigelow, either of the Lionbergers, Potter, Paine or MacVeagh. Norcross did build the Ames Gate Lodge, the Hayden Building, and the stations at Holyoke, Wellesley Hills and Newton. It is likely he also built the Higginson House. Finally, Norcross prepared cost estimates for Richardson's project for the Connecticut State Capitol.

72. Julia (Mrs. H.H.) Richardson to her mother, January 6, 1867 (Archives of American Art).

73. "The Railroad-Station at Auburndale, Massachusetts," *Garden and Forest*, II (March 13, 1889), 124-125; "The Railroad-Station at Chestnut Hill," *Garden and Forest*, II (April 3, 1889), 159-160.

74. H.B. Weinberg, "John La Farge and the Decoration of Trinity Church, Boston," to appear in the December 1974 issue of *JSAH*.

75. Saint-Gaudens Papers, Baker Library, Dartmouth College, Box 16 contains a number of documents.

76. Evans first worked for Richardson at Trinity Church. Among other works he carved Saint-Gaudens' portraits of the Ames brothers on the Sherman, Wyoming, monument. Papers relating to his firm have recently been given to the Boston Public Library. See also cat. nos 25 and 26.

77. See cat. no. 8.

78. H.H. Richardson, *Description of Drawings for the Proposed New County Buildings for Allegheny County, Penn.*, Boston, 1884, pp. 4-5: "Although, under your requirements, a great preponderance of openings is necessary, the intention has been to produce that sense of solidity requisite in dignified, monumental work, by a careful study of the piers and by a perfectly quiet and massive treatment of the wall surfaces." Richardson, *Cincinnati Chamber*

of Commerce, Boston, n.d., pp. 4-5: "Although, under your requirements, as great preponderance of openings is necessary, the intention has been to produce that sense of solidity requisite in dignified, monumental work, by a careful study of the piers and by a perfectly quiet and massive treatment of the wall surfaces." Richardson, *The Hoyt Public Library, East Saginaw, Michigan*, Boston, n.d., p. 4: "The intention has been to produce that sense of solidity requisite in dignified, monumental work, by a perfectly quiet and massive treatment of the wall surfaces." This late refrain was the result of earlier thinking. In the Sketchbook (f. 2ᵛ, see Appendix), probably under date of 1869, he wrote: ". . . depend upon simple & monumental effects." In Gambrill & Richardson's *Descriptive Report and Schedule for Proposed Capitol Building of the State of Connecticut*, New York, 1872, we find the same idea expressed less succinctly: ". . . in using granite we must depend on an effective distribution of the masses, judicious fenestration, and a majesty in keeping with the stern nature of the material," and avoid "meretricious ornament." And again, ". . . on account of the great *movement* of the design, and the necessary number of openings . . . there is a need for repose." See also comments in letters to Olmsted, cat. no. 20.

79. HHR to Olmsted, October 13, 1868: "I have just risen from a sick bed & been unable until now to attend to Monument to be erected to Mr: Bache — I will notify you when the studies are at all advanced." See also C.P. Patterson to Olmsted, July 13, 1868, and Gambrill & Richardson to Olmsted, November 24, 1868 (Olmsted Papers, General Correspondence, Library of Congress, Box 8). I do not know the fate of the project. See Laura Roper, *FLO: A Biography of Frederick Law Olmsted*, Baltimore, 1973, p. 320.

80. Staten Island Improvement Commission, *Report of a Preliminary Scheme of Improvements Presented January 12ᵗʰ, 1871*, signed: Fred. Law Olmsted, Elisha Harris [a doctor], J.M. Trowbridge [a civil engineer] and H.H. Richardson. See Roper, *Olmsted*, pp. 325-326. It is difficult to understand the architect's contribution to this report. Olmsted's recommendation of Richardson called him "a gentleman trained in the most thorough French technical school, familiar with European road and sanitary engineering, and of highly cultivated tastes with a strongly practical direction" (Olmsted Papers, General Correspondence, Library of Congress, Box 9 [typed copy of a letter of September 22, 1870]).

81. Olmsted, who had been living in Brookline, in 1883 purchased a house on Warren Street just downhill from Cottage. Richardson wanted him even closer. In a letter of February 6, 1883, the architect asked Olmsted ". . . what would you say to building on my lot (or Hoopers) I think I may own the place in a year & have arranged with Hooper or can (he is with me) to have you build at once." Richardson also sketched a plot plan showing the house ("a beautiful thing in *shingles?*") west of the Perkins house (Olmsted Papers, General Correspondence, Library of Congress, Box 18). Richardson died Hooper's tenant.

82. *AABN*, XXIII (January 7, 1888), 4.

83. Albert Fein, *Frederick Law Olmsted and the American Environmental Tradition*, New York, 1972.

84. See for example, Roper, *Olmsted*, ch. XXVI: "Four Reports," and, more specifically, Olmsted's justification of Richardson's Memorial Arch in Buffalo in *Fifth Annual Report of the Buffalo Park Commissioners*, Buffalo, 1875, pp. 15-16.

85. Roper, *Olmsted*, pp. 372-373, sees the relationship differently, assuming that Olmsted deferred to Richardson in architectural matters. This may have been true as regards details, but the flow of design philosophy would appear to have moved in the reverse direction.

COLOR PLATES

1b. Trinity Church, Boston, 1872-1877 et seq. *Longitudinal Section*

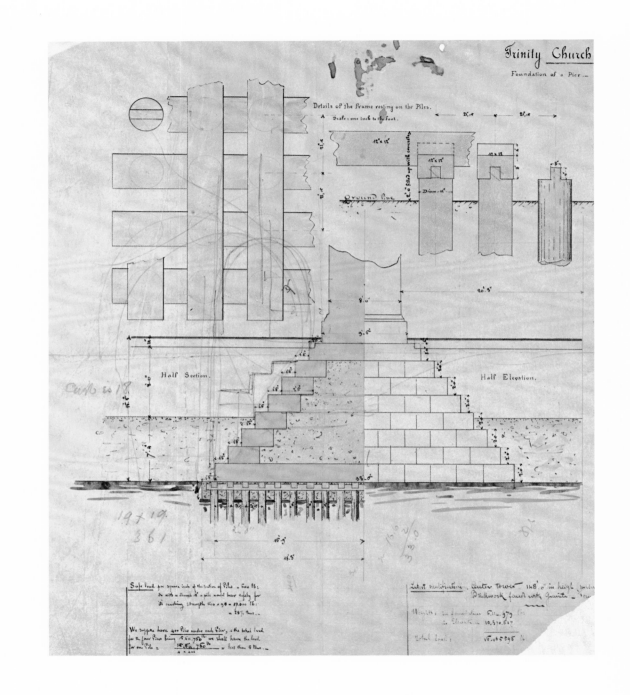

Trinity Church

Foundation of a Pier.

Details of the frame resting on the Piles.

Scale : one inch to the foot.

Ground line

Half Section.

Half Elevation.

1f. Trinity Church, Boston, 1872-1877 et seq. *Pier Foundation*

3a. Emmanuel Episcopal Church, Allegheny City (Pittsburgh), 1883-1886.
Front Elevation Study

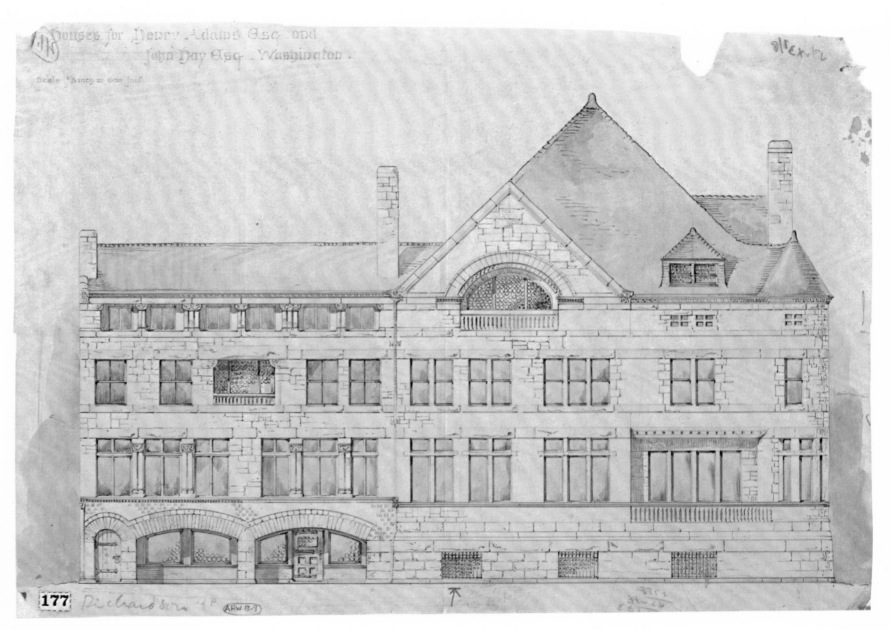

8e. *Hay-Adams Houses, Washington, D.C., 1884-1886. Elevation of H Street Fronts*

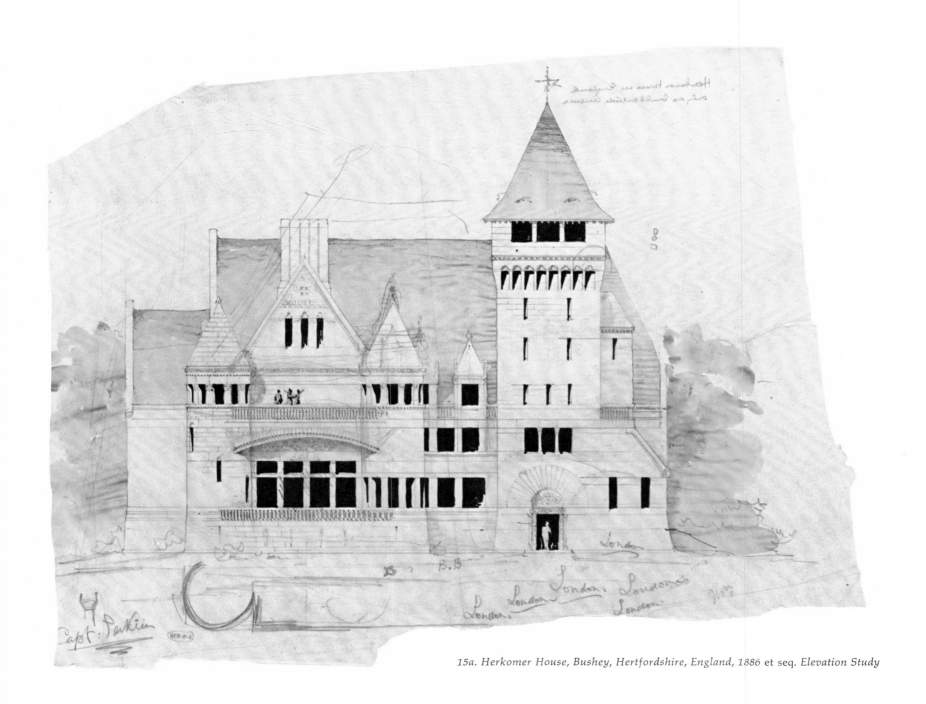

15a. Herkomer House, Bushey, Hertfordshire, England, 1886 et seq. *Elevation Study*

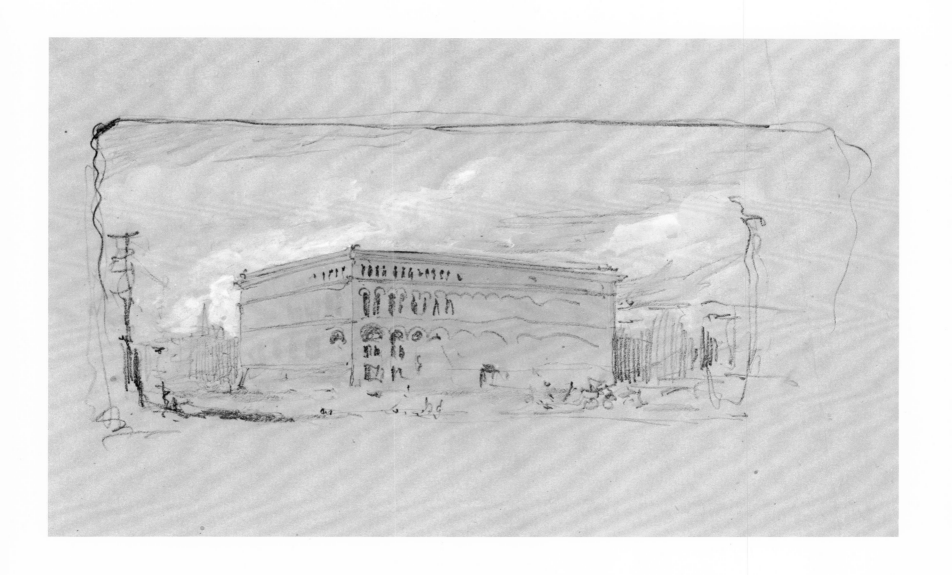

19b. Marshall Field Wholesale Store, Chicago, 1885-1887. Perspective Sketch

20h. New York State Capitol, Albany, 1875 et seq. *Interior of Senate Chamber*

22f. Allegheny County Court House, Pittsburgh, 1883-1888.
Main Elevation

LIST OF ABBREVIATIONS

AABN	*The American Architect and Building News*
AIA	American Institute of Architects
CAC	Charles A. Coolidge
GFS	George F. Shepley
HHR	Henry Hobson Richardson
JSAH	*Journal of the Society of Architectural Historians*
HCL	Harvard College Library
Hitchcock 1936	Henry-Russell Hitchcock, *The Architecture of H.H. Richardson and His Times*, New York, 1936
Hitchcock 1961	*Ibid.*, 2nd ed., Hamden, Conn., Archon Books
Hitchcock 1966	*Ibid.*, paperback ed., Cambridge, Mass., MIT Press
MIT	Massachusetts Institute of Technology
SBRA	Shepley, Bulfinch, Richardson and Abbott
SRC	Shepley, Rutan and Coolidge
Van Rensselaer	Mariana Griswold (Mrs. Schuyler) Van Rensselaer, *Henry Hobson Richardson and His Works*, Boston, 1888

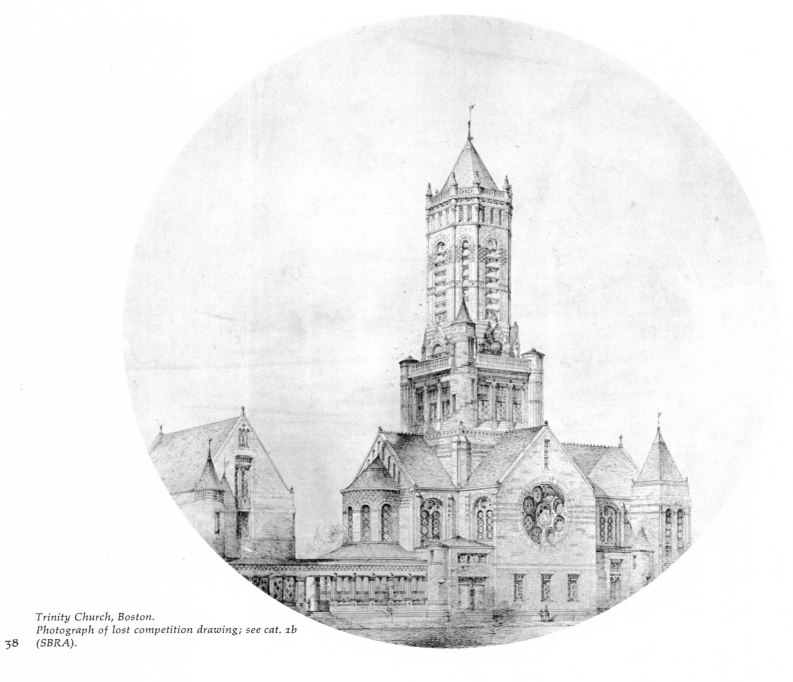

Trinity Church, Boston.
Photograph of lost competition drawing; see cat. 1b
38 *(SBRA).*

CATALOGUE

JAMES F. O'GORMAN

The descriptions give in order: media, dimensions in inches, draughtsman, previous publication, the Harvard College Library catalogue number or name of lender, and any notes. The sheets were measured through the centers; height precedes width. "Autograph" means the drawing appears to be by HHR himself.

ECCLESIASTICAL BUILDINGS

Although not thought of primarily as a "church architect," Richardson in twenty years did produce well over a dozen executed and projected ecclesiastical designs. They were of considerable significance in his career, and in our estimate of it. The demolished Church of the Unity in Springfield, Massachusetts, commissioned in November 1866, became his first independent building. Grace Church, Medford, Massachusetts, designed in the spring of 1867, stands as the oldest surviving building to come from his draughting board. Trinity Church, Boston, is the key monument of his early maturity, and his first building of national importance. The Albany Cathedral project was among his most discussed creations in the nineteenth century, and the little brick Emmanuel Church in Pittsburgh among his most praised in the twentieth.

1. Trinity Church, Boston, 1872-1877 et seq.

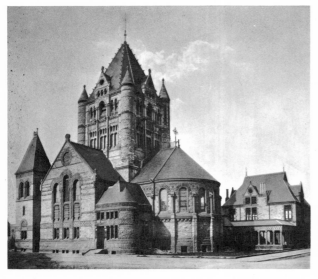

Photograph 1870's (HCL)

Restudy of the documents and drawings in the Trinity Church Archives and in possession of Shepley, Bulfinch, Richardson and Abbott makes necessary some revision in the early history of the design given in Stebbins' basic study.

On March 12, 1872, letters went out from the Building Committee to prospective architects requesting designs for a church on a rectangular lot at the northwest corner of Clarendon Street and St. James Avenue (cat. no. 1a). The Committee selected six architects or firms to compete: William A. Potter, John Sturgis, Peabody and Stearns, Ware and Van Brunt, Richard M. Hunt, and H.H. Richardson (the letter was not sent to Gambrill & Richardson). Documents in Trinity Archives associate other architects with the competition as well: C. Arthur Totten of New York and John Ames Mitchell and L. Frere of Boston all corresponded with the Committee; Faulkner & Clarke of Boston asked to compete, but could not produce a design owing to the press of business from their office in fire-ravaged Chicago; Edward T. Potter refused to enter the contest.

Drawings were due on May 1, and the commission was awarded on June 1. While the Committee discussed the merits of the entries, the shape of the site for which the designs had been prepared was changed. It is clear from the minutes of the Committee's meetings that on May 11 authorization was given to purchase the triangular piece of ground immediately north of the original rectangle, and on May 22 the sale was made (the deed conveyed on June 14). Since the purchase occurred before Richardson was selected as architect, he cannot have been solely responsible for the decision. Rather, the wisdom of such a move seems to have been plain to a number of people. During April both Van Brunt and Mitchell wrote to the Committee asking if the triangle was to remain free of building. No answer is recorded; all competition drawings were prepared for the original rectangular lot.

Meanwhile, the Committee was studying drawings and interviewing architects. On June 1, Richardson was awarded the commission. The thinking of one member of the Committee is preserved. The day before the decision, Charles R. Codman wrote to chairman George M. Dexter that only two designs could even be considered, those of John Sturgis and H.H. Richardson. He favored Sturgis' because Richardson's would be "too costly," and he was worried about building "so heavy a structure on piles." Codman's judgment might have been affected by the fact that he was Sturgis' brother-in-law, but his appraisal, although rejected by his colleagues, proved all too prophetic.

All competition drawings were prepared for the original site. When Richardson received the Committee's letter asking for designs, he turned it over and sketched alternative plans, a Greek cross and a nave church with narrow aisles (cat. no. 1a). The longitudinal scheme quickly disappeared. (The plot

plan showing a trapezoidal lot with the outline of an asymmetrically-towered nave church published by Stebbins, fig. 4, cannot be connected with Richardson. The trapezoidal lot was achieved through purchase in May, as we have seen, *after* designs for a rectangular lot were in the Committee's hands. We know from a section [cat. no. 1b] that Richardson had by then decided upon a central tower. In a letter of March 15, John Sturgis mentioned contemplating a southwestern tower. This plot plan may relate to his project, or, what is more likely, was something prepared for the Committee for promotional use. The date 1873 is written on one copy of this plan found in the Archives. There is nothing to corroborate the statement of Phillips Brooks' biographer, Alexander V.G. Allen, that a corner tower "was at first intended.") Richardson developed the cross plan with high central tower and "Chapel" or parish house to the rear as his competition entry (cat. no. 1b). Having won the commission he wrote to the Committee on June 13 that he had spoken with Phillips Brooks about the project, and had begun "arranging the plan according to the demands of the new lot." It was the first of many revisions.

From this point on, the data given by Stebbins is essentially correct regarding the building (his remarks about Richardson's payment for Trinity need revision in the light of the full documentation in the Archives). During the next ten months Richardson produced a mature set of drawings which he presented in April 1873. After the building of a model (delivered to Boston in December; now lost) and several changes caused by concern over the weight of the tower (March-June 1873), contract drawings were completed by late summer and, after still more changes, Norcross Brothers were awarded the contract to build Trinity from the top of the pilings on October 10, more than sixteen months after Richardson received the commission.

Winter 1873-1874 saw the piles driven and foundations prepared. The "Chapel" went up between March and November 1874. The definitive, "Salamanca tower" was established after another period of concern in April 1874, although the revised contract with Norcross was not signed until April 1875. The cornerstone of the main church was laid on May 20; the main arches were complete by July 27. After the usual seasonal halt, work resumed in April 1876. John La Farge signed his contract for the interior decoration on September 15, and on November 29 Norcross Brothers informed Richardson in writing that their contract had been fulfilled in all essentials. Dedication took place on February 7, 1877.

Trinity was not, however, complete. The western turrets were redesigned and the main porch added by Shepley, Rutan and Coolidge. The interiors of both church and "Chapel" were later altered.

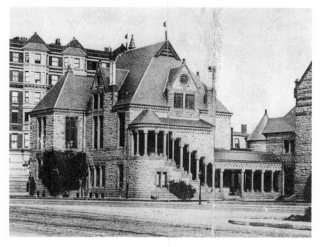

Trinity Parish House ("Chapel"). Photograph 1870's (HCL)

Sources: Trinity Church Archives; documents in possession of SBRA; *Consecration Services of Trinity Church, Boston, February 9, 1877, with . . . a Description of the Church Edifice, by H.H. Richardson,* Boston, 1877; Theodore E. Stebbins, Jr., "Richardson and Trinity Church: The Evolution of a Building," *JSAH,* XXVII (December 1968), 281-298.

1a. Letter from the Building Committee of Trinity Church, with Autograph Sketches

Ink and pencil on lined white stationery; 9¾ x 15½ in. (unfolded). Partially autograph. Unpublished.
Lent by Shepley, Bulfinch, Richardson and Abbott

Boston, March 12. 1872

H.H. Richardson Esq. / Nr. 57 Broadway [New York]
Sir,

You are requested to furnish designs for the erection of a Church on a lot of land recently purchased by Trinity Church, a plan of which is herewith enclosed. The lot measures 250. feet by 100. feet reserving 10. feet on St. James Avenue.
It is desired to seat on the floor 1000. persons and 350. in the galeries [*sic*].
[in Richardson's hand at end of line: *what allowances*]
No Columns, Well lighted, warmed & ventilated with good acoustic qualities. Robing Room & Organ on either side of Chancel, & no basement [in Richardson's hand above line: *what is meant*]. *Also In rear of the Church a Parish building containing a Lecture room capable of seating 500. persons, a Sunday School room over lecture room, and an Infant School room, and three or four small rooms* [in Richardson's hand above line: *(all 15 x 16)*] *for Bible classes & society rooms. To furnish a ground Plan, three elevations, Longitudinal & cross sections, and a perspective drawing. Scale 1/8. with an approximate estimate including foundation not to exceed $200.000-dollars.*
The Building Committee will pay for your designs Three Hundred dollars. The plans to become their property. The Architects name to be in Cypher. [in Richardson's hand: *now front —*]

G.M. Dexter ⎰ *For Building*
Chas. Henry Parker ⎱ *Committee*

Plans to be sent in on, or before May 1. 1872.

On the verso are HHR's sketches as first thoughts for Trinity. One is a Greek cross using the allowed ninety feet north and south. The altar is located in front of the rectangular chancel. The alternate sketch is a nave church with narrow side aisles, clerestory and gable roof. It is shown both in plan and in section. The date is mid-March 1872.

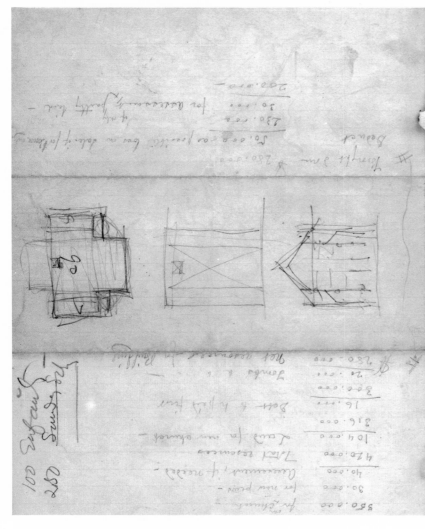

H. H. Richardson Esq.
№ 57 Broadway Boston March 12'. 1872.

 Sir,
 You are requested to furnish
designs for the erection of a Church on a lot of land recently
purchased by Trinity Church, a plan of which is herewith
enclosed. The lot measures 250. feet by 100. feet reserving 10. feet
on St. James Avenue.
It is desired to seat on the floor 1000. persons and 350. in the
galleries. what allowance
No Columns, Well lighted, warmed & ventilated with good acoustic
qualities. What is meant
Robing Room & Organ on either side of Chancel, No basement, Also
In rear of the Church a Parish building containing a
Lecture room capable of seating 500. persons, a Sunday School
room over lecture room, and an Infant School room, and
three or four small rooms for Bible classes & society rooms [alt 15 x 16]
To furnish a ground Plan, three elevations, Longitudinal &
Cross sections, and a perspective drawing. Scale 1/8 with an
approximate estimate including foundation not to exceed
$200.000 - dollars.
The Building Committee will pay for your designs Three Hundred
dollars. The plans to become their property. The Architects
name to be in Cypher.
 how front - G. M. Dexter) For Building
 Chas. Henry Parker) Committee
Plans to be sent in on, or before May 1st. 1872.

1a. Letter from Trinity Church Building Committee with Autograph Sketches

Richardson's Sketchbook (f. 29ʳ, see Appendix) contains a series of sketch plans identified as *Trinity*. These must follow the alternate schemes jotted on the back of this letter, and precede nos. 1c and 1d, which are for a trapezoidal lot and therefore correspond to Richardson's letter of June 13. The Sketchbook plans show the architect working away from the Greek cross with rectangular apse toward the rounded chancel of the final building. He has begun to place the parish house off to one side, but the only indications show a rectangular lot. (The possibility exists that these sketches relate to Trinity Church, Buffalo, also of 1872, but the final design [Hitchcock 1966, fig. 22] had a longer nave and corner tower. A clearly recognizable preliminary plan for the Buffalo church is on folio 28ʳ of the Sketchbook, see Appendix.)

On this same letter Richardson figured costs, resulting in *$280,000 Net resources for Building*, just $6,000 off the initial contract price awarded to Norcross Brothers some nineteen months later.

1b. Longitudinal Section (see color plate)

Ink and watercolor on watercolor paper; 27½ x 39½ in. (sheet torn and mended; some losses). Charles F. McKim? Unpublished. (TC-C1)

The height and design of the tower and the placement of the parish house to the rear of the church in this section correspond to the design shown in the tondo perspective published by Stebbins (fig. 3) as a "Competition Drawing (?)" for Trinity. That lost perspective is known only from a photograph (see p. 38) in the large album at SBRA. This section, then, is the only survivor of the set of winning competition drawings submitted to the Building Committee on May 1, 1872. Hitchcock assigns the preparation of the set to McKim.

Richardson had already indicated a figurative decorative program for the tower five years before John La Farge began his work. (An article in the December 1974 issue of *JSAH* by Barbara Weinberg will discuss this drawing in relation to La Farge's program.)

1c. Plan

Pencil, blue pencil and brown ink on watercolor paper; 4⅜ x 4½ in. Autograph. Stebbins, fig. 5.
Written in pencil at right: *Dress'g Room*
Lent by Shepley, Bulfinch, Richardson and Abbott

The earliest known sketch showing the trapezoidal plot. Probably early June 1872, as is no. 1d.

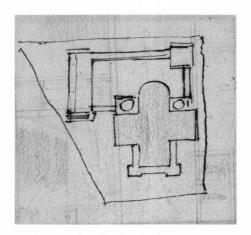

1c. Trinity Church. Sketch Plan

1d. Plan

Pencil, blue pencil and brown ink on watercolor paper; 3¾ x 6 in. Autograph.
Van Rensselaer, p. 124; Stebbins, fig. 5.
Written in brown ink in HHR's hand upper right: *Trinity Sketch*
Lent by Shepley, Bulfinch, Richardson and Abbott

The parish house and cloister have drifted to the northern end of the trapezoidal site, and the plan of the church has begun to assume its definitive form.

1e. West Elevation

Pencil, ink and wash on linen-mounted paper; 29¼ x 24¼ in. Draughtsman.
Stebbins, fig. 10. (TC-B6)
Lettered in black ink at left: TRINITY CHURCH, BOSTON / FRONT ELEVATION / SHEET 5 / SCALE 1/8 *in.* = 1 *ft.*

Stebbins sees this as part of the set of contract drawings ready by September 1873. The tower is, of course, the intermediate design between the original proposed in no. 1b and the definitive in no. 1g. The pattern of color created by granite walls and sandstone trim is indicated.

1f. Foundation of a Pier (see color plate)

Pencil, ink and watercolor on buff tracing paper; 18⅞ x 15⅝ in. (sheet cut off at right). Draughtsman. Unpublished. (TC-C19)
Lettered in black ink upper right: *Trinity Church . . . / . . . Foundation of a Pier . . .*
Notation in black ink lower left: *Safe load per square inch of the section of Piles = 600 lb: / So with a diam = 11″ a pile would bear safely for / its crushing strength 600 x 95 = 57,000 lb: / = 28½ tons. / We suppose here 400 Piles under each Pier, & the total load / for the four piers being 15,611,750lb we shall have*

$$the\ load\ /\ for\ one\ Pile = \frac{15,611,750^{lb}}{4\ x\ 400} = less\ than\ 5\ tons. —$$

Notation in red ink lower right: *Latest modification. Center tower 148'-0″ in heigh [sic] . . . Brickwork faced with Granite — . . .*
Weights: in foundation 6,114,979 lb:
* in Elevation 10,370,617*
Total load: 16,845,596 lb:

Dimensioned half section and half elevation of a main pier foundation. A granite-faced pyramidal footing rests upon a wooden frame encased in con-

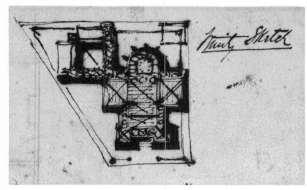

1d. Trinity Church. Sketch Plan

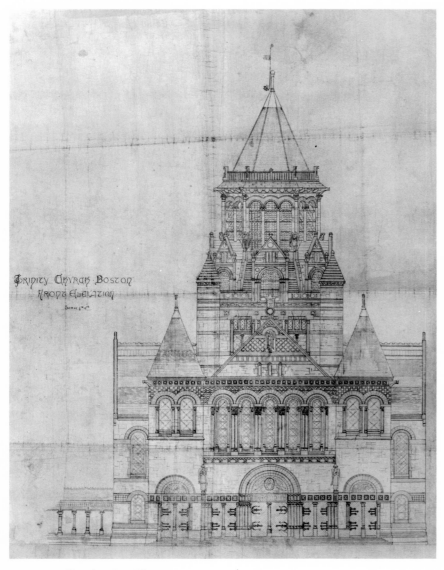

1e. Trinity Church, West Elevation

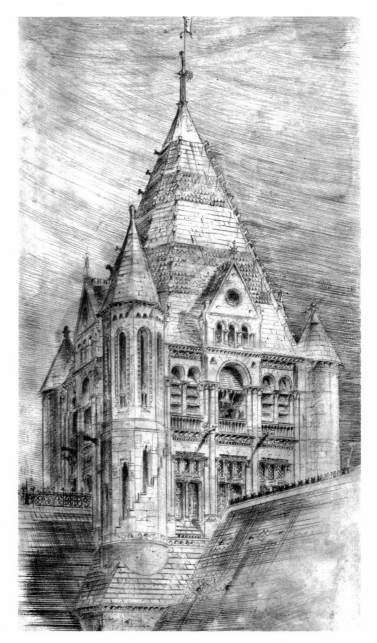

1g. Trinity Church. "Salamanca Tower"

crete at the top of the pilings. The filled soil of the Back Bay made necessary these extraordinary footings; Richardson's *Description* discusses their fabrication.

1g. Perspective of the "Salamanca Tower"

Pencil on paper; 21⅝ x 9⅝ in. Stanford White? Stebbins, fig. 14.
Lent by Shepley, Bulfinch, Richardson and Abbott

Stebbins dates this drawing April 1874 and attributes it to White. The preparatory autograph sketch (Stebbins, fig. 12) is on folio 51ʳ of the Sketchbook (see Appendix).

1h. Perspective of Church and "Chapel" (Parish House) from the Northwest

Pencil on heavy buff paper; 35¼ x 46 in. (sheet torn and mended; some losses). Draughtsman. Unpublished. (TC-F8)

Outline drawing without shades or shadows. Study for the western towers and apsidioles flanking the main façade, shown without porch. The apsidioles were never built. This drawing, like all that follow, must stem from the years after HHR's death.

1i-k. Studies for Western Front

1i. Pencil with freehand border on tracing paper; 10⅞ x 13⅞ in. Charles A. Coolidge? Stebbins, fig. 24. (TC-D214)

1j. Pencil with freehand border on tracing paper; 11⅞ x 14⅜ in. Charles A. Coolidge? Unpublished. (TC-D222)

1k. Pencil on tracing paper; 13½ x 20⅛ in. (sheet torn and mended; loss upper left). Charles A. Coolidge. Unpublished. (TC-D40)
 Written and signed in pencil at left: *Raise this same as A / keeping double row of arches / CAC*

Stebbins describes these studies as a Poitiers-type façade and dates them ca. 1888. His guess that Coolidge was the draughtsman is probably correct.

1l-s. Studies for Western Porch and Turrets

1l. Pencil on tracing paper; 6⅜ x 5⅞ in. Draughtsman. Unpublished. (TC-D128)

1m. Pencil on tracing paper; 6 x 6¾ in. Draughtsman. Unpublished. (TC-D133)

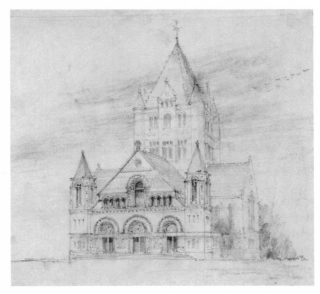

1j. Trinity Church. Study for Western Front

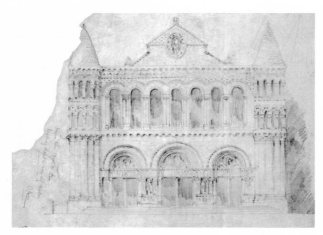

1k. Trinity Church. Study for Western Front

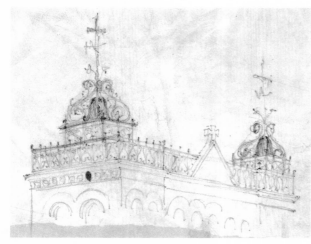

1t. Trinity Church. Study for Western Turrets

1n. Pencil on tracing paper; 8¾ x 5⅞ in. Draughtsman. Unpublished. (TC-D131)

1o. Pencil on tracing paper; 5⅞ x 3½ in. Draughtsman. Unpublished. (TC-D134)

1p. Pencil on tracing paper; 6¼ x 5⅝ in. Draughtsman. Unpublished. (TC-D127)

1q. Pencil on tracing paper; 6½ x 5 in. Draughtsman. Unpublished. (TC-D129)
Written in pencil at bottom: *Latin*

1r. Pencil on tracing paper; 7¼ x 5¾ in. Draughtsman. Unpublished. (TC-D130)

1s. Pencil on tracing paper; 6 x 3½ in. Draughtsman. Unpublished. (TC-D135)

Series of perspective studies for the western porch and turrets, all from the office of Shepley, Rutan and Coolidge.

1t-u. Studies for Western Turrets

1t. Pencil on tracing paper; 10½ x 18 in. Charles A. Coolidge? C. Price, "Henry Hobson Richardson: Some Unpublished Drawings," *Perspecta* 9/10 (1965), fig. 7. (TC-D195)

1u. Pencil on tracing paper; 7¾ x 9⅝ in. Charles A. Coolidge? Unpublished. (TC-D193)

Posthumous perspective studies for the western turrets. Those in no. 1t are of ironwork.

1v. Parish House ("Chapel") Partial Plan

Ink and watercolor on linen; 13 x 19⅞ in. Draughtsman. Unpublished. (TCPH-A2)

Written in brown ink in plan: *The cloister foundation walls / (or covered passageway) joining / church and Sunday School, to / be built of old stone 2'-4' thick*
Notation in red ink at right: *Alterations in Walls for Foundation / of Chapel and Cloister, to comply / with the requirements of the Law / Dec. 12th 1873 /*

The alterations are only in the thick- / ness of the walls, the ashlar line of / walls above remaining unchanged
Signed in black ink: *Correct, / Gambrill & Richardson / by T. M. Clark*
Signed in black ink upper right: *Approved / C. H. Parker chairman / B Comm*
Initialed in brown ink: *H.H.R.*

Theodore Minot Clark was Richardson's superintendent at Trinity. This drawing represents one of the innumerable changes in the design of both church and "Chapel."

1w-x. Parish House ("Chapel") Plans

1w. Ink and watercolor on paper; 13 x 13¾ in. Draughtsman. Unpublished. (TCPH-A4)

Main floor as built.

1x. Ink and watercolor on paper; 13 x 18¼ in. Draughtsman. Unpublished. (TCPH-A6)

Alternate plan of main floor.

1y-z. Parish House ("Chapel") Elevations

1y. Ink and watercolor on linen; 14 x 14¼ in. Draughtsman. Unpublished. (TCPH-B7)
Lettered in ink below: TRINITY CHAPEL. NORTH ELEVATION / SCALE ⅛" APR. 16, 1874, and written twice across windows: *Wooden Sash and Frames*

1z. Ink and watercolor on linen: 14½ x 15¼ in. Draughtsman. Unpublished. (TCPH-B6)
Lettered in ink below: TRINITY CHAPEL. WEST ELEVATION / SCALE ⅛ IN. APR. 16, 1874
Notations in ink on drawing: *Chimney to project 4 inches / This part to be according to / the detail Drawing, / which is different / from this*

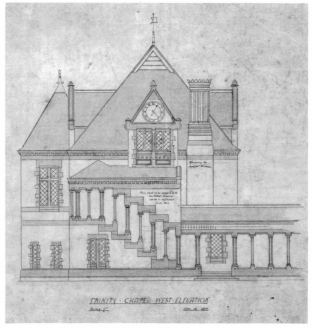

1z. *Trinity Parish House ("Chapel"). Elevation*

2. All Saints Episcopal Cathedral, Albany (project), 1882-1883

On July 10, 1882, Richardson wrote from London to his wife that he had received "a letter from Bishop Doane about his new Cathedral in Albany — offering me $1000 to complete my drawings to be ready about the 15th of January — next — . . . I am a little annoyed . . . as I can't help thinking about it but I won't let it worry me." Richardson was not supposed to be thinking about business; he was on a trip abroad to confer with Sir William Gull of Guy's Hospital about his chronic case of Bright's Disease, and to see the Romanesque architecture of France, Italy and Spain. Nonetheless, on August 27 he wrote again from Zaragoza, saying he had "answered a note from Bishop Doane . . . accepting the terms of competition he enclosed to me in London but I wish the matter kept quiet until my return. The program is a superb one & the drawings are to be ready by November. Dont you tell anyone about it — There is only one competitor besides myself."

William Croswell Doane (1832-1913) was born in Boston where his father was rector of old Trinity. Appointed first Bishop of Albany late in 1868, he was able, after considerable delay, to begin his cathedral when ground on Elk Street was given to the diocese in the summer of 1882 (the purchase date was June 30; the Bishop wrote immediately to HHR). Richardson's competitor was the English-born Albany architect Robert W. Gibson (1854-1927). Doane's adviser on architectural matters was Charles Babcock (1829-1913), professor of architecture at Cornell, trained by Richard Upjohn, and since the late 1870's an Episcopal minister.

The terms of the competition apparently called for the provision of a temporary structure to be erected for use of the congregation while funds were collected to finish the building. Richardson submitted drawings for both temporary and final church, together with estimates prepared by Norcross, sometime in March 1883. He also sent a memorandum to explain his design. This is now lost but known in part from extracts published by Van Rensselaer. Doane apparently found this insufficient, for on April 12, 1883, Richardson wrote again to explain his project. Van Rensselaer published parts of this letter too, but misdated it March 30. The fire-scorched original, now among the R.W. Gilder papers, bears the later date. Van Rensselaer deleted the opening paragraphs in which Richardson stresses the perspective effects of his design, which he says are not apparent in the drawings. He wrote, for example, that "in imagination the grandeur of the great arches diminishing in perspective as they recede, and the effect of arches seen through arches, may . . . be seen."

Neither drawings nor letters swayed the Bishop. The next month, on May 6, Doane wrote the architect to explain why his project had been rejected. One reason is familiar: "Apart from other considerations, the great expense of the completed building and the unsatisfactoriness of the temporary structure made

the acceptance of the plans impossible." But there were other factors in the decision to award Gibson the commission.

In the spring of 1884 Richardson sent his unsuccessful drawings to Richard Watson Gilder (1844-1909), editor of *The Century Magazine*, and a brief correspondence resulted. On April 7, 1884, Richardson wrote that he would be "very glad to send the original drawings for my design of the Albany Cathedral." He enclosed "Babcocks letter to Osgood & Co. . . . Babcock was the man agreed upon by us all as the impartial professional advisor of the Chapter. In the conditions there was no limit as to money — they only called for a first class Cathedral & nothing was said about English Gothic forms. I also send you a [s]et of the reproduction of my competition drawings which as I only had 3 months to prepare them in must be considered as mere sketches — without study — particularly the principal front."

On April 23 in answer to Gilder's questions Richardson wrote that he had followed no style in his design "but tried to adapt structurally the principles of the best Romanesque work (suggested by the old apsidal churches in the Southern part of France Auvergne &c.) and used transitional forms for windows & other openings — as a Gothic building was called for by the terms of the competition. Had I built the Cathedral I would have flattened the arches still more or made simple round arches, a very favorite form with me." So Gothic, if not English Gothic, *was* a requirement of the program.

Babcock's letter to Osgood cannot now be found (in a letter of April 11, HHR asked for its return). It presumably explained his selection of Gibson's English Gothic over Richardson's slippery Romanesque-cum-Gothic. Richardson may have had a way with clients, but here as in the Hoyt Library competition (cat. no. 30) he seems to have misjudged his clients' advisers. An Upjohn-trained Episcopal minister might have been presumed to favor Gibson's Anglophile cathedral. Richardson was either naive or ill-informed to think Babcock "impartial."

In a later letter dated May 27, Richardson told Gilder to keep the drawings as long as he liked but stressed again "the importance of not making any *public* use of them. This is the more important as articles have appeared in some of the papers upholding my work as against Mr. Gibson's, and, as it were, hitting him over my shoulders. The competition . . . is over. . . . Especially should I be loth [?] to do anything . . . which might seem to be directed against Mr. Gibson." As so many of his contemporaries noted, Richardson did not long hold a grudge against any man.

Gibson's Gothic design was accepted on April 30, 1883, the cornerstone of his building laid on June 3 of the next year, and the unfinished church dedicated in 1888.

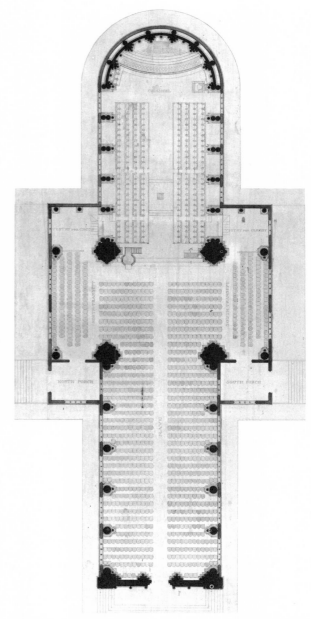

2p. Albany Cathedral Project. Plan of Intermediate Stage 53

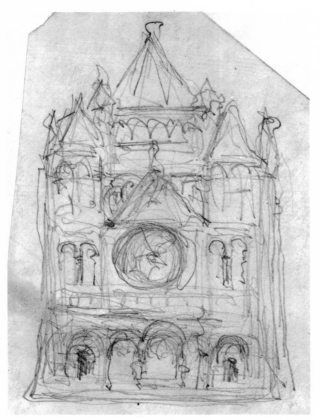

2e. Albany Cathedral Project. Study for Main Façade

2a. Albany Cathedral Project. Sketch Plan

Sources: Letters in possession of SBRA; Richard Watson Gilder Papers, Manuscript and Archives Division, The New York Public Library, Astor, Lenox and Tilden Foundations; Montgomery Schuyler, "An American Cathedral," in his *American Architecture and Other Writings*, W.H. Jordy and R. Coe, eds., Cambridge, Mass., 1961, I, pp. 229-245; *Harper's Weekly*, XXVII (April 26, 1884), 264, 266 (Gibson's design); George E. DeMille, *A History of the Diocese of Albany*, Philadelphia, 1946, pp. 91-103.

2h. Albany Cathedral Project. Study for Main Façade

2a-c. Sketch Plans

2a. Brown ink and pencil on buff paper; 8⅝ x 5½ in. Autograph. Unpublished. (ASA-A4)
Written in pencil in HHR's hand: *166060 / Did Charles* [Rutan?] *bring the distance from Elk & Lafayette / Did Mr* [F. E.?] *Alden go to Marion* (the Percy Browne House at Marion, Massachusetts, was then under construction).

2b. Brown ink and pencil on buff paper; 8½ x 5½ in. Autograph. Unpublished. (ASA-A1)
Figuring and notations in pencil: *Elk Street / To Lafayette / Lafayette*

2c. Pencil and brown ink on engraved blue gray stationery (faded); 8⅛ x 9¾ in. Autograph. Van Rensselaer, p. 123
Written in brown ink in HHR's hand: *out,* and in pencil above: *no. 59 GFS* [George F. Shepley]; plus other notations
Lent by Shepley, Bulfinch, Richardson and Abbott

Thumbnail sketch plans, the first two with cloister to right. The final drawings eliminate the cloister. Since HHR did not return to Brookline until October, these must be dated fall 1882.

2d-i. Studies for Main Facade

2d. Pencil on tracing paper; 7⅞ x 6½ in. Autograph. Unpublished. (ASA-B14)

2e. Pencil on white paper; 5½ x 3¾ in. Autograph. Unpublished. (ASA-B15)

2f. Pencil on tracing paper; 6⅝ x 4¼ in. Autograph. Unpublished. (ASA-D2)

2g. Pencil on tracing paper; 3⅛ x 2½ in. Autograph. Unpublished. (ASA-D35)

2h. Pencil on tracing paper; 3⅝ x 4¾ in. Autograph. Unpublished. (ASA-F3)

2i. Pencil on tracing paper; 3½ x 3⅞ in. Autograph. Van Rensselaer, p. 87. (ASA-B6). Written in pencil in HHR's hand: *Too Much*

These six doodles, the last well known and much used in discussions of Richardson's style, show the architect working from silhouette to façade articulation in the most general terms.

2j-l. Tower

2j. Pencil on white paper; 8⅜ x 5⅜ in. Draughtsman? Dated in pencil *Jan 12ᵗʰ*. Unpublished. (ASA-D28)

2k. Pencil on white paper; 9⅝ x 5 in. Draughtsman? Unpublished. (ASA-D29)

2l. Pencil on tracing paper; 6 x 6 in. (irregular). Draughtsman? Unpublished. (ASA-D31)

By early 1883 the office had turned its attention to the problem of the main tower.

2m. Tower Elevation

Pencil on tracing paper; 14 x 7⅞ in. Draughtsman. Unpublished. (ASA-D33)

This partial elevation of the tower shows the office beginning to study the problem in tracings at accurate scale. This is close to, but not identical with, the final design.

2n. Study for West Elevation

Pencil on tracing paper; 31½ x 19¾ in. Draughtsman, with additions by Richardson? Unpublished. (ASA-B16)

The slow process of accurate draughting gives way to the quicker sketch technique, roughing out aspects of the main façade not yet decided.

2o. Study for West Elevation

Pencil on watercolor paper; 16⅓ x 20⅛ in. Draughtsman. Unpublished. (ASA-B4)

A preliminary study at accurate scale, left unfinished.

2p-s. Presentation Drawings

2p. Plan
Pencil, ink and watercolor on heavy linen-mounted paper bordered with pasted gray mounting; 43⅞ x 26⅛ in. Draughtsman. Unpublished. (ASA-A3)

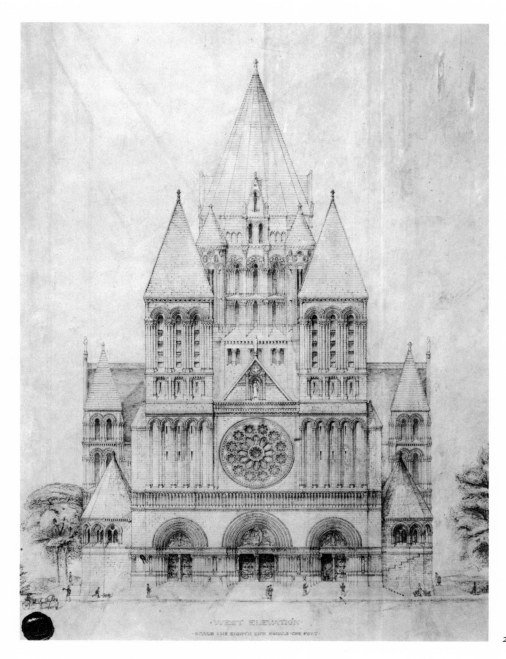

·WEST ELEVATION·

·SCALE ONE EIGHTH INCH EQUALS ONE FOOT·

2r. Albany Cathedral Project. Presentation West Elevation

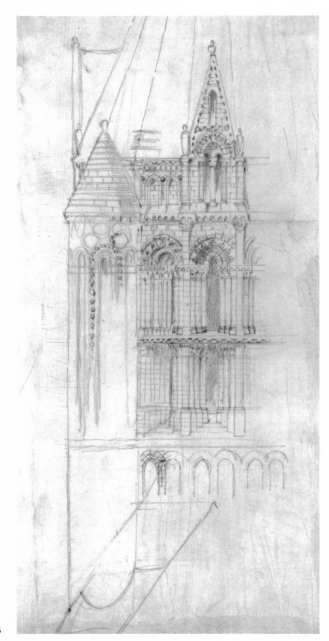

Lettered in red and black ink at top: CATHEDRAL OF ALL SAINTS ALBANY NY /
DESIGN FOR THAT PORTION OF THE STRUCTURE / WHICH IT IS PROPOSED TO BUILD
FOR TEMPORARY USE

THIS PLAN INCLUDES	AND BOTH TRANSEPTS
ALL THE NAVE, CROSSING	EXCEPT EXTREME
AND APSE (CHANCEL AND CHOIR)	NORTH AND SOUTH BAYS

Red wax seal lower left impressed with initials HHR

2q. South Elevation

Brown ink on heavy linen-mounted paper bordered with pasted gray
mounting; 28¾ x 39 in. Draughtsman. Unpublished. (ASA-B1)

Lettered on overlay in red and black ink at top: CATHEDRAL OF ALL SAINTS.
ALBANY. N.Y. / DESIGN FOR THAT PORTION OF THE STRUCTURE / WHICH IT IS
PROPOSED TO BUILD FOR TEMPORARY USE, and at bottom: SOUTH ELEVATION /
SCALE ONE EIGHTH EQUALS ONE FOOT

Red wax seal lower left impressed with initials HHR

Presentation drawings for the intermediate stage in which HHR proposed
to lay the foundations of the final church and provide temporary enclosure
above them.

This is the first appearance of HHR's wax seal, used on presentation draw-
ings. He had acquired the die on his summer trip. On July 11, 1882, he
wrote Julia from London that "I am going to have my monogram with a
serpent biting its own tail cut on the big seal," and again on August 27 from
Zaragoza: "I told you I was having my monogram cut on the big seal with
two strange beasts round the edge both biting at a piece of forbidden fruit.
Something like this

if it is well done it will be very good. I call it forbidden — it may not be." The
second version prevailed.

2m. Albany Cathedral Project. Tower Elevation

2r. West Elevation

Brown ink on heavy paper (formerly mounted on stretcher); 41½ x 29¼ in. Draughtsman. Van Rensselaer, between pp. 88-89. (ASA-B2)
Lettered in black ink at bottom: WEST ELEVATION / SCALE ONE EIGHTH INCH EQUALS ONE FOOT
Red wax seal lower left impressed with initials HHR

2s. Perspective

Brown ink on joined heavy paper (formerly on stretcher; edges frayed); 36 x 48¾ in. Draughtsman. Van Rensselaer, between pp. 88-89. (ASA-F4)
Red wax seal upper left impressed with initials HHR

Nos. 22r and 22s are two of the set of much-reproduced presentation drawings.

2s. Albany Cathedral Project. Presentation Perspective

3. Emmanuel Episcopal Church, Allegheny City (Pittsburgh), 1883-1886

Photograph ca. 1963 (Jean Baer O'Gorman)

The lot on the corner of Allegheny and North Avenues in what is now Pittsburgh's North Side was purchased in 1882; the commission entered the office in August 1883, according to Van Rensselaer. Plans were sent to Pittsburgh early in 1884. In July the vestry directed the Building Committee "to communicate with Mr. Richardson and inform him that the means obtainable were inadequate to build after his plans and ask him if he desired to furnish other plans for a much plainer church building to cost say $12,000 or $15,000 complete and ready for use, but so constructed as to permit an enlargement." Drawings for the new project were exhibited to the vestry in February 1885; in April a bid for $12,300 from Henry Shenk was accepted and the foundation begun. The church was dedicated on March 7, 1886 (the final cost, furnished, was close to $25,000).

Van Trump has suggested that the early design was not entirely discarded. He sees the Newton, Massachusetts, Baptist Church, commissioned in October 1884, as a reworked version of the rejected Emmanuel project. Hitchcock, according to Van Trump, sees parallels between the second design and certain churches projected by the English architect William Burges.

Source: James D. Van Trump, "The Church Beyond Fashion," *Charette*, XXXVIII (April 1958), 26-29.

3a-b. Elevations (see color plate)

3a. Pencil and watercolor on tracing paper; 12½ x 12 in. (irregular). Draughtsman. Unpublished. (ECA-B4)

3b. Pencil and watercolor on tracing paper; 11¾ x 13½ in. Draughtsman. Unpublished. (ECA-B11)
Note in pencil upper right: *Roof to be larger so / as to counteract the / Perspective —*

Scale studies of front and side elevations of the first scheme. Cruciform with stubby central tower.

3c. Perspective

Brown ink on tracing paper; 10¾ x 14½ in. Draughtsman. Unpublished. (ECA-F2)

Perspective study of the second project, second half of 1884. The side windows carry through into dormers. The foreground figures are woefully out of scale.

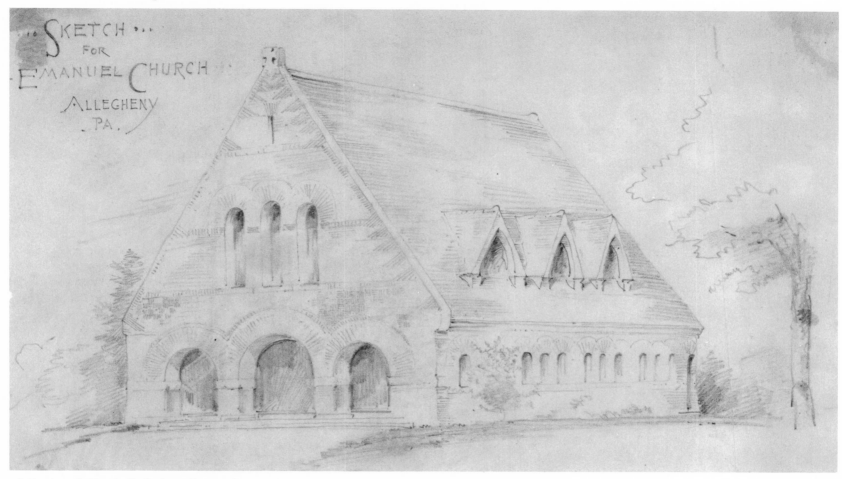

3d. Emmanuel Church. Preliminary Perspective

3d. Perspective

Pencil on tracing paper; 9 x 13¼ in. Draughtsman. Unpublished (cf. Van Rensselaer, p. 85). (ECA-F1)

Lettered in pencil top left: SKETCH / FOR / EMANUEL [*sic*] CHURCH / ALLEGHENY / PA.

Preliminary perspective, close to what was built.

4. Church, Crystal City, Missouri (project), 1885-1886

Crystal City is near the Mississippi River in Jefferson County, some thirty miles south of St. Louis. Local sand deposits account for the glass-making industry which gives the town its name. The area began to flourish in the mid-1870's under the ownership of the Crystal Plate Glass Company; the Pittsburgh Plate Glass Company, which took over the earlier firm in 1895, continues in the same location. The Crystal Company built the town, its houses, schools, library, store and its only church. The president of the St. Louis-owned company, Ethan Allen Hitchcock (1835-1909), was later Secretary of the Interior (1898-1907).

Grace Presbyterian Church in Crystal City stands in a landscaped park across from the entrance to the glass manufacturing plant. Erected by the Company in 1891 (datestone on the east end) as an Episcopal church, it was given to the Presbyterians in 1926. It is a long, low, gable-roofed, gray slate and limestone ashlar building with anchoring tower located amidships. Since its history is not well understood, the following must suffice as an interim report until a local historian can unravel the conflicting published testimony and answer outstanding questions.

Although erected in 1891 the church (excluding the 1960 eastward extension of the nave; the orientation of the church is not traditional) follows somewhat the design shown on a set of ink and watercolor drawings owned by the congregation. These are signed and dated *G. F.* [or *G. H.*] *Eliot . . . May 1886.* The lines of the building correspond to the drawings, but the projected brick and half-timber walls on a stone water table were changed to monochromatic stonework in execution five years later. Yet Eliot's church was begun. Goodspeed's history of 1888 says that "a foundation is laid for a brick and stone edifice large enough to seat 300 persons, and the building will soon be completed. It will be free for all Christian denominations."

The nondenominational chapel became an Episcopal church with the influx in the late 1880's of skilled English glass workers. What interrupted construction for five years, and why the rich brick and half-timber exterior became a dull stone one, are questions that cannot now be answered. Our interest, however, is in the history of the project prior to Eliot's drawings.

The cluster of transverse gable, tower, corner turret and shed porch, which forms the focus of the composition in the drawings and the existing church, was not Eliot's invention. It stems from the series of sketches preserved among the Richardson drawings and identified as for a church or chapel in Crystal City, Missouri. No other document I have seen connects the building to Richardson. That these sketches originated before his death would seem to be suggested by the appearance of one of them (now lost) as an unidentified

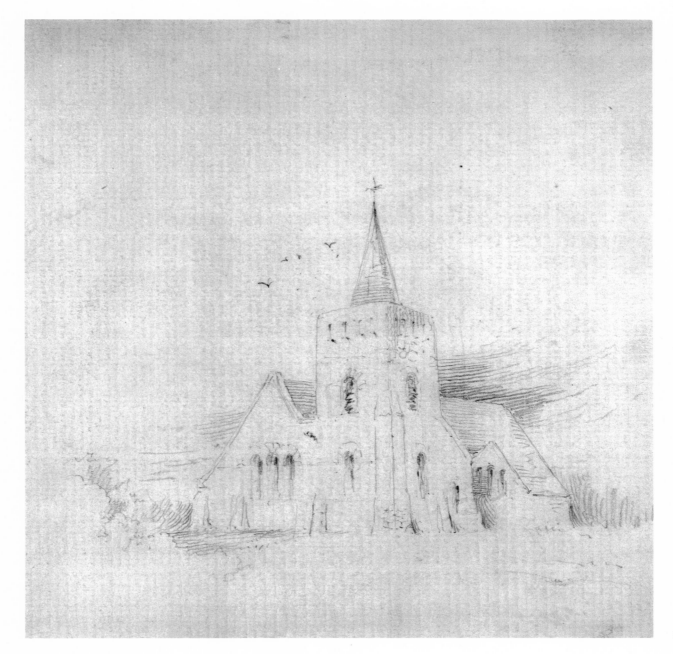

63

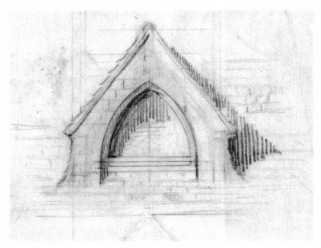

4c (detail). Crystal City Church Project.
Study for Dormer

vignette in Van Rensselaer, p. 86, although she does not include the building in her "List of Works." It would seem that Eliot knew a sketch like those preserved in the Harvard College Library. He changed Richardson's short round-apsed nave to a longer, square-ended one, reversed the orientation, pointed the openings, and introduced a mixture of materials, perhaps in the hope of producing a more English-looking design.

The church as it now stands is, then, based upon Eliot's design of 1886, which took its silhouette and massing from Richardson's earlier sketches. Why Richardson's sketches were altered after his death we do not know. How Richardson became involved in a project this remote can only be a matter of conjecture. There are several possibilities. The local superintendent of the Glass Company, George F. Neale, was a Bostonian who frequently visited the East in the mid-1880's. The Crystal Plate Glass Company provided glass for the New York State Capitol (cat. no. 20). But the most likely connection was the company president. E.A. Hitchcock also had Eastern ties, but, more importantly, he was the father-in-law of John Foster Shepley, the brother of Richardson's heir.

Sources: Jefferson Democrat (Hillsboro, Mo.), 1885-1891; *History of Franklin, Jefferson . . . Counties, Missouri,* Chicago: Goodspeed; 1888, pp. 436 ff.; R.S. Douglass, *History of Southeast Missouri,* New York and Chicago, 1912 (reprinted 1961), pp. 274 ff.; W.L. Eschbach and M.C. Drummond, *Historic Sites of Jefferson County, Missouri,* Hillsboro, Mo., 1968, p. 51.

4a. Perspective

Pencil on paper; 6¾ x 7 in. Draughtsman? Unpublished (cf. Van Rensselaer, p. 86). (CRY-F7)

One of a number of perspective studies preserved. The slender spire in this sketch is unlike the squat broach that appears on most drawings.

4b. Transverse Section

Pencil and watercolor on white tracing paper; 12¼ x 14⅛ in. Draughtsman. Unpublished. (CRY-C1)
Written in pencil upper left: *Chapel / Crystal City Mo / scale ¼″ = 1 Ft,* and lettered in pencil below: TRANSVERSE SECTION

The high gable roof supported by wooden trusses springs from low stone walls; dormers admit light overhead. Eliot's interior did not follow Richardson's lead. This section grows out of the executed design for Emmanuel Church, Pittsburgh (cat. no. 3).

4c. Studies for Dormer

Pencil on white tracing paper; 7 x 9 in. Draughtsman. Unpublished. (CRY-D1)
Titled in pencil: *Dormer / Crystal City Church*, and written on section: *Pivot or Hinge*

Elevation and section of gabled, pointed-arch dormer; this appears as a round-headed opening in some perspectives.

RESIDENTIAL BUILDINGS

Just as churches do not spring to mind at the mention of Richardson's name, so we do not associate him primarily with domestic design. Here he is said to have left much to his assistants. In fact, no matter what the building type, Richardson left the detailing to others. In the 1880's the firm averaged over three executed houses per year, and there are residences among Richardson's most characteristic and powerful works. Of those designed after 1880, we accept the Bryant House in Cohasset, the Stoughton House in Cambridge, the Glessner House in Chicago and the Potter House in St. Louis as outstanding examples of stone or shingle building. Despite the neglect or even bad press suffered by the Paine House in Waltham, the Gurney House in Prides Crossing, the Hay-Adams Houses in Washington, the Gratwick House in Buffalo and the Bigelow House in Newton Centre, Massachusetts, these too add significantly to the architect's dominant position in post-Civil War American architecture. Frank Lloyd Wright began his career of predominance in domestic design in the Shingle Style to which Richardson's example gave such currency in the 1880's.

5. Rectory for Trinity Church, Boston, 1879-1880

Photograph before 1893 (HCL)

Commissioned in April 1879, according to Van Rensselaer, the house was finished by 1880. Phillips Brooks (1835-1893; Harvard '55) was its first occupant. The existing third story was added under the direction of Shepley, Rutan and Coolidge by Norcross Brothers in 1893; the interior remodeled 1974 by SBRA.

Source: Bainbridge Bunting, *The Houses of Boston's Back Bay*, Cambridge, Mass., 1967, pp. 214 ff.

5a. Elevation of Clarendon Street Front

Pencil on buff paper; 7⅝ x 11½ in. Autograph? Hitchcock 1936, fig. 68. (TCR-B5)

Preliminary study for Clarendon Street front showing segmental entrance arch with alternating voussoirs, asymmetrical saddle-back gables and projecting eaves. Hitchcock names Richardson as the draughtsman.

5b-c. Elevations of Clarendon Street Front

5b. Pencil on tracing paper; 13¾ x 21 in. Langford Warren? Unpublished. (TCR-B4)

5c. Pencil on tracing paper; 13¾ x 21 in. Langford Warren? Unpublished. (TCR-B6)

Draughted preliminary Clarendon Street elevations with freehand changes on no. 5b, which is the earlier of the two. The round-arched entry is here, and the window arrangement of the first two stories is established, but the windows in the gables, dormers, Newbury Street elevation and roof line are still under study. Hitchcock suggests Warren as the draughtsman.

5d-f. Elevation and Perspectives of Newbury Street Front: Exterior Details

5d. Pencil on tracing paper; 4¾ x 3⅞ in. Draughtsman? Unpublished. (TCR-D10)

5e. Brown ink on tracing paper; 7 x 6¾ in. Draughtsman? Van Rensselaer, p. 103 (tondo). (TCR-D15)

5f. Brown ink on tracing paper; 7⅝ x 9½ in. Dated *1880* in plaque on chimney. Draughtsman? Unpublished. (TCR-D5)

Alternative studies for the upper part of the chimney and elevation facing Newbury Street. Loggias, fluted chimney and balcony are all tried out and discarded.

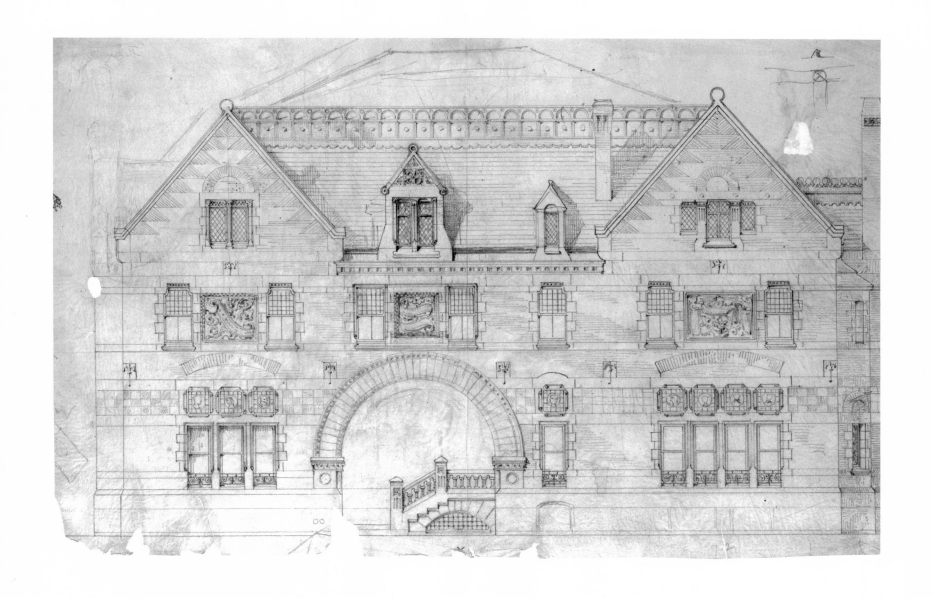

5b. *Trinity Church Rectory. Preliminary Clarendon Street Elevation*

5e. Trinity Church Rectory.
Preliminary Studies, Newbury Street Elevation

5g. Perspective of Newbury Street Front

Pencil on buff paper; 11⅛ x 12½ in. Draughtsman? *Back Bay Boston; The City as a Work of Art*, Boston, Museum of Fine Arts, 1969 (exh. cat.), p. 115. (TCR-D19)
On verso: partial pencil perspective for alternative design with loggias.

Perspective of the Newbury Street end of the house (plus to right, a small sketch of a roof for a different building). Fluted chimney, sun dial and squared attic level are not found on the completed structure.

5h-i. Fireplace Studies

5h. Brown ink with freehand double border on tracing paper; 3⅞ x 5⅞ in. Draughtsman? Unpublished. (TCR-E13)
Written in brown ink at bottom: *Fireplace in Chamber over Study — Parsonage*

5i. Light brown ink and pencil with pencil sketch of scale figure on tracing paper; 11⁹⁄₁₆ x 8⁷⁄₁₆ in. Draughtsman? Unpublished. (TCR-E11)
Written in brown ink at bottom: *Study for Fireplace in Dining Room / at the Parsonage*

5h. Trinity Church Rectory. Fireplace Study

5f. *Trinity Church Rectory. Chimney Study*

Study · for · Fireplace · in · Dining · Room · ·
· at · the · Parsonage ·

5i. *Trinity Church Rectory. Fireplace Study*

6. Oliver Ames House, Boston (project), 1880

Oliver Ames (1831-1895), of the North Easton manufacturing family, became a Massachusetts State Senator in 1880, Lieutenant Governor in 1882 and Governor in 1886, serving three consecutive one-year terms as the state's highest officer. He needed a Boston house from the beginning of his political career.

Hitchcock puts this Back Bay project in the period 1879-1880. Elevation studies in the Harvard College Library (OA-F3 and F4; not in exhibition) bear the initials *H.W.* (Herbert Langford Warren) and the date *March / 80*. Bunting gives 1882 as the date Carl Fehmer replaced Richardson as architect of the house for reasons unrecorded. Fehmer's building still stands at 355 Commonwealth Avenue.

Source: Bainbridge Bunting, *The Houses of Boston's Back Bay*, Cambridge, Mass., 1967, p. 212.

6a. Sketch Plan

Pencil on engraved blue stationery; 7⅝ x 4⅞ in. Autograph. Unpublished. (OA-A4)

Sketch plan with dimensions and notes on room use. Central cruciform space with corners filled out to a rectangle. Probably the first study.

6b. Sketch Plan

Brown ink over pencil on engraved blue stationery; 9¾ x 7¾ in. Autograph. Hitchcock 1936, fig. 81; 1961, fig. 70. (AO-A2)
Written in brown ink below: *Westchester Par¢k* [*sic*], and to right: *Com:wealth Ave.*
On verso: light pencil sketches and later notes.

Sketch plan with dimensions and notes on room use, roughed out in pencil and firmed up in ink. The cruciform central space flows out through broad openings to the perimeter of the plan. Developed from preliminary plan no. 6a.

6c. Presentation Plans

Pencil, ink and watercolor on heavy white paper; 26½ x 24 in. Draughtsman. Unpublished. (AO-A1)
Lettered in brown ink at right: STUDY / FOR / A CITY RESIDENCE / SCALE ⅛ⁱⁿ· = 1 FOOT, and below plans: SECOND STORY PLAN / FIRST STORY PLAN. Additional light pencil notations. On verso: *Hon^bl Oliver Ames / I will see you Monday / & would like to come out to N Easton* [] *you call*

Presentation plans of the first and second floors with penciled notes and changes. The first floor plan closely follows the study in no. 6b, although the

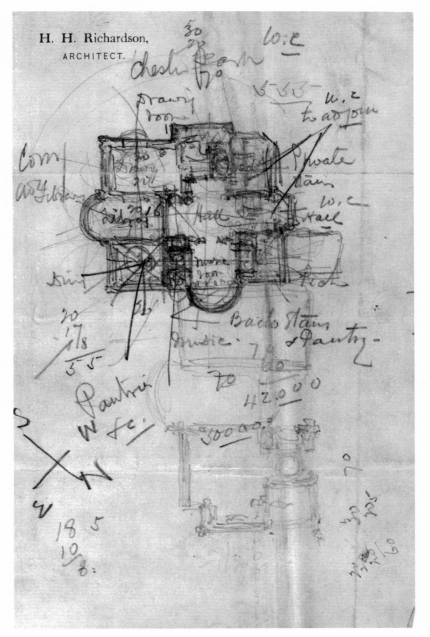

scaled drawing results in a more oblong perimeter than suggested in the sketch. The notes on the first floor plan refer to the interior color scheme: oak walls and ceiling with red hangings in the hall; mahogany stair; old gold predominant in the music room; mahogany and olive green in the dining room; low bookcases with walls above of blue green with jute hangings in the library; gold ceiling panels divided by white painted pine strips, pine woodwork painted ivory and pearly white, and walls of transparent ultramarine in the parlor; warm gray in the reception room.

6c. Ames House Project. Presentation First Story Plan

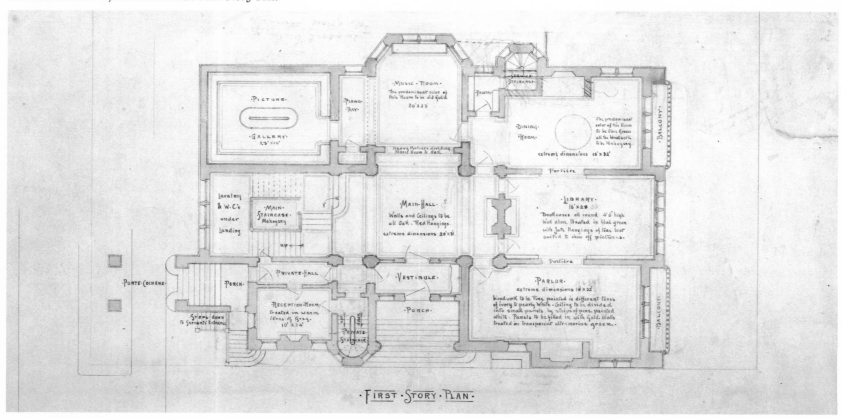

The house was erected for F.L. Higginson (1841-1925; Harvard '63), younger brother of the more colorful and better-known Henry and partner with him in the investment firm of Lee, Higginson & Co. from 1869 to 1885. A characteristically sarcastic portrait of the client is given by Mrs. Henry Adams in a letter dated April 22, 1883: "Such clients as F.L. Higginson and [N.L.] Anderson are not educated as to what is ultimate — don't know their own minds, though the proportions are not excessive in either case — and being highly irritable, they take out their temper in railing at H.H.R., who set many temptations before them, as it's his business to."

The Higginson house was commissioned in February 1881, according to Van Rensselaer. On March 9, Richardson wrote to Augustus Saint-Gaudens asking him "to make studies for the carving of a porch of an important city house," and added, "I've got a jolly porch for you." He wrote again on March 24: "Don't forget that you are engaged to work with me on the Higginson Home but at present I want nothing said about it." A week later, on March 30, Saint-Gaudens answered: "I am your man for the Higginses [sic]," but no actual carving seems to have resulted from this exchange of letters.

The house was coeval with its neighbor designed by McKim, Mead & White for another Lee, Higginson partner, Charles A. Whittier. The Whittier House was erected by Norcross Brothers, making it very likely that they built Higginson's as well. Finished in 1883, the Higginson House stood at 274 Beacon Street in the Back Bay until pulled down in 1929.

In June 1886, Shepley, Rutan and Coolidge sent Higginson a drawing for a sideboard.

Sources: AABN, XIV (November 24, 1883), photograph; Century Magazine, XXXI (November 1885-April 1886), 677 ff.; Boston Today, Boston, 1892, pp. 325-326; Bliss Perry, Life and Letters of Henry Lee Higginson, Boston, 1921; W. Thoron, ed., The Letters of Mrs. Henry Adams, Boston, 1936, p. 442; Bainbridge Bunting, The Houses of Boston's Back Bay, Cambridge, Mass., 1967, p. 221 (where the client is incorrectly identified as Henry Lee Higginson); Saint-Gaudens Papers, Baker Library, Dartmouth College, Box 16; "DWGS. LIST BOOK #5," p. 40 (SBRA).

7. Francis Lee Higginson House, Boston, 1881-1883

Higginson House at left. Photograph ca. 1890 (Walter C. Kidney, The Architecture of Choice, *New York, Braziller, 1974)*

7a. Presentation Plan

Pencil, black ink and watercolor with pencil corrections and notations on heavy white paper; 24½ x 17⅛ in. Draughtsman. Unpublished. (FLH-A11)
Lettered in black ink upper right: NºC, and at bottom: FIRST FLOOR PLAN / SCALE ⅛ IN. = 1 FOOT, and above plan: THE WHOLE REAR WALL IS TO BE HOLLOW / AIR SPACE TO HAVE HOT AIR PIPE BELOW AND / OUTLET ABOVE
Embossed stamp lower left: TO BE RETURNED / TO / H.H. RICHARDSON

Presentation plan with pencil alterations to dimensions and details.

7b. Presentation Plan

Pencil, black ink and watercolor with pencil changes and notations on heavy white paper; 24½ x 17⁹⁄₁₆ in. Draughtsman. Unpublished. (FLH-A12)
Lettered in black ink upper right: Nᵒᴅ, and at bottom: SECOND FLOOR PLAN / SCALE ⅛ IN. = 1 FOOT, and at right edge of plan: AREA TO HAVE GAS JETS TO LIGHT HALL AT NIGHT / AND TO CREATE A CONSTANT CIRCULATION OF AIR
Embossed stamp lower left: TO BE RETURNED / TO / H.H. RICHARDSON

Presentation plan of the second floor with changes in dimensions and details. Of particular interest are the "canopy" treatment of Mrs. Higginson's bedroom in the center of the front of the house, and the use of gas jets to assist air circulation. These jets were to be placed behind large windows in the main stair hall; perhaps HHR had in mind decorated glass by La Farge.

7c-d. Elevations

7c. Colored ink with pencil changes on linen; 26⅞ x 36⅛ in. Draughtsman. Dated on dormer: A.D. / MDCCCLXXXI. Unpublished. (FLH-B5)
Written in pencil: *Webster & Dixon / Not to be used / See These / Cast Iron*
Embossed stamp: TO BE RETURNED / TO / H.H. RICHARDSON

7d. Colored ink on linen; 27½ x 42½ in. Draughtsman. Dated on dormer: A.D. / MDCCCLXXXI. Unpublished. (FLH-B8)
Written in pencil: *rough for carving / see quoins to windows / as to light / 1 stone*
Embossed stamp: TO BE RETURNED / TO / H.H. RICHARDSON

Commonwealth Avenue elevations of HHR's Higginson House and McKim, Mead and White's Whittier House. Neither drawing is definitive.

7e. Interior Elevation of Stair Hall

Black ink with pencil notations on heavy white paper; 21 x 42⅜ in. Draughtsman. Unpublished. (FLH-E2a)
Lettered in ink upper right: F.L. HIGGINSON / BOSTON / NO. 81, and below: EAST SIDE OF HALL / SCALE ¾ = 1 FT
Scattered notes in pencil: *Trimmed Screen Work forming a Cove - Leave at Present - concealed Door - Tiled floor dished - quartered / white oak / for vestibule,* and in red ink: *Panelling lowered 9"*
Embossed stamp lower left: TO BE RETURNED / TO H.H. RICHARDSON

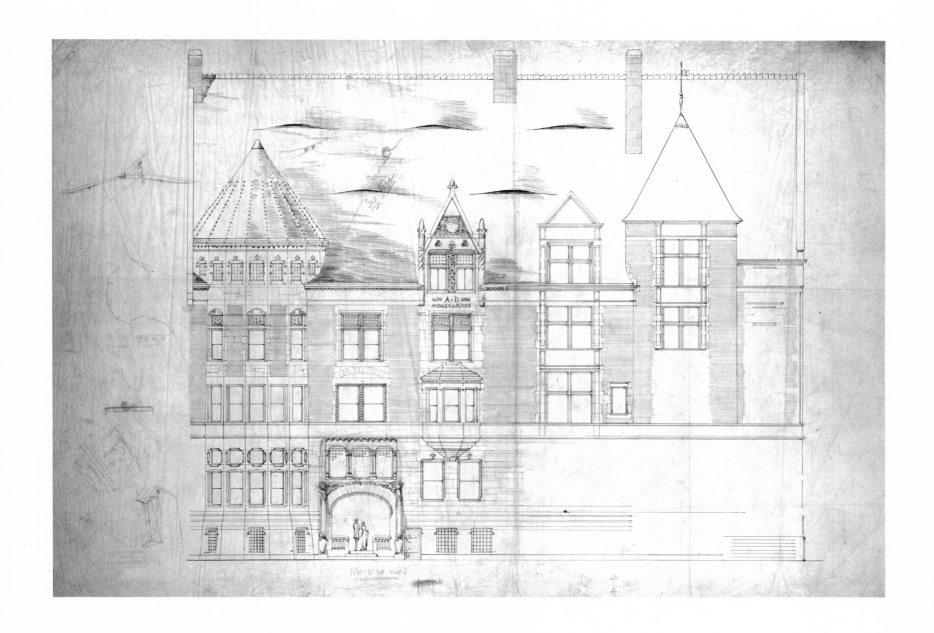

7c. Higginson House. Elevation

8. Hay-Adams Houses, Washington, D.C., 1884-1886

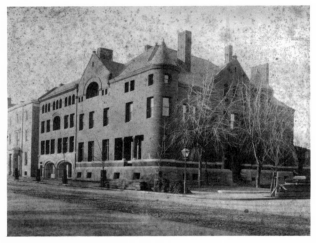

Photograph 1880's (Adams National Historic Site, Quincy)

Although separate townhouses for two prominent but very different clients, these commissions were studied as a pair in the office and have always been discussed as such. The existence of Friedlaender's definitive article makes the task here easier.

In December 1883, John Hay and Henry Adams bought adjacent lots on 16th Street at the intersection of H, on Lafayette Square opposite the White House, Hay taking the larger corner lot. On the 28th Richardson wrote Adams that "we can talk house" when the architect reached Washington from Pittsburgh. In mid-January 1884, both clients asked Richardson to prepare sketches based upon scale drawings each independently provided him. On February 9, Richardson wrote to Adams, who had supplied plans and an elevation, that he had "followed your instructions implicitly." And in a later letter, written on May 18 to C.M. Gaskell, Adams said that "we have arranged our plans; our architect has finished them." In fact, both Hay and Adams should be given partial credit for the design of their houses.

In the case of the Adams House especially (Hay was a more pliable client), an important problem arises. The early designs for the Adams façade show a marked dependence upon Viollet-le-Duc, in particular upon a figure in his *Entretiens sur l'architecture* (p. 58, lower left). Was the architect or the client responsible for this? The scale drawings given to Richardson by Adams cannot be found, so we must rely upon strong circumstantial evidence for our answer. Although there is no record that Adams owned Viollet's *Entretiens*, he did possess the *Dictionnaire raisonné*, which contains several plates in the same spirit. He also relied heavily upon Viollet during his years teaching medieval history at Harvard. On May 30, 1872, for example, he wrote to Gaskell: "I highly approve of Viollet le Duc, by the bye. . . ." Richardson, of course, owned both the *Entretiens* and the *Dictionnaire*, and we are told by Peter B. Wight in his *Inland Architect* obituary of the architect that he "was a studious reader of . . . Viollet. . . . And I think that this influence was patent in shaping his artistic career . . . [Richardson became] one of the most brilliant exponents of his teachings." But Wight exaggerated, and in any case was speaking of the early years. Richardson's later opinion of Viollet ("an archaeologist — a theorist — never an architect") as a source of inspiration is contained in a letter to Adams dated June 7, 1885: "The depths to which you must have fallen in quoting him as an authority on design is painful."

The conclusion is that Adams was not only Richardson's collaborator in the design of his own house, but with characteristic irony managed to get Richardson, against his better judgement, to go partners in a facade that originated in the Ducian camp.

After some give and take during February 1884, with the architect complaining of restrictions imposed by the client, Adams approved the sketches and hired Richardson as his architect in March. Hay followed the next month.

On April 7, Richardson wrote to Adams that he was "going to scale now where every inch counts." At this point the exterior material was intended to be "cream colored stone from Ohio," but a week later, on April 15, the architect requested Adams to send him samples of Washington brick. The final buildings were executed in this less costly material, although Richardson retained stone trim on the Hay House until December 1884, well after contracts had been signed. On December 3, he wrote Hay that he had "suppressed the light stone in the upper stories & hope this will meet with your approval — I think it is a great improvement & rejoice in the change — as I hope you will."

On May 12, 1884, Richardson had written to E.W. Hooper, Adams' brother-in-law and agent in financial matters (see Introduction), that the drawings would be "ready for Contract within a week." There was still some delay, however, for on July 24 bids were still awaited, and it was not until August 9 that Adams could write to Hay saying that "Richardson [is] now in Washington arranging the contracts with [Charles] Edmonston [the builder]."

Construction carried on through the next year, with the final touches applied early in 1886. The houses were pulled down in 1927 to make way for a hotel called, with an irony Adams would have relished, the Hay-Adams House.

Source: Marc Friedlaender, "Henry Hobson Richardson, Henry Adams, and John Hay," *JSAH,* XXIX (1970), 231 ff.

8a. Perspective of Hay House

Brown ink on yellow tracing paper; 9¾ x 17½ in. Draughtsman. Unpublished. Lent by the John Hay Library, Brown University (P01341)

Preliminary perspective of the Hay House. The drawing is inexplicably reversed, with 16th Street to the left. The stonework establishes a date before April 15, 1884. Richardson's letter to Adams of February 9 mentions Hay's porte-cochère on 16th Street, but also a principal entrance on Lafayette Square. The drawing must stem from the period between these dates. The corbeled corner turret appears on one other surviving drawing (AHW-B8; not in exhibition), a study for the H Street elevations of both houses, where, however, it is slightly different in detail.

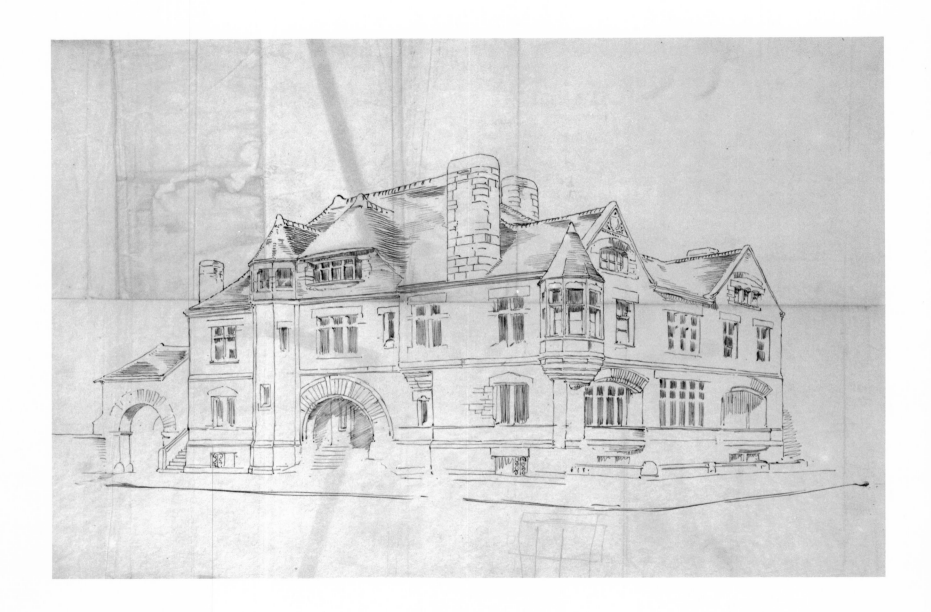

8a. Hay House. Preliminary Perspective

8b. Elevation of 16th Street Front, Hay House

Ink and watercolor on tracing paper; 18¾ x 23⅜ in. Draughtsman. Unpublished. (AHW-B13)

Preliminary study, brick with stone trim. The segmental arch at the entry is a form HHR often played with, but usually discarded in favor of the semicircle. The corner turret now rises from the sidewalk.

8c. Elevation of 16th Street Front, Hay House

Pencil and wash on tracing paper; 19¼ x 29¾ in. Draughtsman. Unpublished. (AHW-B14)
Written in pencil upper left: *Why not brick? R.*

Later study. Stone trim has been shown on the drawing, but the notes change it to brick. Gable, turrets, window arrangement and entrance arch have begun to assume definite form.

8d. Elevation of 16th Street Front, Hay House

Brown ink on heavy paper; 20 x 35¾ in. Draughtsman. Hitchcock 1936, fig. 122. (AHW-B16)
Lettered in brown ink at bottom: HOUSE / FOR / JOHN HAY, ESQ.
Written in pencil on base course to right: *Rock Face Granite*

Presentation drawing as built, all brick except for the base.

8e. Elevation of H Street Fronts (see color plate)

Pencil, ink and watercolor on tracing paper; 10½ x 14⅞ in. Draughtsman. Friedlaender, fig. 4; Hitchcock 1936, fig. 121. (AHW-B9)
Lettered in pencil upper left: HOUSES FOR HENRY ADAMS ESQ. AND / JOHN HAY ESQ. WASHINGTON / SCALE ⅛ IN. = 1 FOOT

Elevation of the houses prior to April 15, 1884, when the basic material changed from stone to brick. The massing in general and the arrangement of the foundation is established, but most details were to change with further study.

8f. Elevation of H Street Fronts

Brown ink on heavy paper with pencil notations; 23⅞ x 31½ in. Draughtsman. Friedlaender, fig. 5. (AHW-B2)
Lettered in brown ink at bottom left and right: HOUSE FOR / HENRY ADAMS ESQ. /

8f (detail). Hay-Adams Houses. Entrance to Adams House

OVERLEAF:
8b. Hay House. Elevation of 16th Street Front

81

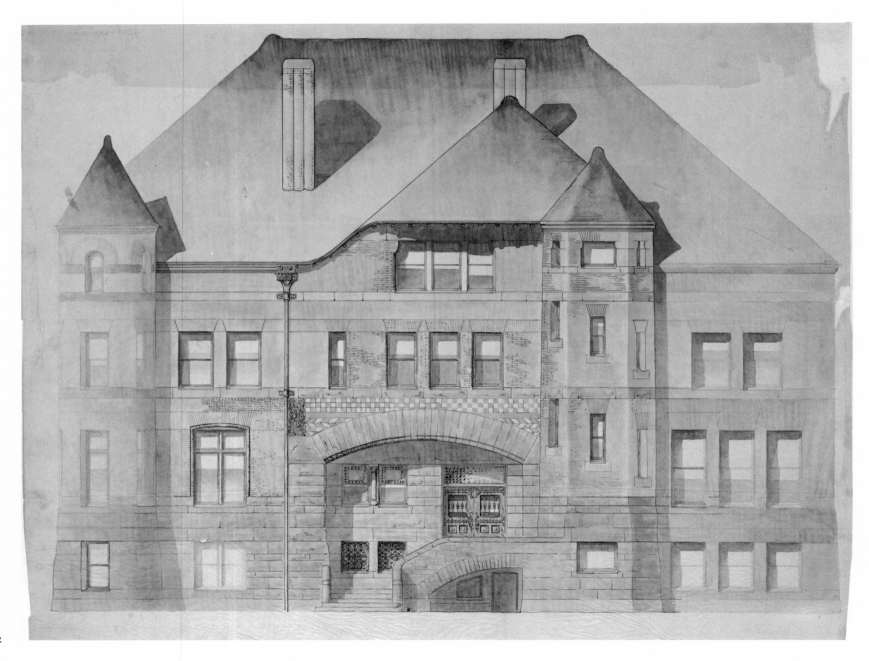

Written in black ink upper left: . . . *as to Roof's height* [signature illegible], and written in pencil below Adams entrance: *What stone for steps? / See me in the morning R.*

Presentation drawings of the final design. Friedlaender dates this late in 1884 or early in 1885. Corresponds to elevation no. 8d.

8g. Interior of Stair Hall, Hay House

Pencil and watercolor on buff paper; 10½ x 16⅛ in. Draughtsman. Unpublished. (AHW-E1t)
Written in ink upper left: *119.*
On verso: light sketch of a tower.

Study for the stair hall of the Hay House, much as built.

8h-j. Studies for interior details, Hay House

8h. Pencil on tracing paper; 5¾ x 9¾ in. Draughtsman. Unpublished. (AHW-E1n)

Studies for stair brackets.

8i. Brown ink on buff paper; 7 x 4¾ in. Draughtsman. Unpublished. (AHW-E1m)

Study for turned balusters.

8j. Brown ink on tracing paper; 7½ x 8¾ in. Draughtsman. Van Rensselaer, p. 106. (AHW-E1s)

Study for beam and bracket of stair hall ceiling. On each detail of the design is noted its price.

8k-p. Fireplace Studies, Hay House

8k. Pencil on tracing paper; 4¼ x 5 in. Draughtsman. Unpublished. (AHW-E6d)

8l. Pencil on tracing paper; 4¼ x 5 in. Draughtsman. Unpublished. (AHW-E6e)

8m. Pencil on tracing paper; 4¼ x 6⅝ in. Draughtsman. Unpublished. (AHW-E6f)

8n. Pencil on tracing paper; 5⅝ x 6½ in. Draughtsman. Unpublished. (AHW-E6g)

8i. Hay House. Study for Balusters, Stair Hall

8j. Hay House. Study for Beam and Bracket, Stair Hall 83

84 *8g. Hay House. Stair Hall*

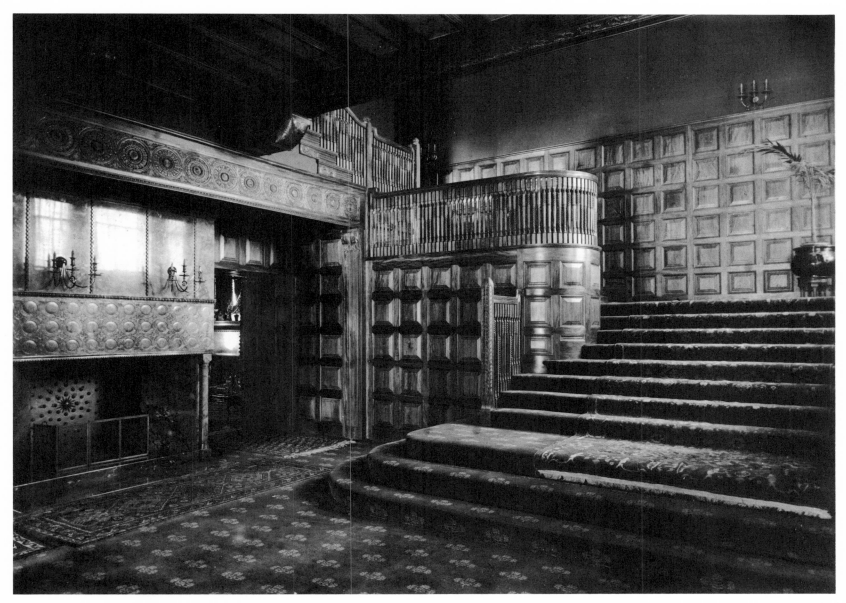

Hay House, Stair Hall. Photograph 1880's (Brown University, John Hay Library)

8o. Pencil on tracing paper; 4 x 6 in. Draughtsman. Unpublished. (AHW-E6h)

Studies for hall fireplace, Hay House.

8p. Pencil on tracing paper; 4 x 8½ in. Draughtsman. Unpublished. (AHW-E6i)

Study for fireplace wall in dining room, Hay House.

8o. Hay House. Study for Hall Fireplace

8p. Hay House. Study for Dining Room Fireplace

J.J. Glessner (1843-1936) was vice-president of Warder, Bushnell & Glessner, manufacturers of harvesting machinery (B.H. Warder commissioned a Washington house from Richardson in 1885). After 1900 he became a vice-president of International Harvester.

According to Glessner's own account, during dinner the day after inspecting the newly acquired lots at 18th Street and Prairie Avenue in the center of Chicago's original Gold Coast, "Richardson called for pencil and paper, saying: 'If you won't ask me how I get into it, I will draw the plan for your house.' First, making a few marks to get an idea of scale, he rapidly drew the first floor plan, almost exactly as it was finally decided on." That dinner took place on May 16, 1885, according to Sprague. As close as the sketch (cat. no. 9a) was to the final building, the design matured slowly over the next year. In late December 1885, Richardson wrote to his son Hayden, then a guest at the Prairie Avenue home of Marshall Field: "If you meet Mrs. Glessner be very polite to her — you know I am designing a house for her." The basic set of construction documents are listed under date of February 3, 1886 in the office ledger, although drawings were being prepared for details into 1887.

Contracts were let to Norcross on May 20, 1886; construction began on the first of June; and the Glessners moved into the house on December 1, 1887.

Sources: Letters in possession of SBRA; J.J. Glessner, "The Story of a House," 1923, unpublished (extensive excerpts in Percy Maxim Lee and John Glessner Lee, *Family Reunion*, Privately printed, 1971, pp. 319 ff.); David Van Zanten, "H.H. Richardson's Glessner House," *JSAH*, XXIII (May 1964), 106-111; Charles Price, "H.H. Richardson: Some Unpublished Drawings," *Perspecta* 9/10 (1965), 200-210; Paul Sprague, "Glessner House," *Outdoor Illinois*, May 1973, pp. 8-23; "H.H.R. DRAWING LISTS BOOK NO 2," pp. 12, 30-35 (SBRA).

9. John Jacob Glessner House, Chicago, 1885-1887

Photograph 1890's (J.G.M. Glessner)

9a. Sketch Plan

Pencil on white notebook paper; 7 x 5⅛ in. (irregular). Autograph. Sprague, p. 10.
Written in pencil in HHR's hand above: *Stalls &c &c*, and at right:
11 ft / 1st Story / 10 ft / 2 Story
Written in brown ink on verso: *Mr. Richardsons sketch*
Lent by the Chicago School of Architecture Foundation, Glessner House

Sprague identifies this as the drawing made on May 16, 1885. The basic arrangement of the living area of the first floor is set; the service area to the west was later significantly changed.

9a. Glessner House. Sketch Plan

ABOVE RIGHT:
9j. Glessner House. Elevation of Prairie Avenue Front

RIGHT:
*9k. Glessner House.
Perspective Study for Courtyard Elevation*

OPPOSITE PAGE:
9b. Glessner House. Presentation Plan

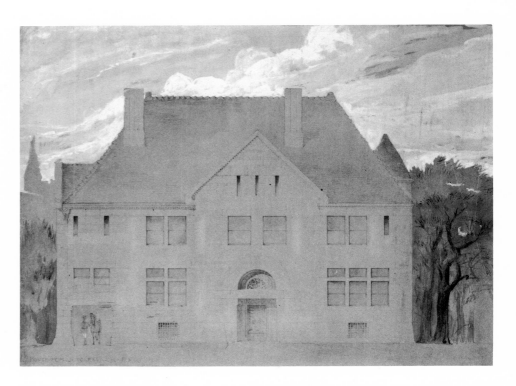

9b. Presentation Plan

Pencil and watercolor on tracing paper mounted on board; 11⅝ x 25⅞ in.
Dated May 1885. Herbert Jacques? Unpublished. (GLE-A3)
Lettered in pencil at bottom: SKETCH PLAN FOR FIRST FLOOR OF HOUSE FOR J.J.
GLESSNER. ESQ. CHICAGO. Nº1. / SCALE ⅛ INCH = 1 FOOT, and initialed lower left:
A.H.J.—5.85

Presentation plan including proposed landscaping of court, perhaps a companion to cat. no 9l. Produced within two weeks of no. 9a, this is perhaps one of the preliminary drawings Glessner says he approved, only to have HHR say, "That's for show. Now . . . we'll go to work on your real house."

The general arrangement is as built, but the hall does not yet have a fireplace and the stable plan has not been finally determined. Windows and fireplaces in the rooms overlooking Prairie Avenue were subsequently changed. Those shown here correspond to the elevation no. 9i.

9c. Elevation of Prairie Avenue Front

Pencil on tracing paper; 5 x 9⅜ in. Draughtsman. Unpublished. (GLE-B6)

Preliminary study. The elevated main floor made necessary a stair within the entry; HHR's desire to provide natural light from the east led to a series of studies for transoms above the main portal, here a loggetta. In the final design he pulled doorway and transom into one overarching form. The roof fluctuates between gable and hip. The footway shown in no. 9b is present here, but was subsequently eliminated. Main floor windows as in no. 9b and no. 9d.

9d. Perspective

Pencil with partial freehand border on tracing paper; 6¾ x 15⅛ in. Draughtsman. Unpublished. (GLE-F1)

Related to no. 9c, this shows a hip roof over the Prairie Avenue block. The transitional turret between outer elevations has not yet appeared. The stable and tradesmen's entrance are not final.

9e-f. Elevations of 18th Street Front

9e.　Pencil on tracing paper; 6 x 13 in. Draughtsman. Price, fig. 13 (GLE-B7)

9f.　Pencil on tracing paper; 4¾ x 12⅝ in. Draughtsman. Price, fig. 12.
　　(GLE-B8)

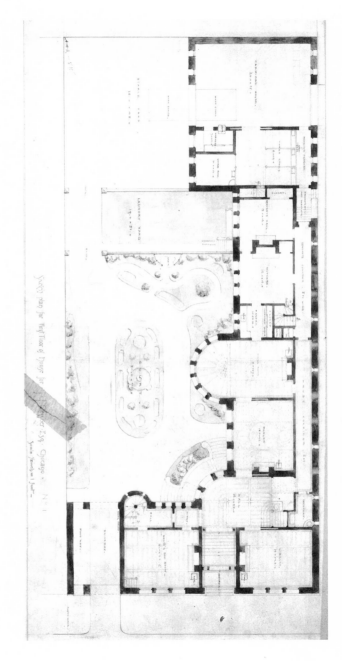

9h. Glessner House. Elevation Detail of 18th Street Front

Preliminary studies. The turret defining the main stair and forming the transition between outer façades holds the draughtsman's interest. The treatment of the stable gable and the opening above the tradesmen's entrance is still undecided.

9g. Elevation and Perspective

Pencil on tracing paper; 20½ x 17⅜ in. Draughtsman. Unpublished. (GLE-D2)

Study for the eastern half of the 18th Street elevation, with perspective study lower right of the Prairie Avenue front and eastern half of the 18th Street front. The elevation is a window and turret study. Floral glass patterns are suggested for the transom windows. The perspective shows a gable, later eliminated, above the round-arched entry.

9h. Elevation (detail) of 18th Street Front

Pencil on tracing paper; 9¼ x 10¼ in. Draughtsman. Unpublished. (GLE-D16)

Elevation of the tradesmen's entrance on 18th Street. The prominent imposts and ramping handrail disappear in the final design.

9i. Elevation of Prairie Avenue Front

Pencil, india ink and watercolor on buff paper; 23¼ x 27½ in. Draughtsman. Van Zanten, fig. 7. (GLE-B1)
Written in pencil upper left: *Letters*

Preliminary study. The outline is fixed, but all details here were eventually changed. The pattern of main floor windows here corresponds to the plan, no. 9b. HHR established his plan more easily than his draughtsmen achieved a satisfactory elevation. The roof, the chimneys and the arrangement (but not the details) of upper and basement windows reappear in the final design. The entrance shown here did not survive further study.

9j. Elevation of Prairie Avenue Front

Pencil and watercolor heightened with white on buff paper; 19¼ x 25¼ in. Draughtsman. Van Zanten, fig. 6. (GLE-B2)
Lettered in pencil lower left: HOUSE FOR J.J. GLESSNER ESQ.

Preliminary study. Here the main entry is close to final, but the design otherwise looks as if it were held over from the Hay House. The stair turret on 18th Street is the right shape but the wrong size. Nos. 9i and 9j were combined with some change of detail to produce the final Prairie Avenue front.

9k-l. Perspective Studies for Courtyard Elevations

9k. Pencil on buff stationery; 8 x 11 in. Draughtsman? Unpublished. (GLE-D15)

Written in pencil upper left: *Glessner*

Written twice (and crossed out) in brown ink on verso in HHR's hand: *H H Richardson,* and light pencil sketches, among which a squinch and section through floor of hollow tiles spanning between girders.

Preliminary study; all elements of the final design are present but details are not established.

9l. Brown ink and watercolor on watercolor paper; 10⅞ x 19 in. Draughtsman. *The Bulletin of the Victorian Society in America,* II, no. 2 (April 1974), 4.

Lent by the Chicago School of Architecture Foundation, Glessner House

Preliminary study, perhaps representing the same stage of the design as no. 9b. Although an advance over no. 9k, this drawing is not final either. At this stage the stonework of the exterior elevations was to carry into the courtyard; in fact, these walls were built of brick with stone trim. Details of the conservatory above the dining room bay and the roof line of the Prairie Avenue block to the right changed in execution. The fountain never appeared.

9d. Glessner House. Perspective

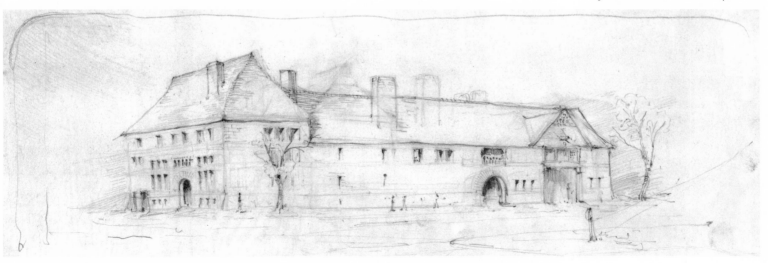

10. William Henry Gratwick House, Buffalo, 1886-1889

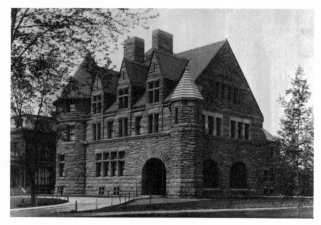

Photograph ca. 1890 (HCL)

W.H. Gratwick (1839-1899) was a partner in Gratwick, Smith & Fryer, one of the largest lumber companies in the country, and president of both the Cleveland and the Aetna Steamship companies.

This is the last commission listed by Van Rensselaer, who dates its entry into the office February 1886. On March 13, Richardson wrote to George F. Shepley that "Mr. Gratwick['s] plan . . . is settled, unless they pull it all to pieces in Buffalo, where I forwarded revised studies last night." Working drawings commenced in July, with a "corrected" set prepared in the fall. The detail drawings for fireplaces (not in exhibition) are stamped *Shepley, Rutan & Coolidge / Mar 4 1887 / Brookline . . . Mass.* The last drawings are dated 1888.

The house stood at 776 Delaware Avenue until pulled down in the late 1920's.

Sources: Letter in possession of SBRA; drawings WGG-E1 and E10 in HCL; "H.H.R. DRAWING LISTS BOOK NO 2," pp. 90-91, 104-107, 152-153 (SBRA).

10a.　Preliminary Plan

Ink over pencil on buff paper; 5¼ x 11 in. Autograph. Unpublished. (WGG-A1)
Written in brown ink upper left in HHR's hand: *Sk^{th} for / M^r Gratwich:* [sic]

Preliminary plan with room use and basic dimensions indicated. In general, although not in detail, this plan is much like the final building. Its L-shape is developed from the Glessner house.

10b.　Intermediate Plan

Pencil and watercolor on tracing paper; 16½ x 20½ in. Draughtsman. Unpublished. (WGG-A4)
Lettered in pencil upper left: HOUSE FOR W.H. GRATWICK ESQ. / BUFFALO, N.Y. / SCALE ⅛ INCH = 1 FOOT / FIRST FLOOR PLAN
Additional notations.

An intermediate plan, one of several in the Harvard College Library, developed from no. 10a, but not as finally built. Reflected ceiling patterns are shown.

10c.　Sketch for East Elevation

Pencil on tracing paper; 16¼ x 21 in. Charles A. Coolidge. Unpublished. (WGG-B6)
Written in pencil lower left in Charles A. Coolidge's hand: *Buffalo. 86 / CAC*

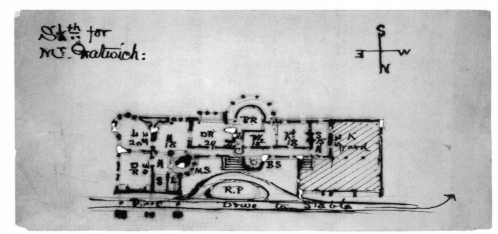

10a. Gratwick House. Preliminary Plan

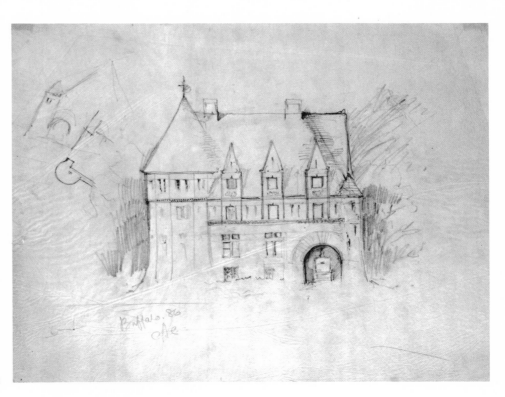

10c. Gratwick House. Sketch for East Elevation

10d. Gratwick House. Perspective from Southeast

10e. Gratwick House. Perspective from Northeast

Close to final design, although the drawing room windows have not yet taken the form as built. This drawing and no. 10a document individual contributions to this last work. HHR established the plan in general; CAC worked out the elevations. If this was drawn in Buffalo on the basis of revised plans sent from Brookline, it should be dated mid-March 1886.

10d. Perspective from Southeast

Pencil on white paper; 5⅜ x 8¼ in. Charles A. Coolidge? Unpublished. (WGG-F2)

10e. Perspective from Northeast

Pencil on white paper; 5⅜ x 8¼ in. Charles A. Coolidge? Unpublished. (WGG-F3)

10f. Roof Framing Plan and Truss Details

India ink, red ink and watercolor with pencil corrections on linen; 37½ x 56 in. Draughtsman. Unpublished. (WGG-A8)
Lettered in ink upper left: Wm H GRATWICK ESQ. / BUFFALO N.Y. / No 5ᵈ
Various instructions written in red and black inks.

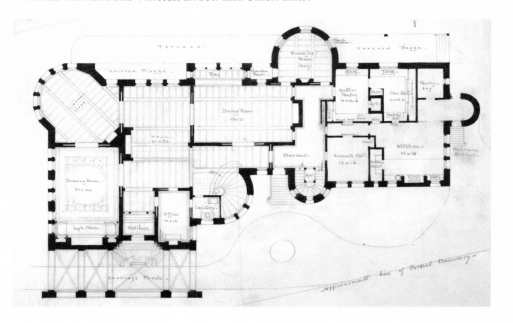

10b. Gratwick House. Intermediate Plan

W.W. Sherman (1842-1912) was educated as a physician, but long associated with the New York banking house of Duncan, Sherman & Co. A philanthropist and scholar, he was described by Maud Elliott as a "living encyclopaedia Newportiana." His first wife, whom he married in Newport in 1871, was the daughter of Governor George P. Wetmore. The Sherman House stands on land sold by Wetmore, whose palatial *Château-sur-Mer* still exists across Shepard Street.

Van Rensselaer gives September 1874 as the date of commission. Sketches and draught specifications for house and stable appear in the Sketchbook (ff. 31ᵛ-51ʳ, see Appendix). The house was decorated by Stanford White and John La Farge during the next decade, and later enlarged by Dudley Newton. Further additions and alterations were necessary during conversion to its present use as a retirement home.

Sources: Maud Howe Elliott, *This Was My Newport*, Cambridge, Mass., 1944, pp. 182-183; V.J. Scully, Jr., *The Shingle Style*, New Haven, 1955, pp. 15 ff.; P.L. Veeder II, "The Outbuildings and Grounds of Château-sur-Mer," *JSAH*, XXIX (December 1970), 307-317; A. Downing and V. Scully, *The Architectural Heritage of Newport, R.I.*, Cambridge, Mass., 1952, pp. 142-144.

11a. Interior of Dining Room

Pencil and ochre wash on watercolor paper; 6¾ x 8½ in. Stanford White? Unpublished. (WSH-E1)
Lettered in pencil at bottom within border: FIREPLACE IN DINING ROOM / FOR W. WATTS SHERMAN, ESQ.
On verso: partial plan of dining room in pencil.

One of several known studies that have been attributed to White. Only this one, apparently, survives in the original. It captures the spirit but not the scale of several interiors in Joseph Nash's *The Mansions of England in the Olden Time* (1839), the four volumes of which were in Richardson's library.

11. William Watts Sherman House, Newport, Rhode Island, 1874 et seq.

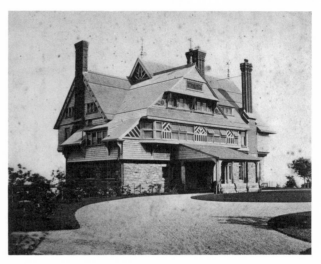

Photograph ca. 1880 (Boston Athenaeum)

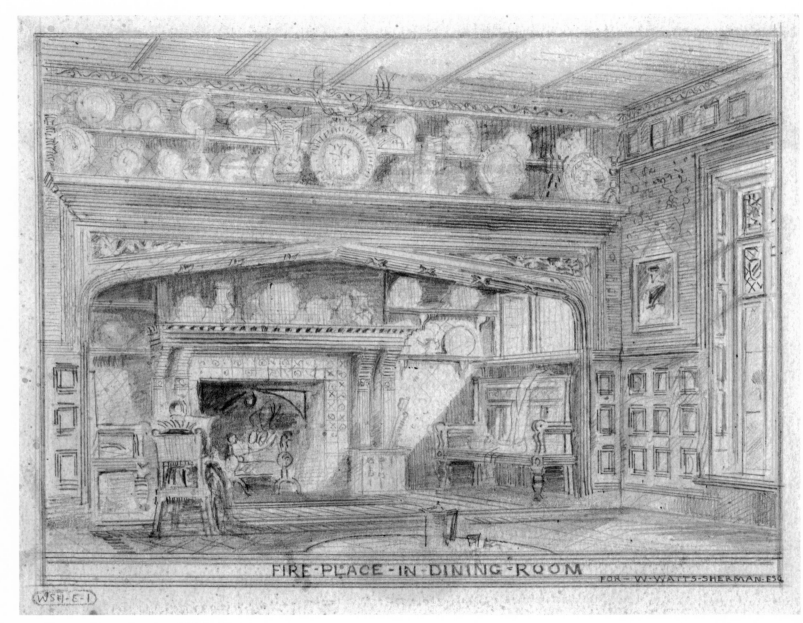

FIRE·PLACE·IN·DINING·ROOM

FOR·W·WATTS·SHERMAN·ESQ

WSH·E·1

96 *11a. Sherman House. Interior of Dining Room*

Dr. John Bryant, the eldest son of Dr. Henry Bryant, was a member of a prominent Cohasset family; his wife, Charlotte, was the daughter of Frederick Law Olmsted. Van Rensselaer gives September 1880 as the date of the commission. A plan in the Harvard College Library (BRY-A4; not in exhibition) is dated November 24, 1880. The house survives in altered condition at 150 Howard Gleason Road, Hominy Point. It is the property of Boston College and is now called Bellarmine House.

Source: Burtram J. Pratt, *A Narrative History of the Town of Cohasset*, Boston, 1956, II, pp. 74 ff.

12a. Preliminary Plan

Pencil on white laid paper; 5½ x 8¼ in. Autograph. Unpublished.
Lent by Shepley, Bulfinch, Richardson and Abbott

From the pencil designations of the rooms we learn that this house was designed for a *Dr. B* or a *Dr. B jr.* These initials plus the dogleg shape of the plan suggest the Bryant House. If this is the Bryant House, it is an early rejected scheme. The final plan bears little relationship to this room arrangement.

12b. Elevation

Pencil on board; 18⅝ x 35¾ in. Draughtsman. Hitchcock 1966, fig. 60. (BRY-B2)
Lettered in pencil at bottom: HOUSE FOR DR. JOHN BRYANT COHASSET MASS. / SOUTH EAST ELEVATION / SCALE ¼ IN. EQUALS 1 FOOT

A draughted elevation with freehand changes and small sketches of details. As built, in stone and shingle.

12. John Bryant House, Cohasset, Massachusetts, 1880-1881

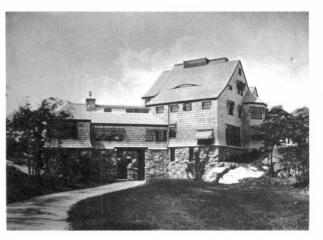

Photograph ca. 1890 (HCL)

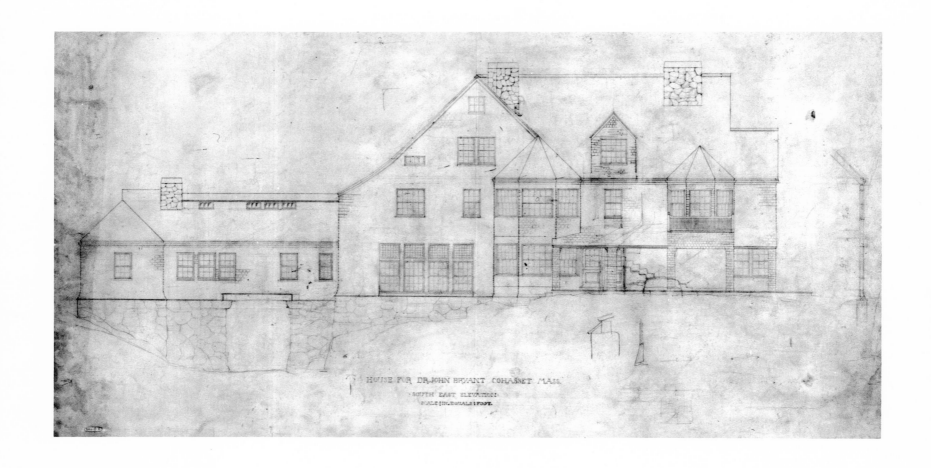

HOUSE FOR DR. JOHN BRYANT COHASSET MASS
SOUTH EAST ELEVATION
SCALE 1 IN. EQUALS 1 FOOT

12b. Bryant House. Southeast Elevation

E.W. Gurney (1829-1886) was professor of history and classics at Harvard, and first Dean of the College under Charles W. Eliot. His wife was Ellen Hooper, sister of Marian Hooper (Mrs. Henry Adams) and E.W. Hooper (see Introduction and cat. nos. 8, 23 and 24). Gurney preceded Adams as editor of the *North American Review*.

In 1881 the Gurneys purchased about fifty acres of the "Common" near Prides Crossing in Beverly Farms on the North Shore of Boston. The Hooper family and the Adamses were already established summer residents of "The Farms," and according to Marian Adams' correspondence, Richardson was first engaged in the area to put an addition onto the summer house of Gurney's father-in-law, Dr. Robert W. Hooper, in 1883. Described as a *succursale* combining playroom and study (in a letter from Mrs. Adams to her father on May 20, 1883), it remains to be seen whether it was ever built.

Van Rensselaer gives December 1884 as the date the Gurney commission entered Richardson's office, but as early as October 18 the *Beverly Citizen* noted that "Prof. Gurney . . . will erect an elegant house on land he purchased here last year [sic]. . . . It will be built of wood of the Queen Anne style." Construction ran from the spring of 1885 into the summer of 1886 with the *Citizen* publishing periodic progress reports. Quarter-scale drawings were sent to Gurney in March 1885 for inspection by Dr. Hooper; the contractors (local masons and carpenters) were picked by May 9; on the 28th Richardson visited the site with the Gurneys (at this point construction cost was given as $22,000); and on July 4 it was reported that three feet had been added to the ell of the house, that is, to the foundation then going in. Carpentry began early in August, and the first floor was reported laid on the 22nd. By September 19, the second floor of the ell was on. Interior work carried through the winter and into the summer. It was not until August 14, 1886, that the *Citizen* could report that "Gurney's new stone mansion . . . is now finished, the family intends to move in to-day. . . . The house is three stories high, built of rough stones with their moss on, and presents a most picturesque and unique appearance. The mason work gives evidence of a master hand and attracts . . . architects and builders from the city and elsewhere who visit The Farms especially to see the edifice."

The gothic mind would describe the Gurney House as cursed. Dr. Robert Hooper died in April 1885, as the drawings were being finished. Marian Hooper Adams committed suicide in December 1885. The architect died in April 1886, before construction was complete. Gurney died on September 12, 1886, less than a month after moving into the new house. Fourteen months later Ellen Hooper Gurney walked in front of a moving freight train. The house survives with additions and alterations.

13. Ephraim Whitman Gurney House, Prides Crossing, Massachusetts, 1884-1886

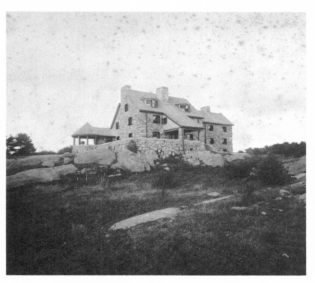

Photograph ca. 1890 (Boston Athenaeum)

13h. Gurney House. Perspective of Porch

13b. Gurney House. Study Plan

Sources: Ward Thoron, ed., *The Letters of Mrs. Henry Adams*, Boston, 1936, pp. 301, 451-452; *Beverly Citizen*, 1884-1886; DWGS. LIST BOOK #5, p. 9 (SBRA).

13a. Plans

Pencil on tracing paper; 5½ x 5¾ in. Draughtsman. Unpublished. (EWG-A3)
Written in pencil (cut off at right) in Charles A. Coolidge's hand: *Gu*[rney?] / *P* [reserve this?]

Study plans for lower and upper floors. A more grandiose scheme than no. 13b or 13c, or what was built.

13b. Plan

Pencil on tracing paper; 8¾ x 11 in. (Sheet torn at right). Draughtsman. Unpublished. (EWG-A1)
Written in pencil upper left and lower right in Charles A. Coolidge's hand: *Gurney / Preserve this / C.A.C.* Additional figuring in pencil.

Study plan, close to final design. The central chimney and stair separate dining from living rooms; the service wing is to the left.

13c. Plan

Pencil and watercolor on tracing paper; 7½ x 13¼ in. Draughtsman. Unpublished. (EWG-A2)
Written in pencil upper left in Charles A Coolidge's hand: *Gurney*

A study plan developed from no. 13b, with materials indicated by color.

13d. Perspective

Pencil on tracing paper; 7½ x 12¼ in. Draughtsman. Hitchcock 1966, fig. 104. (EWG-F4)
Written in pencil upper left: *Richardson*

Perspective study, but not connected to no. 13a, 13b or 13c. Stone first story, shingle above. Semi-circular entrance arch. Perhaps this is the "Queen Anne design" mentioned by the *Citizen*, although only half-wood.

13e. Perspective

Pencil on watercolor paper; 4 x 7¾ in. Draughtsman. Unpublished. (EWG-B3)

A stage between no. 13d and 13f.

GURNEY

13f. Gurney House. Perspective

13f. Perspective

Pencil on tracing paper; 8¼ x 15 in. Draughtsman. Unpublished. (EWG-F6)
Lettered in pencil at bottom: GURNEY

This perspective study is clearly related to no. 13d, but the material is now all stone, and the roof to the right is hipped.

13g. Perspective

Pencil on tracing paper; 4 x 6⅝ in. Draughtsman. Unpublished. (EWG-F5)

Design approaching final stage. The turret was built but later altered.

13h. Perspective

Pencil on tracing paper; 13¾ x 14 in. (irregular). Draughtsman. Unpublished. (EWG-D2)

Study in perspective of porch on west, close to final design.

13i. Interior of Dining Room

Pencil and watercolor on tracing paper; 8½ x 17⅝ in. Draughtsman. Unpublished. (EWG-E2)
Written in pencil (twice): *4 x 8 Beam*

Elevation of paneled dining room fireplace wall.

13i. Gurney House. Interior of Dining Room

H.S. Potter (1851-1918) was president of the St. Louis Steel Barge Company. His wife was Margaret Clarkson Lionberger, member of a family for whom the firm designed two other houses in St. Louis (one, the I.H. Lionberger House on Grandel Square, survives in considerably altered condition). The law firm of Lionberger and Shepley included John Foster Shepley, the brother of one of Richardson's chief assistants (cf. cat. no. 4).

The Potter House is not included in Van Rensselaer's "List of Works"; nonetheless, the design and the working drawings were finished before Richardson's death. The drawings were begun in February 1886, and the architect wrote to George F. Shepley on March 6 that "Mr. Potter's plans & specifications will go off Monday."

Long the residence of E.J. Russell, member of the St. Louis office of Shepley, Rutan and Coolidge and a prominent architect in the city, the house stood at 5814 Cabanne Avenue (corner Goodfellow) until pulled down in 1958, after Russell had willed it to the city.

Sources: Letter in possession of SBRA; "H.H.R. DRAWING LISTS BOOK NO 2," pp. 42-43 (SBRA).

14. Henry S. Potter House, St. Louis, 1886-1887

Photograph ca. 1900 (J.A. Bryan, Missouri's Contribution to American Architecture, *1928)*

14a-b. Plans

14a. Black and red ink and pencil on tracing paper within pencil border; 16½ x 18½ in. Draughtsman. Unpublished. (POT-A2)
Lettered in pencil upper left: HOUSE FOR MRS. H.S. POTTER / SKETCH PLAN FOR 1ST STORY / SCALE ⅛" = 1'
Notations in pencil across sheet: *Living-Library & smoking Room — / Horses where the* [] *breeze*

14b. Black and red ink and pencil on tracing paper within pencil border; 16¾ x 20¼ in. Draughtsman. Unpublished. (POT-A7)
Lettered in pencil upper left: HOUSE FOR MRS. H.S. POTTER / SKETCH PLAN FOR 2ND STORY / SCALE ⅛" = 1'
Embossed stamp upper left: TO BE RETURNED / TO / H.H. RICHARDSON

A linear plan made L-shape with a one-story stable wing. The relation of this to the final house remains a question.

House for Mrs. H. S. Potter.

Sketch plan for 1st Story.
Scale 1/8" = 1'

Stable Yard.

Carriage House.
19'-0" x 26'-0"

Wash Stand.
8'-0" x 11'-0"

Harness Room
7'-0" x 8'-6"

Box-Stall.
9'-0" x 12'-0"

Stable.
Open Space 9'-0" x 18'-6"

Stalls
6'-0" x 9'-0"

Kitchen Yard.

Horse-Shed.
15'-0" x 18'-6"

Driveway
11'-0" wide.

Living-Library + Smoking Room —

Parlor.
15'-0" x 19'-6"

Reception
Room.
18'-0" x 13'-6"

Garden
Entrance

Lavatory.

Dining Room.
15'-0" x 19'-6"

Serving Room.
8'-0" x 9'-0"

Kitchen.
12'-0" x 15'-0"

Laundry.
12'-0" x 18'-0"

Covered
Driveway.
11'-0" wide.

Wood-Shed.
15'-0" x 18'-6"

Corridor
& Servants

Hall.

Porch.

Passage. 3'-6" wide.

Store Room.

Cold
Closet.

S.

E. — W.

N.

Richardson's contribution to the residence of this fashionable Anglo-Teutonic portrait painter was minimal. In December 1885, Herkomer proposed to the architect that he paint Richardson's portrait (see Introduction) in exchange for "elevations to my ground-plans." Van Rensselaer lists the commission as January 1886; on March 13 Richardson wrote George F. Shepley that he was trying to get the house "out of the way." As erected between 1889-1894, *Lululaund*, as the house was named after Herkomer's wife, followed the drawings from Richardson's office only in modified external outline. Herkomer filled in the form, color and surface texture which he believed the architect would have approved. Richardson had nothing to do with the plan and interior.

The house was destroyed about 1939; only a fragment, including the main arched portal beneath the tower, remains at 43 Melbourne Road, Bushey.

Sources: Letter in possession of SBRA; H. von Herkomer, *The Herkomers*, London, 2 vols., 1910-1911, II, pp. 6, 187 ff.; W. Shepherd, "Von Herkomer's Folly," *Country Life*, 86 (December 16, 1939), 636.

15a. Elevation (see color plate)

Pencil, watercolor and india ink on tracing paper; 14½ x 19 in. (irregular). Charles A. Coolidge? Unpublished. (HER-B2)
Written in pencil at bottom, probably in Charles A. Coolidge's hand: *Capt. Perkins / B.B. / London* (repeated six times), and on verso: *Herkomer House in England / only one built outside America*

Draughted study for main elevation with long gabled main roof. Freehand changes in pencil are perhaps by HHR, although the handwriting looks more like CAC's.

15b. Elevation

Pencil, colored pencil and watercolor on tracing paper; 15¾ x 19 in. (irregular). Charles A. Coolidge? Unpublished. (HER-B3)
Written in pencil above: *Herkomer*

Draughted study for main elevation with short hipped main roof, enlivened with freehand scale figures. These two elevations correspond in time, technique and style to elevation studies in the Harvard College Library (WGG-B1, B2, B3; not in exhibition) for the Gratwick House in Buffalo. Since CAC's hand is recognizable in the sketches for the latter, these drawings should be tentatively assigned to him.

15. Sir Hubert von Herkomer House, Bushey, Hertfordshire, England, 1886 et seq.

15c. Herkomer House. Gable Elevation

15c. Elevation (detail)

Pencil and india ink on tracing paper; 12½ x 9½ in. (losses in lower corners of sheet, mended). Draughtsman. Unpublished. (HER-D1)

Draughted study of elevation of main gable flanked by towers with segmental arch below. The executed building followed this design in vague outline only.

15d. Elevation

Pencil on tracing paper; 11 x 16⅛ in. Draughtsman. Unpublished. (HER-D2)

Unfinished study for side elevation to left of main façade.

15b (detail). Herkomer House. Elevation

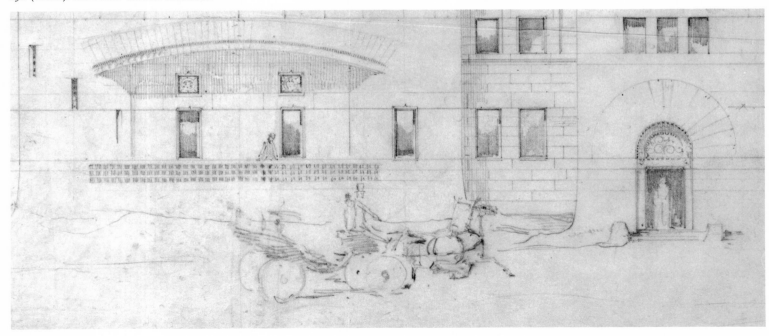

16a. Plan of Suburban House

Brown ink with pencil alterations on tracing paper; 15¾ x 14⅝ in. Autograph. Unpublished. (UDH-15a)

First floor plan of an L-shaped suburban house. The room notations in brown ink refer to the second as well as the first story. From them we learn that the house is for Mr. and Mrs. B, and that another person, John, was also to live in it. The drawing cannot with certainty be associated with any of Richardson's clients whose names began with *B*: Arthur Blake, Borland, Benjamin Bowles, Percy Browne, John Bryant or the Bagley Estate.

16b. Plans of Low Cost Houses

Pencil on light blue laid paper; 5⅞ x 6¼ in. Autograph. Unpublished. (UDH-20)
Written in pencil below: *1040 sq͏ʳ ft. about / cost about $4000. # / Small Hous*[e]
see James House for upper story
On verso: miscellaneous pencil calculations and fragments of plan.

Three first floor plans for low cost houses. HHR's drawing for the Henry James House is in HCL.

16c. Elevation

Pencil and brown ink on engraved blue stationery; 7⅝ x 4⅞ in. Autograph. Unpublished. (UDH-21)
Written in pencil at top: *Bring down* [?] *Da Vinci / Screen with line* [?]
On verso: light pencil sketch with partial brown ink overlay of a turret against a wall and a block plan of a building surrounding a courtyard.

Thumbnail sketch of a house with low-swooping hip roof.

16d. Perspectives

Pencil on blue laid paper; 4⅞ x 4⅞ in. Autograph? Unpublished. (UDH-26)

Two studies for a small gabled house, perhaps variations on the same plan. These seem unrelated to the plans in no. 16b (which show more fireplaces).

16e. Interior

Brown ink, gray and bistre wash with freehand double border on tracing paper; 7⅞ x 8½ in. Stanford White? Unpublished. (UDH-25)
Lettered in brown ink lower left: HALL

16. Unidentified Domestic Designs

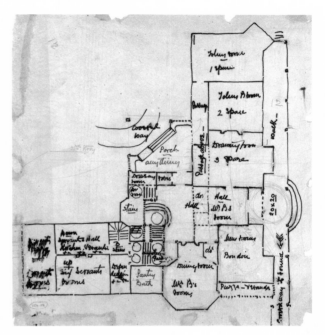

16a. Unidentified Domestic Plan

Perspective of a domestic interior with stair, patterned glass windows and curtained doorway. The draughtsmanship is close to White's. The style would date this to the mid-70's, but it is not the Watts Sherman House. Could this be a study for one of the Cheney House projects?

16e. Unidentified Domestic Interior

16c. Unidentified Domestic Elevation

COMMERCIAL BUILDINGS

Because of the central position of the Marshall Field Store in the development of the urban commercial style in late nineteenth-century America (Louis Sullivan called it an "oasis"), Richardson's contribution to the skyscraper has been distorted. The suggestion that, had he lived, he would have adopted metallic framing as architectural expression runs counter to everything we know about the man's preferences. The organization of wall surfaces by architectonic means, by gathering stories into repeated binding arches, which we associate with his work, can be found in the work of others as well, especially that of George B. Post.

It is true that Richardson's characteristic simplified massing was easily adapted to economical commercial building. But commercial architecture does not loom numerically large in the list of the architect's own works: less than ten buildings in twenty years. It should be noted too that he designed only one bank, and that (Agawam National, Springfield, Massachusetts, 1869) very early in his career.

17. R. and F. Cheney Building, Hartford, Connecticut, 1875-1876

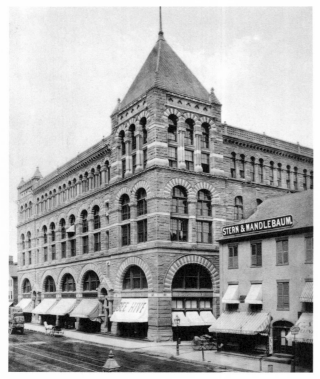

Photograph ca. 1890 (SBRA)

R. and F. Cheney were two of four brothers active in Cheney Brothers, silk manufacturers of South Manchester and Hartford, described in 1876 as the "largest and most celebrated of our manufactories of silk goods." *F* was Frank (1817-1904), who had also backed the Spencer Repeating Rifle Company during the Civil War. *R* could be either Ralph (1806-1897) or, more likely, Rush (1815-1882). Richardson designed unexecuted houses for Rush, and for James Cheney of the next generation, in the same decade that he built the commercial block.

The building on Main Street in Hartford was commissioned in September 1875, according to Van Rensselaer. The contract went to Norcross Brothers in November, and the building was finished the following year. It is now owned by G. Fox Department Store.

Sources: L.P. Brockett, *The Silk Industry in America*, New York, 1876; Glenn Brown, *Memories 1860-1930*, Washington, D.C., 1931, pp. 23 ff.

17a. Plans

Ink, terra-cotta, yellow and gray wash on heavy paper (dimensioned in black and red ink); 25⅜ x 38⅜ in. Draughtsman. Unpublished. (RFC-A4)
Lettered in black ink at top: BUILDING FOR / MESSRS R. & F. CHENEY / HARTFORD, CONN. / SCALE ⅛ INCH = 1 FOOT / SECOND, THIRD / AND FOURTH STORY / PLANS, and at bottom left to right: SECOND STORY PLAN / THIRD STORY PLAN / FOURTH STORY PLAN

Three half-plans of the upper levels of the building. Folio 56ʳ of the Sketchbook (see Appendix) contains a study for the plan of the building.

17b. Elevation of Main Street Front

Pencil, yellow and blue wash on stiff linen-mounted paper, with pencil corrections and notations; 24⅜ x 34⅞ in. The left gable bears the date of expected completion: *1876*. Draughtsman. Unpublished. (RFC-B1)
Lettered in black ink upper right: BUILDING FOR MESSRS. R. & F. CHENEY / HARTFORD CONN. / GAMBRILL & RICHARDSON ARCH'TS / 57 BROADWAY NEW YORK, and at bottom: ELEVATION ON MAIN STREET / SCALE ⅛ INCH = 1 FOOT
Penciled notes identify various stones: *Longmeadow, Ohio, granite, Westerly.*

Draughted main elevation. The drawing is preliminary, but, with the penciled change from gable to flat balustrade above the left pavilion, represents the building as erected. The date is probably October 1875. Four pages in the Sketchbook (ff. 52ʳ-55ʳ, see Appendix) contain autograph studies for this elevation.

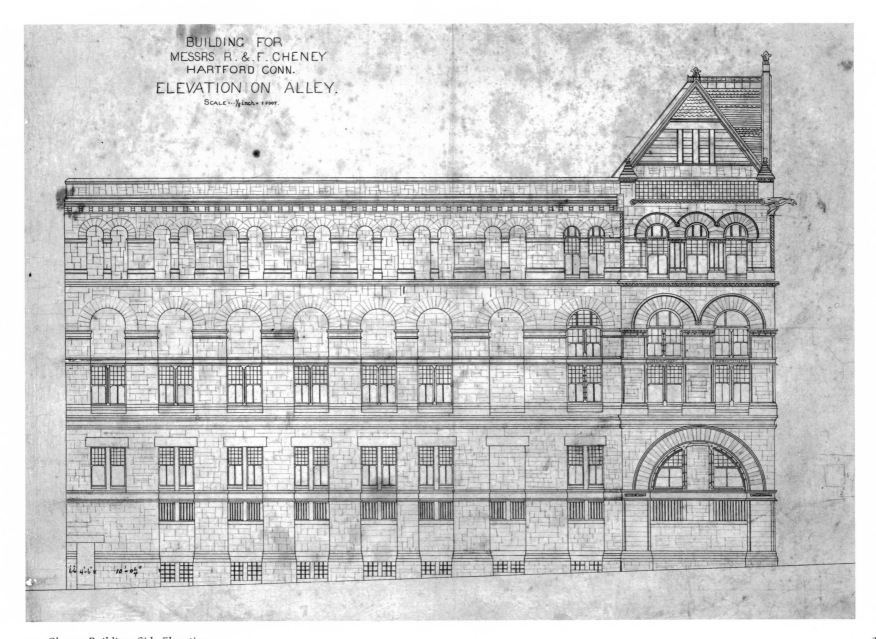

BUILDING FOR
MESSRS R. & F. CHENEY
HARTFORD CONN.
ELEVATION ON ALLEY.
SCALE---⅛inch=1 FOOT.

17c. Cheney Building. Side Elevation

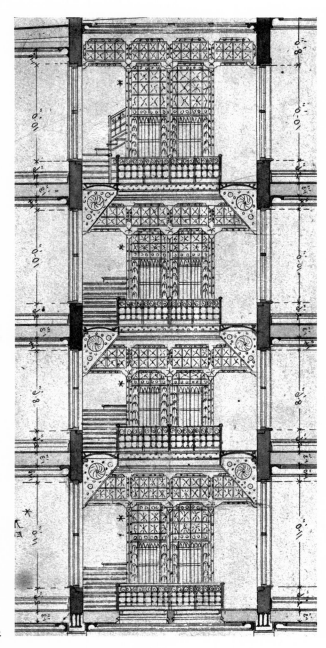

17c. Side Elevation

Black ink on linen; 20½ x 26¼ in. Draughtsman. Unpublished. (RFC-B3)
Lettered in black ink upper left: BUILDING FOR MESSRS R. & F. CHENEY / HARTFORD CONN. / ELEVATION ON ALLEY

The design was developed from the side of the just-finished Hayden Block on Washington Street in Boston (Sketchbook, f. 58ʳ, see Appendix). The stone lintels of the top windows of the earlier building give way here to arches; ornament is here more lavishly applied.

17d. Section

Black ink, terra-cotta, yellow, blue, gray and brown wash on stiff linen-mounted paper, with light pencil notations (dimensioned in black and red ink); 20⅞ x 25⅜ in. Draughtsman. Unpublished. (RFC-C2)
Lettered in black ink at top: BUILDING FOR / MESS R & F CHENEY / HARTFORD CONN / SECTION THROUGH BUILDING / AT RIGHT ANGLE WITH MAIN STREET / SCALE ⅛ INCH = ONE FOOT, and in red on section: NO IRON FRETWORK AROUND ELEVATOR. SEE SPECIFICATION

The interior of the building was gutted long ago. The section shows the elaborate decorative ironwork in the central light-well running parallel with Main Street, and the mantels at the front of the upper floors.

17d (detail). Cheney Building. Section through Light-well

F.L. Ames (1835-1893; Harvard '54) was a member of the North Easton manufacturing family and Richardson's friend and very important patron. As an officer of the Old Colony Railroad he commissioned the station at North Easton (cat. no. 32), perhaps Richardson's finest. The Gate Lodge for Ames' North Easton estate (cat. no. 37) is among the architect's most familiar works.

Ames was also a speculator in Boston real estate; this is one of a number of properties he developed with the help of Richardson and his firm. The commission entered the office in March 1882, according to Van Rensselaer. The building was erected on the corner of Bedford and Kingston Streets in the following year and was destroyed by fire on November 28, 1889. A new building by Shepley, Rutan and Coolidge replaced it.

Source: Harold F. Williamson, *Edward Atkinson*, Boston, 1934, pp. 126-128.

18a. Elevation

Black ink on linen; 24 x 29 in. Draughtsman. Unpublished. (BED-B1)
Lettered in black ink at bottom: FRONT ELEVATION / ⅛ INCH = 1 FOOT
Written in pencil at bottom: *Bedford St Stores*
Embossed stamp lower left: TO BE RETURNED / TO / H.H. RICHARDSON

Draughted main elevation as built. The design is simply a variation of the Main Street front of the Cheney Block (cat. no. 17b) with an elaborate roof-scape. Another drawing for the Bedford Street Store (BED-A1; not in exhibition) is marked *To be returned Fred Pope, Architect, 289 Washington St, Boston.*

18. Frederick Lothrop Ames Building, Bedford Street, Boston, 1882-1883

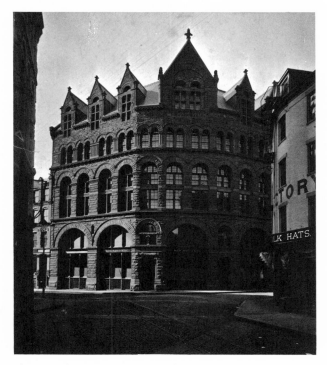

Photograph ca. 1885 (Boston Athenaeum)

113

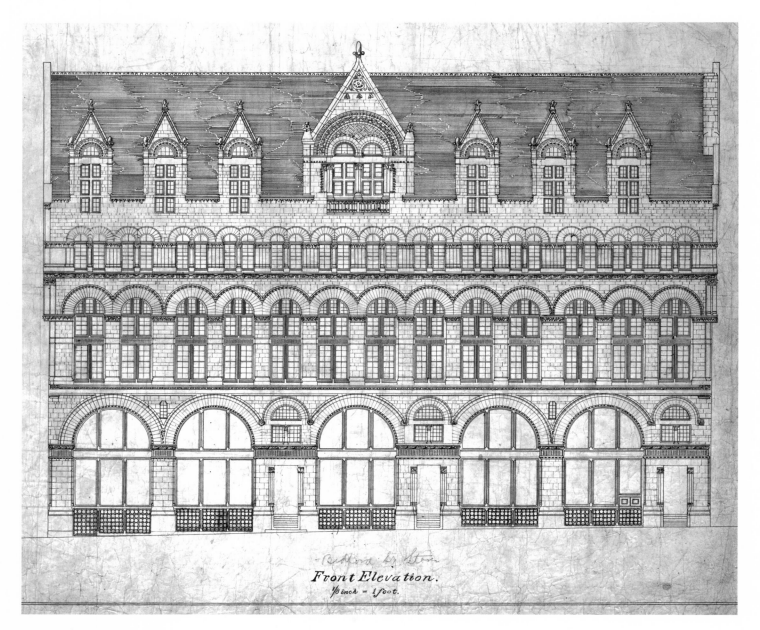

Front Elevation.
⅛ inch = 1 foot.

114 18a. Ames Building. Front Elevation

Richardson and Marshall Field (1835-1906) apparently became friends during work on this store, for the architect's eldest son, called Hayden, visited the Fields in their Prairie Avenue home (the design of Richard Morris Hunt) over New Year's 1886 (cf. cat. no. 9). Richardson wrote to his son that he "might be interested in seeing the Cattle Yards also the system of Parks which is very fine and was originally laid out by Mr. Olmsted. There is no public building in Chicago worth seeing." This presumably includes his own American Merchants' Union Express Company building of the early 1870's.

The commission for the Field Store reached Richardson's office in April 1885, according to Van Rensselaer. The architect wrote Hayden from Chicago in a letter that is only partially preserved but probably dated October 1885, that he hoped "contracts for Mr. Fields Building will be signed tomorrow . . . then I must go again to Pittsburgh, to Washington New York to Albany & probably to Cincinnati & Springfield Ohio ! ! ! !" Construction by Norcross began in the spring of 1886, and the building was finished by Shepley, Rutan and Coolidge in 1887.

Source: Letters in possession of SBRA.

19a. Plan

Pencil, and red, blue and brown wash on tracing paper; 15⅜ x 22⅜ in. (edges torn and mended). Draughtsman. Hitchcock 1966, fig. 98. (MF-A10)
Lettered in pencil upper left (torn): [MA]RSHALL FIELD & CO. / [CHI]CAGO, ILLS., and at bottom: FIR[ST] STORY PLAN / SCALE 1/16″ = 1′0″
Written in HHR's hand (?) at left: *entrance*

Preliminary scale plan showing six window openings on each end, and eleven on each long side (only those five upper center are inscribed *arch*). The building as constructed had seven and thirteen window openings, respectively. The center of the plan is occupied by a skylighted court.

19b. Perspective (see color plate)

Pencil, black crayon and red wash heightened with white, with partial freehand border on buff paper; 11⅜ x 19⅞. Draughtsman? Unpublished. (MF-F3)
On verso: light pencil sketch of group of standing figures.

The color suggests that this brilliant sketch is for the early, brick version of the design.

19. Marshall Field Wholesale Store, Chicago, 1885-1887

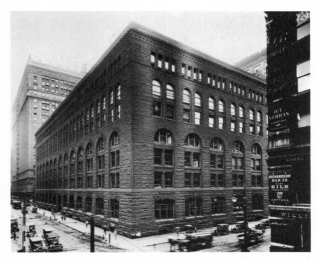

Photograph after 1900 (Chicago Architectural Photographing Company, from the Collection of David R. Phillips)

19a. Marshall Field Wholesale Store. Preliminary Scale Plan

19c. Elevation (detail)

Pencil and terra-cotta wash on tracing paper; 19¾ x 24¾ in. (irregular). Draughtsman. Unpublished. (MF-D16)
Written in pencil at bottom: *Marshall Field — / 8ᵗʰ Scale (B)*

Alternative studies of fenestration and window detail of upper story. The main arches are only two stories high. The ornamental carving shown here was later eliminated. This drawing makes plain the evolution of the Field Store façades from those of the Hayden, Cheney and Ames buildings.

19d. Elevation (detail)

Pencil and india ink wash on watercolor paper (dimensioned in pencil at left); 19⅞ x 8¾ in. Draughtsman. Unpublished. (MF-D13)

A preliminary study; the main arches are only two stories high and the material is brick. Two matchstick scale figures appear at right.

19e. Elevation

Pencil, red and india ink and blue, black and grey washes on tracing paper; 25¼ x 43¾ in. Draughtsman. Unpublished. (MF-B9)
Written in pencil at bottom: *Marshall Field / Scale ⅛ in = 1 ft.; 14 x 16; Try arches / [Try] piers bigger / Zargossa Cornice*

Preliminary study. The thirteen arches are the final number, but they are still just two stories high and the material is still brick.

19f. Elevation (detail)

Pencil, brown ink and india ink wash on tracing paper with partial overlay at top (dimensioned in pen at left and right); 24 x 17¾ in. Charles A. Coolidge? Unpublished. (MF-D7)
Written in brown ink at bottom in CAC's hand: *Preserve this / C.A.C.*

This study is close to the final window arrangement except for the top story, but the cornice remains a problem.

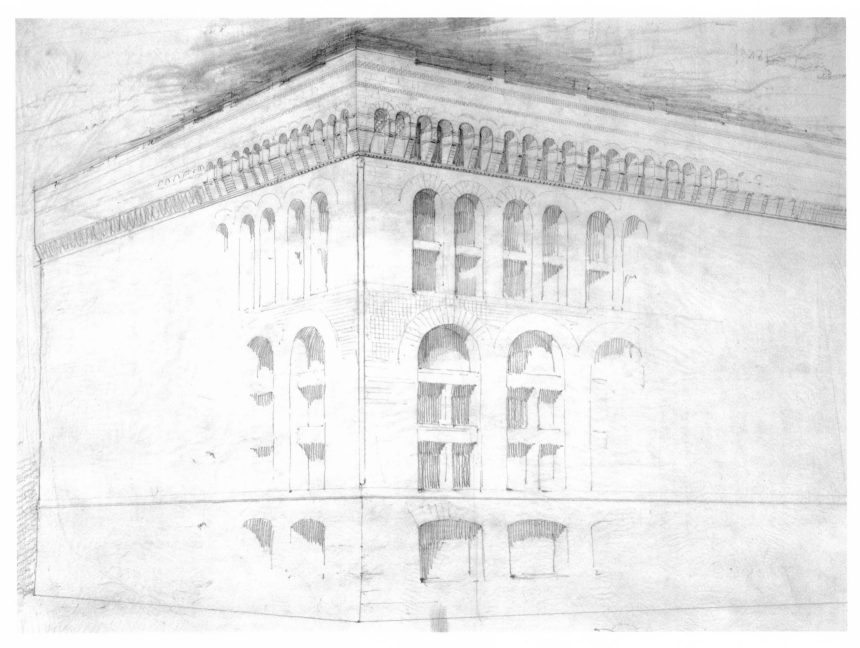

14 X 16 11

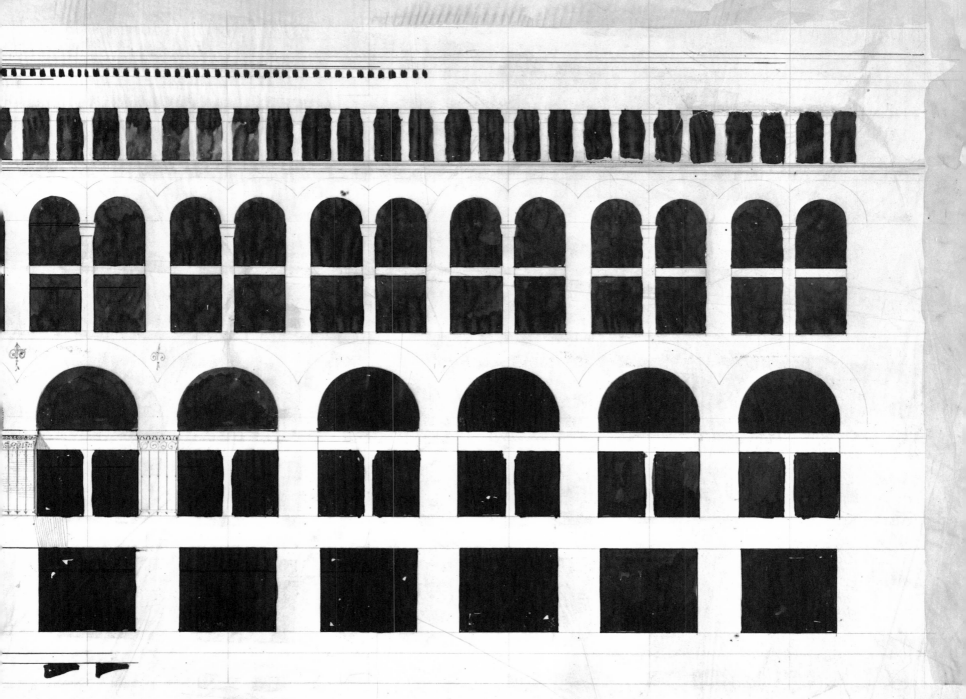

19e. Marshall Field Wholesale Store. Preliminary Elevation Study

19j. Marshall Field Wholesale Store. Cornice Detail

19g. Elevation Detail (see cover)

Pencil and blue wash on tracing paper; 27 x 19¾ in. Draughtsman. Unpublished. (MF-D8)

The final stone design except for the cornice.

19h. Perspective

Pencil on tracing paper; 8⅛ x 12 in. Draughtsman. Unpublished. (MF-D18)

An early study of the cornice at the corner, before window pattern was set.

19i. Perspective

Pencil on tracing paper; 17⅞ x 22½ in. Draughtsman. Unpublished. (MF-D21)

Perspective study of corner. The window pattern is set, but the cornice is being studied. Here it is machicolated.

19j. Cornice Detail

Black ink on tracing paper; 27¼ x 16¾ in. Draughtsman. Unpublished. (MF-D43)
Written in blue pencil at bottom: *No. 1*

The number of preserved studies for window details and cornice treatment suggest the attention lavished by the office on all aspects of design.

PUBLIC BUILDINGS

Although Richardson designed few governmental works, those that were built from his drawings were of great significance. The Hampden County Court House, Springfield, 1871, has been rightly singled out as the first suggestion in stone of the stylistic direction of his mature work. In the Senate Chamber in Albany he projected one of the most lavish and colorful ensembles of Victorian America, although the design was never fully executed. He himself preferred the Allegheny County Buildings above all his efforts. The exterior of the Jail ranks among the world's finest examples of stereometric art.

20. New York State Capitol, Albany, 1875 et seq.

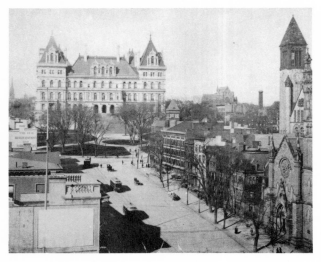

Photograph 1890's (New York State Library)

The New York State Capitol was begun by Thomas Fuller (1822-1898) in 1867. By 1875 the exterior walls had reached the top of the second story, but the original appropriation had been expended. In that year Lieutenant Governor Dorsheimer, new head of the Capitol Commission, appointed an Advisory Board consisting of F.L. Olmsted, L. Eidlitz and H.H. Richardson to make a "critical review" of Fuller's accomplishments and proposals. William Edward Dorsheimer (1832-1888; A.M. Harvard '59), a lawyer, was a major figure in Richardson's early career. He is associated with at least five commissions by 1875: his own house in Buffalo (1868) and a later house project presumably for Albany, the Buffalo State Hospital (1870 *et seq.*), the Buffalo Civil War Memorial (cat. no. 36) and the Capitol.

On March 2, 1876, the Board signed its *Report*, stating that "in September last we exhibited to you sketches, illustrating the manner in which we thought the general exterior appearance of the Capitol might be improved." They were instructed at that time to work up their proposals in large-scale drawings, which they presented with the *Report*. The perspective view of their project was published in *AABN*, March 11, 1876. According to the *Report*, probably written by Olmsted, the new design achieved "repose and dignity," as well as economy, by eliminating from Fuller's design many features such as balconies.

Fuller was dropped, and Eidlitz & Company (Olmsted as Treasurer) finished the building. Although Fuller was not officially dismissed until July 1, on March 26, 1876, Richardson wrote to Olmsted that he had "already begun sketching on the dormers & roofs & know that something good can be done — I am trying also to unite the principal & upper windows of Senate & Assembly Chambers or in some way mark on the exterior the existence of the large rooms. That however is more difficult & I am not too hopeful — many things hamper me. . . ."

Politics delayed work on the building. The Legislature entered the debate over style when it insisted in 1877 that the Capitol be finished in Italian Renaissance. Richardson winked to Olmsted in a letter of March 10 of that year: "I do believe entre-nous that the building can be well finished in Francois Ier or Louis XIV which come under the head of Renaissance."

Division of design responsibility on the interior left Richardson with the Governor's suite, the Senate Chamber, the Western Stair and the New York State Library. Work on the Senate Chamber began in the spring of 1876. By May 21, Richardson wrote Olmsted that Stanford White had arrived "with several suggestions for changing the senate chamber. . . . Carrying piers from ceiling to floors between windows, I do not think best, as it cuts the room into a series of huge panels, at the loss of simplicity and quietness. A simple big unbroken wainscoating [*sic*] is a very imposing thing, & I propose carrying

one of oak up to the string course under the upper tier of windows. The part above the spring of the arches of the lower windows, should be richly carved . . . we proposed making ¼ scale sections . . . and Mr. White will return tomorrow (Monday) night, with everything ready to put in Mr. Eidlitz's hands." He ended, as he did so often, with news that he was not in good health: "I am sick . . . all I have written & will do today & tomorrow is the work of a sick man, in considerable pain, and trust you will remorsely [sic] change as you think best." Five days later he wrote Olmsted that he did not "fear the low ceiling" in the Senate, and asked Eidlitz "to take my two sketches of roofs the finished one and the one in pencil they may be wanted" (presumably in Albany).

He was still working on the Senate Chamber in the fall and had studied other rooms as well. He thanked Olmsted in a letter of November 26, 1876, for a plan of the Governor's room. "My mornings and evenings have been given entirely to the Senate & reception room & Friday I sent to my office in New York completed sketches for everything." Presumably his afternoons were spent with La Farge at Trinity Church. In a postscript he was more specific. "All drawings & specifications for Senate & Governors reception room will be ready Dec. 10th 1876." In fact, they were in Eidlitz's hands by the 9th, as we learn from a letter to Olmsted of the 15th: "More time would have improved them as some things particularly the ends needed study — but that I can give them later — the Senate is improved I have as you see reduced the rich carving to a simple band — I enclose one of my rough sketches."

These drawings were far from the final design, however, for on May 2, 1877, Richardson wrote Olmsted that he had received the Senate plans and was "at work making the changes suggested by Dorsheimer." Again, a year later the room was restudied. In May 1878, according to Charles Baldwin, White wrote to Augustus Saint-Gaudens in Paris that he had "just been paying a last and final visit [White was planning to join Saint-Gaudens] to the abode of the Great Mogul (H.H. Richardson) at Brookline, and there tackled the Albany Senate Chamber, and between us I think we have cooked up something pretty decent . . . it would be a good thing to let a certain feller called St. Gaudens loose on the walls. . . . There are about one hundred and fifty feet by twenty feet of decorative arabesque, foliage and the like, and work in panels. . . . There are two marble friezes in the fireplaces; and one damn big panel for figures — Washington crossing the Delaware or cutting down a cherry tree — about forty feet by eight feet, also in colored cement, and a lot of little bits beside. The whole room is to be a piece of color. . . ."

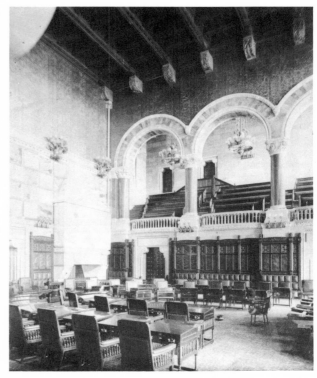

Senate Chamber. Photograph ca. 1890 (SBRA)

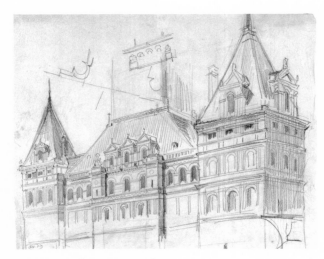

20a. New York State Capitol.
Perspective Study for Upper Stories

Funds were not appropriated for the Senate until 1880. The room was first used in March 1881, fully five years after the initial drawings. Saint-Gaudens never worked there. The Governor's room contains the date 1880; the Court of Appeals (now moved out of the building) was finished in 1881.

Grover Cleveland took office as Governor in 1883 and quickly appointed Isaac Perry as sole Commissioner of the Capitol. Perry directed the work of finishing the building, including the Western Stair, begun in 1884. He embellished it with sculpture not shown on any of Richardson's drawings. It was not finished until 1898. The New York State Library was executed after Richardson's death and destroyed by fire early in this century.

Sources: Report of the Advisory Board Relative to the Plans of the New Capitol, Albany, 1877; Cecil R. Roseberry, *Capitol Story*, [Albany?], 1964; Olmsted Papers, General Correspondence, Library of Congress, Boxes 13, 14, 15 and 18; Letters in possession of SBRA; Charles C. Baldwin, *Stanford White*, New York, 1931, p. 59; Saint-Gaudens Papers, Baker Library, Dartmouth College, Box 20.

20a. Perspective of Upper Stories

Pencil on tracing paper; 11⅛ x 13⅝ in. Draughtsman? Unpublished. (ASC-F1)

Study of upper stories and roof lines showing all three pavilions. The central salient is carried weakly into the third story. The style of the dormers suggests 1877.

20b. Perspectives of Upper Stories

Pencil on tracing paper; 8½ x 10⅝ in. Draughtsman? Unpublished. (ASC-F2)

Sketches of upper stories and roof. At left is a study of the central salient carried through the third story. At right is a study from the same viewpoint of the entire width of the eastern façade. The central salient stops at the top of the second level, as built. The style of the dormers suggests 1877.

20c. Elevation of Roof and Upper Story

Pencil, brown and red wash on paper (freehand perspective detail at left); 13⅞ x 23 in. Draughtsman. Hitchcock 1936, fig. 55; 1966, fig. 44. (ASC-B1)
Lettered in black ink lower right: ALBANY STATE CAP.
Inscribed in pencil upper left: *89 Richardson*, with numeral *89* pasted on

Draughted elevation of the upper portion of the building, with cornice and other details sketched at left. Not as built; the fenestration was altered and regrouped at the third story. Hitchcock dates this 1877.

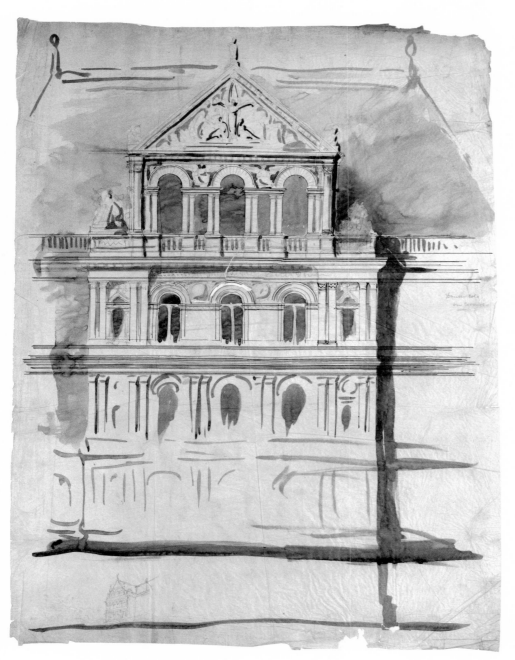

20f. New York State Capitol.
Elevation Study for Central Pavilion

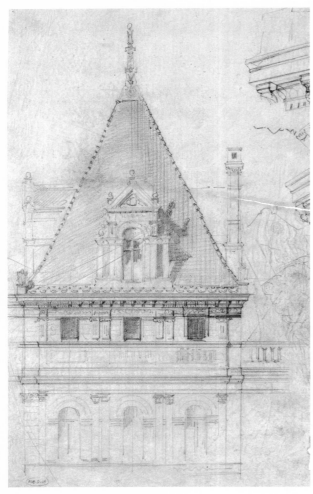

20d. New York State Capitol.
Elevation Study for Corner Pavilion

20d. Elevation of Corner Pavilion

Pencil on tracing paper; 18⅜ x 11½ in. (irregular). Draughtsman. Unpublished. (ASC-D18)

Draughted study of top of a corner pavilion, with cornice sketches at upper right.

20e. Details of Cornices and Decoration

Pencil on tracing paper; 7 x 15 in. Draughtsman. Unpublished. (ASC-D19)

20f. Elevation of Central Pavilion

Pencil, ink and brown wash on tracing paper; 22⅜ x 16⅞ in. Draughtsman. Unpublished. (ASC-D7)
Written in pencil at right: *Double cols / on corners*

Study for the central pavilion on the west, with thumbnail perspective at bottom. The upper pavilion, with more detailed draughting, became the Great Gable in execution.

20g. Interior of Senate Chamber

Watercolor and brown ink (circular design within green wash rectangle) on paper; 9½ x 8 in. Stanford White? Unpublished. (ASC-E3a)

Perspective of the interior of the Senate Chamber. Probably May 1878, since it corresponds to White's description of that date. The lines of this design were preserved in execution, but not its richness. A photograph of a line drawing in the photo album at SBRA corresponds to this watercolor.

20h. Interior of Senate Chamber (see color plate)

Brown ink, pencil and watercolor with gold paint, heightened with white on tracing paper; 15¾ x 16 in. Stanford White? Unpublished. (ASC-E3w)

Interior elevation of Senate Chamber with section through balcony. Nothing of the decoration shown here was executed.

20i. Interior of Senate Chamber (or Governor's Room)

Pencil and brown wash on tracing paper; 11¾ x 8½ in. Draughtsman. Unpublished. (ASC-E14)

Preliminary draughted elevation study for fireplace in Senate or Governor's

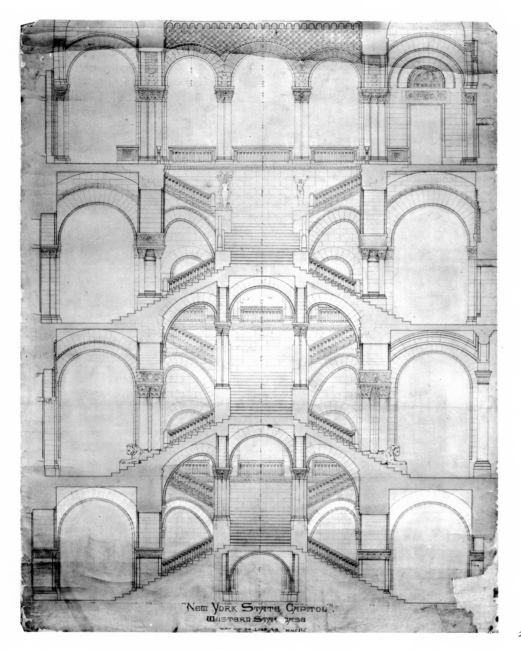

"New York State Capitol".
Western Staircase

20p. New York State Capitol. Western Staircase

20i. New York State Capitol.
Preliminary Study for Fireplace

20r. New York State Capitol.
North Elevation of State Library

Room (see no. 20m). A frieze of figures in niches surmounts a segmental opening.

20j. Study for Fireplace Detail

Pencil on tracing paper; 13¾ x 12¾ in. Draughtsman. Unpublished. (ASC-E18)

Line studies for Senate fireplace with shield and motto EXCELSIOR on fireplace breast; close to final solution, except that the decoration was never executed.

20k-l. Studies for Marbleized Panels

20k. Brown ink and polychrome watercolor on tracing paper; 3¼ x 12½ in. Stanford White? Unpublished. (ASC-E16)

20l. Pencil and polychrome watercolor on stiff buff paper; 4⅛ x 17¾ in. Stanford White? Unpublished. (ASC-E17)

Studies for decoration, perhaps intended to be executed in "colored cement" in the Senate.

20m. Interior Elevation of Governor's Room

Pencil, brown wash and watercolor on buff paper; 10⅝ x 16½ in. (torn and mended). Draughtsman. Unpublished. (ASC-E9a)
Written in pencil upper right: *Governor's Room / Capitol,* and at bottom: *Governor's Room*
On verso: pencil sketches of wooden chairs and tables.

Elevation of fireplace wall with alternative designs for the mantel and the pattern of wood paneling.

20n. Plan of Western Staircase

Red, black and blue ink on heavy, linen-mounted paper; 51¾ x 42½ in. Draughtsman. Unpublished. (cf. Van Rensselaer, opp. p. 76). (AWS-A12)
Written in pencil at top: *Central Court; East; Entrance / (Principal Floor* [crossed out] */ Scale ½″ = 1′0″)*

20o-p. Draughted Sections of Western Staircase

20o. Black and red ink with pencil shading on linen-mounted paper (dimensioned); 52 x 39 in. Draughtsman. Unpublished. (AWS-C7)

20g. New York State Capitol. Senate Chamber

20p. Black ink and red wash with pencil shading on linen-mounted paper (dimensioned); 53½ x 39½ in. (edges frayed). Draughtsman. Unpublished. (AWS-C14)

Lettered in black and red ink at bottom: NEW YORK STATE CAPITOL / WESTERN STAIRCASE / SECTION ON LINE A-B. SCALE ½″ = 1′

20q. Plan of Skylight

Pencil and india ink on tracing paper; 19 x 18¼ in. Draughtsman. Unpublished. (AWS-E15)

Study plan of the iron and glass skylight above the Western Staircase. Although this does not show on the sections published here (nos. 20p-q), it does appear on others.

20r. North Elevation of State Library

Brown ink with pencil corrections within double border on linen; 23⅜ x 31 in. Draughtsman. Unpublished. (ASL-B2)

Lettered in brown ink below: STATE LIBRARY — ALBANY CAPITOL / SCALE ¼ INCH = 1 FOOT / NORTH ELEVATION

Preliminary elevation study in ink with pencil alterations in the region of the vault and ties.

20s. Interior Elevation of State Library (partial plan below)

Pencil and light red wash on tracing paper; 21 x 12 in. Draughtsman. Unpublished. (ASL-B24)

Lettered in pencil at top: NEW YORK STATE CAPITOL / END OF STATE LIBRARY / SCALE ¼″ = 1′, and below: PLAN

Draughted elevation and plan of design close to that executed.

21. City Hall, Albany, 1880-1882

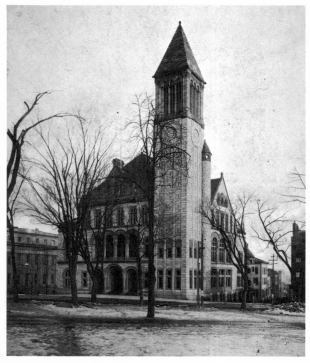

Photograph ca. 1890 (HCL)

Commissioned in November 1880 according to Van Rensselaer, the building was erected by Norcross Brothers. The interior was altered about 1919 by C.G. Ogden and J.J. Gander.

Source: "Alterations to the City Hall at Albany, N.Y.," *American Architect*, CXVII (June 30, 1920), 809 ff.

21a. Sketches of Plan and Elevation

Pencil on engraved blue stationery; 7⅝ x 4⅞ in. Autograph. Unpublished. (ACH-A21)
Written in pencil (and crossed out) on verso: *W.J. MacPherson 440 Tremont / Please send Mr. Gib*[?] []

Preliminary plan and south elevation with notes on room use. All the essentials of the final building are here, although the tower is too stubby.

21b. Sketch Plan

Brown ink over pencil on engraved blue stationery; 7¾ x 7⅜ in. Autograph. Van Rensselaer, p. 126.
Written in brown ink at bottom: *Common council & circuit court opposite each / other. Balcony for addresses in front*, and at right: *Bridge to Jail*, and at top (upside down): *Gallery bridge / & down stairs to level / by Prison stair or jury stairs*
Lent by Shepley, Bulfinch, Richardson and Abbott

Preliminary sketch plan developed from no. 21a.

21c. Presentation Plan

Red and black pencil, india and red ink and light tan wash on board; 22⅛ x 20⅞ in. Draughtsman. Unpublished. (ACH-A22)
Lettered in ink below: FIRST FLOOR ALBANY CITY HALL (added later)

A draughted presentation plan developed from no. 21b.

21d. Preliminary Perspective

Soft pencil on tracing paper; 13½ x 11½ in. Draughtsman. Unpublished. (formerly UNK-F22)

The third story and gable above entry have not yet appeared, nor has the upper arcade in the center of the main façade, but the tower is unmistakable.

21e-f. Presentation Elevations

21e. Pencil and ink on heavy linen-mounted paper bordered with pasted gray mounting; 39 x 28¾ in. Draughtsman. Unpublished. (ACH-B1)
Lettered in brown ink at bottom: WEST FRONT

21f. Pencil and brown ink on heavy linen-mounted paper bordered with pasted gray mounting; 38⅝ x 27¾ in. Draughtsman. Unpublished. (cf. Van Rensselaer, opp. p. 82). (ACH-B4)
Lettered in black ink at bottom: SOUTH FRONT

Presentation drawings with the building in elevation but the scene in perspective. The executed building was modified somewhat.

21g. Details of Upper Gable and Chimney

Pencil and blue wash (dimensioned in black and red ink) on heavy linen-mounted paper; 49⅜ x 35¾ in. Draughtsman. Unpublished. (ACH-D4)
Lettered in pencil on chimney plaque: *1881*
Signed in ink at left: *M W Nolan / Chairman City Hall Commⁿ / Norcross Brothers*
Written in pencil at bottom: *Scale ¾″ = 1 foot*
Embossed stamp upper left: TO BE RETURNED / TO / H.H. RICHARDSON

21a. Albany City Hall.
Preliminary Sketch Plan and Elevation

21d. Albany City Hall. Preliminary Perspective

133

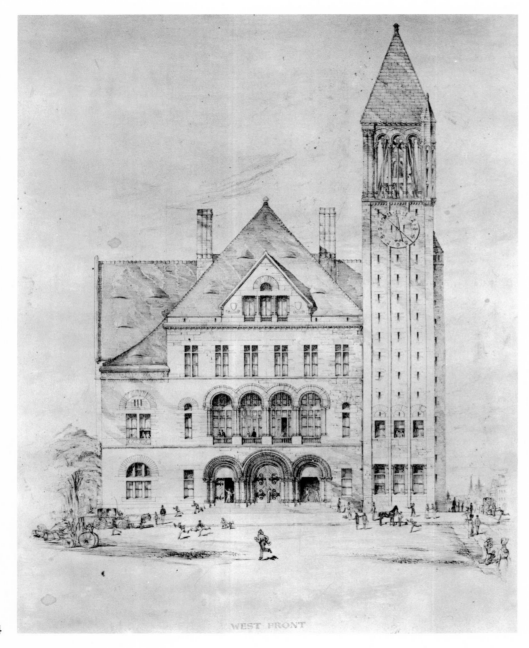

WEST FRONT

21e. Albany City Hall. Presentation Elevation

Richardson was among five architects asked to submit designs for the Allegheny County Court House and Jail to replace a court house destroyed by fire in May 1882. He was notified of his inclusion in the competion on September 28, 1883, plans to be presented on January 1, 1884. At the end of the month he was selected as the architect. On February 9 he wrote to Henry Adams that he "was successful at Pittsburgh in every way . . . ," and on May 27, sent a telegram to Richard Watson Gilder asking him to return his drawings for the Albany Cathedral (cat. no. 2): "My Pittsburgh Commissioners will be with me friday & saturday and wish to see the drawings."

Revised construction drawings were delivered to the Commissioners on July 1, and on September 1, 1884, the contract for construction was awarded to Norcross Brothers. The Jail was completed by 1886. The Court House was finished by Shepley, Rutan and Coolidge and dedicated on September 2, 1888.

Sources: Richard Watson Gilder Papers, Manuscript and Archives Division, The New York Public Library, Astor, Lenox and Tilden Foundations; Hay Correspondence, Hay Library, Brown University; H.H. Richardson, *Description of Drawings for the Proposed New County Buildings for Allegheny County, Penn.,* Boston, 1884; James Van Trump, "The Romanesque Revival in Pittsburgh," *JSAH,* XVI (October 1957), 22 ff.

22a-b. Plans of Court House

22a. Pencil and terra-cotta wash on tracing paper mounted on buff paper with room designations and notations; 19½ x 13¾ in. Draughtsman. Unpublished. (PCH-A31)

22b. Pencil and terra-cotta wash on tracing paper with sketch of section within plan; 21⅞ x 16⅞ in. Draughtsman. Unpublished. (PCH-A41)
Written in pencil in HHR's hand: room designations and, at lower right: *Plan of 3ʳᵈ Story*

Preliminary first and third floor plans of the Court House with pencil notations and changes. The rounded side bays have not yet appeared. The main tower is set back from the main façade and, as shown in the section sketched in the courtyard on no. 22b, has not reached its final height.

22c. Rear Elevation of Court House

Pencil and gray wash with touch of ochre on buff paper; 17⅛ x 13¾ in. Draughtsman. Unpublished. (PCH-B2)

Preliminary study for rear elevation of Court House facing Jail with cross section through the "Bridge of Sighs." The tower has grown from that shown in the section on no. 22b, but has not reached its full height.

22. Allegheny County Buildings, Pittsburgh, 1883-1888

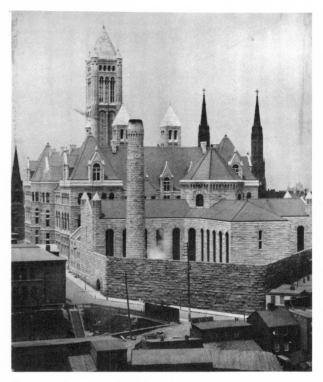

Photograph ca. 1890 (HCL)

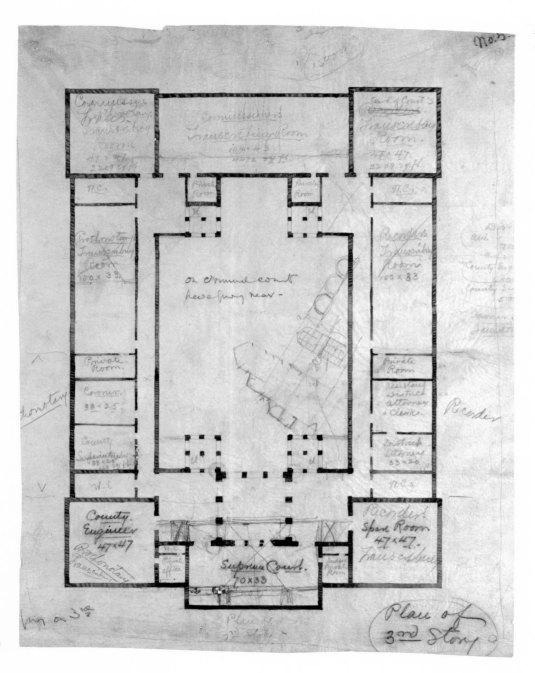

136

22d. Main Elevation of Court House

Brown ink on joined linen-mounted paper; 51 x 39½ in. Draughtsman. Unpublished.
Lent by Shepley, Bulfinch, Richardson and Abbott

A presentation drawing of the design that won the competition, but not the design erected. This drawing, with building in elevation and street scene in perspective, corresponds to the design shown in perspective vignette in HHR's *Description of Drawings for . . . Buildings for Allegheny County* (p. 28). The main tower is buried in the mass of the building and the center of the façade is occupied by a gabled salient. The tower design is not final.

In the *mise-en-scène* at left is the F.L. Ames Store in Boston (cat. no. 18), apparently a whimsy of the draughtsman.

22e. Section of Court House

Brown ink on two joined sheets of heavy linen-mounted paper bordered at bottom with pasted gray mounting; 34⅞ x 34 in. (cut down). Draughtsman. Unpublished. (PCH-C2)
Lettered in brown ink at bottom: DESIGN / FOR / NEW COUNTY BUILDINGS / ALLEGHENY COUNTY, PENN. / TRANSVERSE SECTION / ⅛ SCALE

Presentation drawing of section through courtyard of Court House looking toward Jail.

22f. Main Elevation of Court House (see color plate)

Pencil, blue and terra-cotta wash on tracing paper; 19⅞ x 13¼ in. Draughtsman. Unpublished. (PCH-B7)

The competition has been won but study goes on. The gabled salient is eliminated, the triple-arched entrance broadened, and the tower is placed forward and rises from the front face of the building. In the final design it will move even farther out, rising from the entry itself.

22g-h. Studies for Court House Tower

22g. Pencil on tracing paper; 17 x 5½ in. Draughtsman. Unpublished. (PCH-D15)

22h. Pencil on watercolor paper; 22½ x 6 in. Draughtsman. Unpublished. (PCH-D3)

The clock does not appear on the structure as erected.

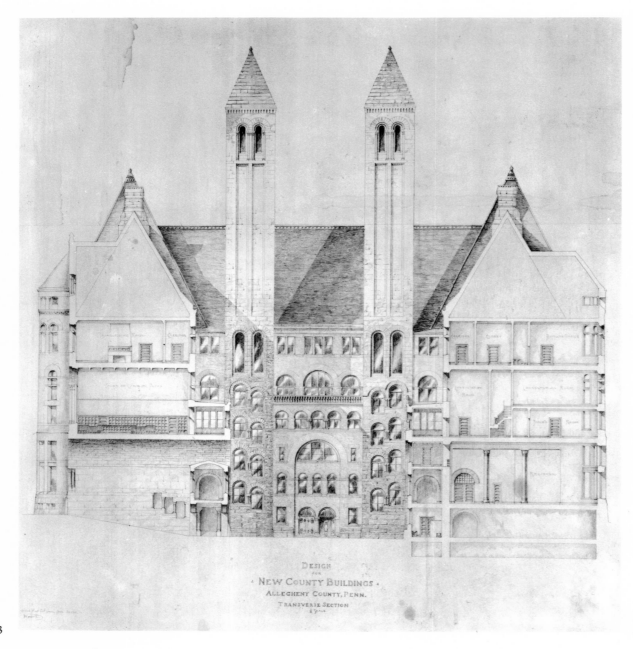

DESIGN
for
NEW COUNTY BUILDINGS
ALLEGHENY COUNTY, PENN.
TRANSVERSE SECTION

22e. Allegheny County Court House.
Section

22i. Perspective of Tower

Black ink on board (?); 32¾ x 8½ in. (sight). Draughtsman. Van Rensselaer, p. 92.
Lent by Shepley, Bulfinch, Richardson and Abbott

Presentation drawing of the Court House tower as built.

22j. Detail of Court House Entrance Arch

Pencil and light brown wash on tracing paper with scale figure; 12⅝ x 23¾ in. Draughtsman. Unpublished. (PCH-D109)
Written in pencil at left: *Look for your / Abaci*

Elevation study of entrance arches for Court House, with additional section through pier.

22k-w. Studies for Court House Capitals

22k. Black ink on tracing paper; 5¾ x 4⅛ in. Draughtsman. Unpublished. (PCH-D169)

22l. Black ink on tracing paper (dimensioned); 6¼ x 4¼ in. Draughtsman. Unpublished. (PCH-D170)

22m. Black ink on tracing paper; 5 x 4½ in. Draughtsman. Unpublished. (PCH-D171)

22n. Black ink on tracing paper; 5¾ x 4¾ in. Draughtsman. Unpublished. (PCH-D172)

22o. Black ink on tracing paper; 5½ x 4 in. Draughtsman. Unpublished. (PCH-D173)

22p. Black ink on tracing paper; 5½ x 4½ in. Draughtsman. Unpublished. (PCH-D174)

22q. Black ink on tracing paper; 6⅝ x 4⅜ in. Draughtsman. Unpublished. (PCH-D175)

22r. Black ink on tracing paper; 6⅞ x 8½ in. Draughtsman. Unpublished. (PCH-D151)
Lettered in black ink at bottom: ALLEGHENY COUNTY COURT HOUSE / CAPS TO PIERS OF SECOND STORY WINDOWS / SCALE 1 IN. = 1FT.

22l. Allegheny County Court House. Study for Capital

139

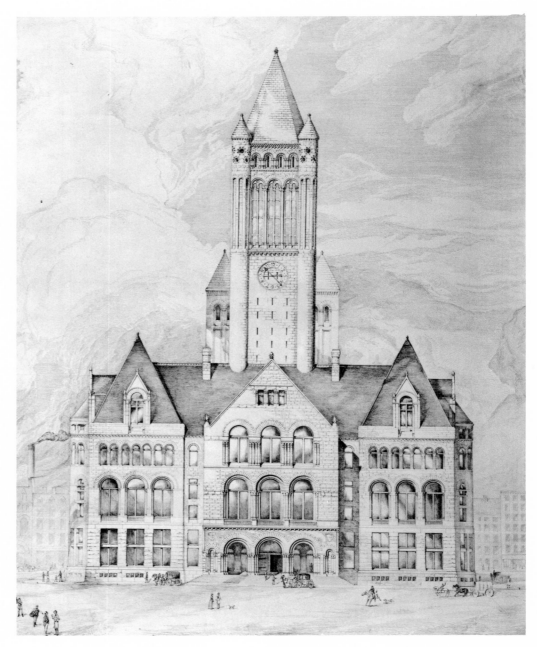

140 *22d. Allegheny County Court House. Main Elevation*

22s. Black ink on tracing paper (dimensioned); 9¾ x 8⅛ in. Draughtsman. Unpublished. (PCH-D152)
Lettered in black ink at bottom: ALLEGHENY COUNTY COURT HOUSE / CAPS TO PIERS OF SECOND STORY WINDOWS / SCALE 1 IN. = 1FT.

22t. Black ink on tracing paper; 7 x 6½ in. Draughtsman. Unpublished. (PCH-D148)
Lettered in black ink at bottom: ALLEGHENY COUNTY COURT HOUSE / CAPS TO PIERS OF SECOND STORY WINDOWS / SCALE 1 IN. = 1FT.

22u. Brown ink on tracing paper; 4⅞ x 5⅛ in. Draughtsman. Unpublished. (PCH-D154)

22v. Brown ink on tracing paper; 9⅞ x 8⅛ in. Draughtsman. Unpublished. (PCH-D155)
Written in pencil at left: *S. R. & C*, and at right: *Take out / Beads*
Embossed stamp: TO BE RETURNED / TO / H.H. RICHARDSON

22w. Brown ink on tracing paper; 6 x 6 in. Draughtsman. Unpublished. (cf. Van Rensselaer, p. 90). (PCH-D156)

22x. Presentation Section through Court House and Jail

Brown ink on joined linen-mounted paper; 35¾ x 65 in. Draughtsman. Unpublished. (PCH-C1)
Lettered in brown ink at bottom: DESIGN / FOR / NEW COUNTY BUILDINGS / ALLEGHENY COUNTY / PENN. / LONGITUDINAL SECTION / ⅛ SCALE, and on sections: room designations.

Off-center section with elevation of "Bridge of Sighs" connecting Court House and Jail.

22y. Plan of Jail

Pencil and terra-cotta wash on tracing paper; 16 x 15¼ in. Draughtsman. Unpublished. (PJ-A25)
Written in pencil upper right: *Note / Witness rooms in front . . . / may be changed . . . / where the rooms are . . . / enough* [sheet cut off]

Preliminary plan of Jail at ground level. This does not correspond to the upper level plan published in Van Rensselaer, p. 93. The vertical arm here is longer, extending to the smokestack at the point of the walled yard. Note L-shaped domicile at lower right.

22v. Allegheny County Court House. Study for Capital

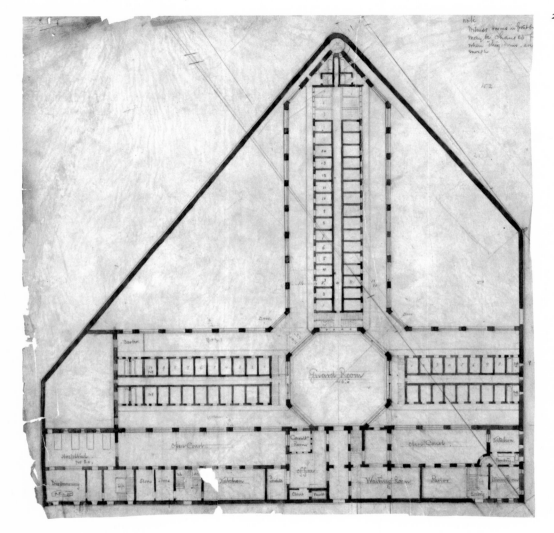

22z. Elevation of Jail

Pencil on tracing paper; 14½ x 23½ in. (irregular, torn and mended). Draughtsman. Unpublished. (PJ-B9)

Preliminary study of the Jail facing the Court House with cross section through the "Bridge of Sighs." Drawn in reverse.

EDUCATIONAL BUILDINGS

Other than the demolished High School in Worcester, 1869-1870, which is important as the first building erected for Richardson by Norcross Brothers, the architect's buildings for educational use were created for his alma mater under the aegis of his friend E.W. Hooper. The differences between Sever and Austin Halls, which were designed only some two years apart, stem from two causes. First, in the Harvard Yard Richardson felt the need to adapt Sever Hall to the existing brick Georgian buildings; in designing Austin Hall, located north of the Yard, he suffered no such constraint. The second reason may be the more important. Sever was built with a fixed sum left by a deceased donor who could not be coaxed for more money; Austin's donor was alive and hence vulnerable to the wiles of Dean Langdell, Richardson and Hooper. Edward Austin's building cost half again as much as the late Anne Sever's.

23. Sever Hall, Harvard University, Cambridge, 1878-1880

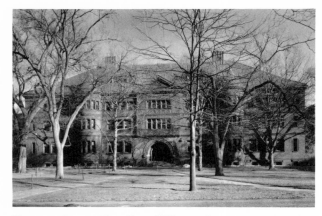

Photograph 1963 (Jean Baer O'Gorman)

By her will of January 22, 1877, Mrs. Anne E. P. Sever left $100,000 to Harvard for "the erection of a dormitory or other building for the use of the under-graduates of the University . . . to be called Sever Hall in memory of my late husband." She also left $20,000 for a library in the building, and another $20,000 unrestricted. In fact, as the *Boston Sunday Herald* reported on December 23, 1877, her will merely reaffirmed that of her husband, the shipmaster, financier and politician James Warren Sever (1798-1871; Harvard '17), who had in his own testament provided for a Harvard building if his wife did not survive him. Sever was already the donor of scholarships to the College.

On April 29, 1878, the President and Fellows voted "that a committee be appointed to build Sever Hall, with the authority to invite Mr. H.H. Richardson to be the architect thereof." The committee consisted of John Quincy Adams (Henry Adams' brother) and Edward W. Hooper, Harvard Treasurer (see Introduction and cat. nos. 8, 13 and 24), who wrote to his friend Richardson on the same day, asking him to name a date early in May for a "full conference." As late as May 17, the location of the building was still undecided. On October 7, Hooper reported to the Corporation that he had received from Mrs. Sever's executors $140,000. Van Rensselaer gives October as the date the commission entered the office, but Richardson had already been thinking about the building for five months.

Working drawings were prepared in the winter of 1878-1879, and the contract awarded to Norcross in the spring. Work commenced in May 1879. The Corporation on January 26, 1880, approved a request by the Faculty to use the upper floor and attic for Class Day, usually held in June. The building was in use by fall of that year. On September 26, 1881, the building committee reported to the Corporation "that their work was finished, and that all bills had been paid" from the Sever Fund, in which "a small balance would remain for any improvements that may be needed." Furnishings not in the original contract exceeding $11,000 were to be paid from the unrestricted Sever gift.

Richardson received $5,000 commission plus $1,200 for supervising and $125 for copying plans, etc. The latter figure was paid by Hooper personally.

Sources: Harvard University Archives: folders relating to J.W. Sever and Sever Hall, Hooper Correspondence (Copy Books) for 1876-1880 and 1880-1883, College Records, vols. 12 and 13; *Annual Report of the President and Treasurer of Harvard College, 1878-1879*, Cambridge, 1880, pp. 40-41.

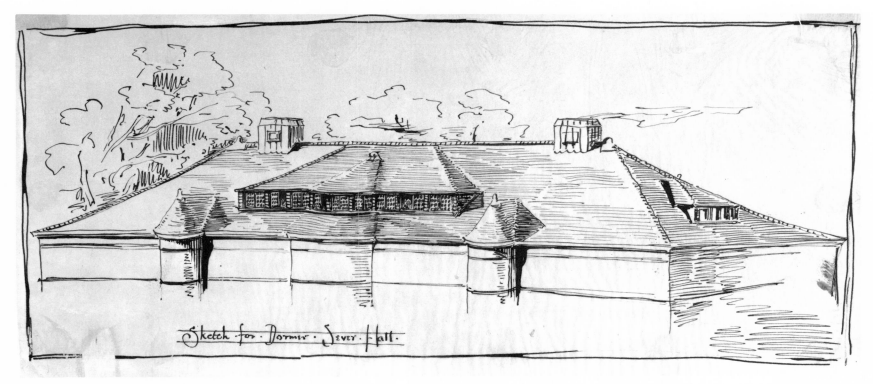

23b. Sever Hall. Perspective Study for Roof and East Dormer

23a. Plan (Contract Drawing)

Black ink and terra-cotta wash on buff linen-mounted paper (dimensioned in red and black ink); 28½ x 48¾ in. Charles H. Rutan? Unpublished. (SH-A4) Lettered in black ink upper left: SEVER HALL / CAMBRIDGE MASS / SCALE ¼ IN = ONE FT, and at bottom: THIRD STORY PLAN
Signed in brown ink at bottom: *J.Q. Adams*
E.W. Hooper } *Committee*
Norcross Brothers

23b-d. Perspective Studies of Roof and East Dormer

23b. Ink with freehand border on tracing paper; 7⅝ x 16¾ in. Draughtsman. Unpublished. (SH-D2)
Lettered in black ink at bottom: SKETCH FOR DORMER SEVER HALL

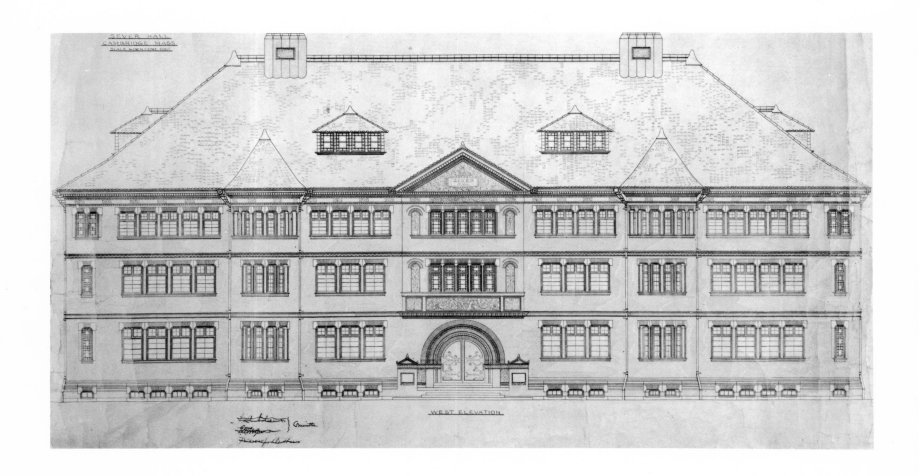

WEST ELEVATION

23c. Ink with freehand border on tracing paper; 6⅝ x 16 in. Draughtsman. Unpublished. (SH-D3)
Lettered in black ink upper right: SEVER / HALL

23d. Ink with freehand border on tracing paper; 6⅝ x 15½ in. Draughtsman. Unpublished. (SH-D1)
Lettered in black ink upper right: SEVER / HALL

Sever's simplified roofscape was the result of intense study by HHR's office.

23e. Elevation

Black ink on heavy linen-mounted paper; 28½ x 48¼ in. Charles H. Rutan? (SH-B1)
Lettered in black ink upper left: SEVER HALL / CAMBRIDGE MASS. / SCALE ¼ INCH = ONE FOOT, and below: WEST ELEVATION
Signed in brown ink (and crossed out) lower left: *J.Q. Adams* ⎫
 E.W. Hooper ⎬ *Committee*
 Norcross Brothers ⎭

Draughted elevation much as built except for some elimination and some changes in the foliate decoration of the central area. The awkward aediculae flanking the entrance arch were never executed.

23f-i. Studies of Ornament and Sheet Metal Downspouts

23f. Brown ink and pencil on tracing paper; 10 x 4⅞ in. Draughtsman. Unpublished (cf. Wendell D. Garrett *et al., The Arts in America, The Nineteenth Century*, New York, 1969, p. 126). (formerly UNK-D6)

23g. Brown ink on tracing paper; 4¼ x 3¼ in. Draughtsman. Unpublished. (formerly UNK-D3)

23h. Pencil on tracing paper; 3⅞ x 3¾ in. Draughtsman. Unpublished. (formerly UNK-D4)

23i. Pencil on tracing paper; 7 x 4¼ in. Draughtsman. Unpublished. (formerly UNK-D2)

23f. Sever Hall. Study for Downspouts

24. Austin Hall, Harvard University, Cambridge, 1880-1884

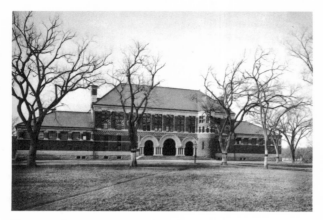

Photograph 1885 (Monographs of American Architecture I, Boston, 1885)

A clipping in the Harvard University Archives from an unidentified newspaper, dated October 31, 1882 in pencil on the mount, relates that in the early winter of 1880-1881 an unnamed "gentleman" offered President Charles W. Eliot $100,000 to erect a law school. "For many months, however . . . it was impossible for the donor, the authorities of the law school and the architect . . . to agree upon any design. Conformity came, however . . . by mutual sacrifice. The donor gave a little more money, the law school authorities yielded some of their ideas, and trifling modifications in the specifications were made by the architect. The contract . . . was awarded to Norcross . . . and early spring of the current year work on the structure, which has now risen to the height of the second story, was fairly begun."

Available documentation seems to confirm this story. Dean Christopher Columbus Langdell expressed the need for a new building in his report to the President in 1879. Van Rensselaer gives February 1881, as the date of commission. There is an enigmatic letter from the donor, Edward Austin, to President Eliot dated February 16, 1881 (filed in the Eliot correspondence under 1886, clearly an error): "The logic of your note . . . is quite a puzzle . . . 'When you are free from the trouble, and annoyance, of that which you have undertaken, by all means undertake another of same kind.' To my mind such a person should be well trounced for his fondness for troubled waters." More than a year later, on April 11, 1882, Edward W. Hooper, Harvard Treasurer (see Introduction and cat. nos. 8, 13 and 23), wrote to Austin that "Mr. Norcross has just given me his figures for the new Law School building, and they settle the question. . . . We cannot at the present price of labor and material build it according to the plan for less than one hundred & fifty thousand dollars, and we cannot much reduce the price without spoiling the building. . . . Mr. Norcross tells me that the plan is a simple one for a substantial and handsome building of stone, and that the cost is due to its size. The Law School professors are confident that a smaller building will not long answer the purposes of the School. I shall not ask you to increase the sum already named by you. . . . I shall only ask that we may go to you again in case we shall need for some other use a smaller building which can be well and handsomely built within the sum. . . ."

Hooper's letter had what was undoubtedly the desired effect. Austin made a more generous offer, and presumably the other compromises mentioned in the newspaper account did occur, because on April 24, 1882, Hooper reported to the Corporation "an offer from Edward Austin Esq. to give to the College on or about the first day of July next, the sum of one hundred and thirty five thousand dollars for the erection of a new building for the Law School, in consideration of certain agreements to be entered into by the Corporation in

relation to such building. . . ." The President and Fellows accepted the offer, agreeing to carry out Austin's itemized wishes:

1st That the Corporation will as soon as possible before said first day of July contract at its own risk with Messrs. Norcross Brothers for the entire construction of a building for the Law School in accordance with the plans of Mr. H.H. Richardson which were submitted to and approved by Mr. Austin on April 22d instant; no modification of the outside of the building as shown upon the plans to be made without Mr. Austin's consent, except the substitution of a slated roof for the tiles and terra cotta.

2d That the changes of plan to be made for the inside of the building to reduce its cost shall not extend to any alterations of the entry ways so as to remove the polished granite columns or faced brick arches, nor to any alteration of the design for the large reading room, beyond the substitution of plaster for sheathing between the roof beams. . . .

3d That no building shall be hereafter erected by the College within sixty feet of any part of this Law School building. . . .

The Corporation then voted to call the Law School Austin Hall according to Edward Austin's "expressed wish that the building shall stand as a memorial" to his elder brother, Samuel Austin.

According to this agreement, the building was to be given to Norcross before the first of July. The newspaper account suggests that construction began soon after the acceptance of Austin's gift. Hooper reported to the Corporation on September 26, 1882, receipt of $135,000.

The building opened for students a year later, despite the fact that it was not entirely completed. On September 14, 1883, Hooper barked a number of orders at Norcross: "The Law School term begins . . . Sept 27th. Every workman must be out of the building [on the] evening [of] Sept 26th. The large reading room must be clean and ready for the carpet layers on . . . Sept 24th. The tables must be put in place in large room as soon as the carpet is laid, and the gas standards fitted to them as fast as they are in place. . . . You can work in the lower part of the building up to Sept 26th, except that the wing lecture rooms must be ready to receive furniture on or before Sept 20th. We have no time to spare, and I am particularly anxious about the fireplace in large reading room."

Hooper's anxiety was well founded. The fireplace was not finished in time, nor were interior painting, the demolition of Holmes House obstructing the view of the building, and the carving of the exterior inscription. These points dominate subsequent correspondence between the Treasurer and the donor. First, Hooper wrote on July 15, 1884, that "Mr. Richardson and I . . . have

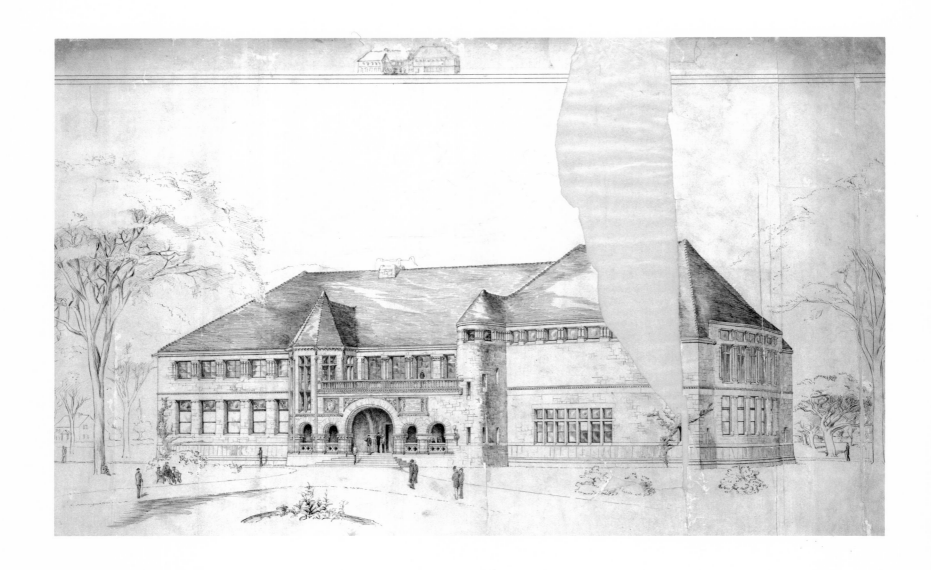

150 24b. *Austin Hall. Presentation Perspective of South Front*

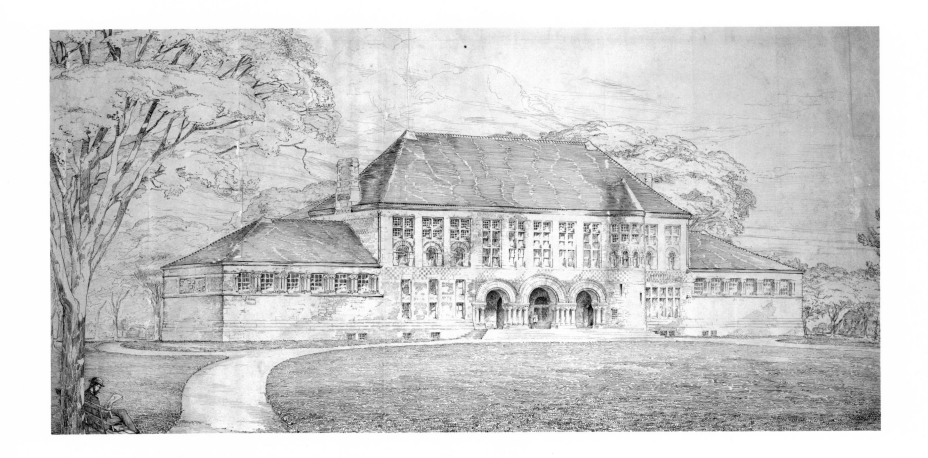

24d. Austin Hall. Presentation Perspective of South Front

24h. Austin Hall. Study for Polychrome Stonework

decided many points as to colors, shades &c with a view of not injuring our light. . . . We think water colors suitable for ceilings, but oil color necessary for the walls. . . . Holmes House . . . is to be torn down at once. The stone cutters are at work upon the large stone mantel piece, but will show you the model of the ornamental carving before they get to that part of the work. . . ." On October 31, 1884, Hooper wrote Austin that "I have just closed the accounts of Austin Hall. . . . The carving of the great fire-place is done, and everything else that we have agreed upon, except the carving of the outside inscription. . . . I hope you will soon go out to Cambridge and look at the building, unless you have seen it since the Holmes House was taken away. The students . . . propose to keep a wood-fire in the great fire-place as soon as we can have some andirons made." On November 24, Hooper reported Austin's gift of $3000 to pay for the demolition of Holmes House.

For the exterior inscription Austin wanted raised Old English lettering, a fact that Hooper reported to Richardson. The architect gently but firmly countered. "He said he was very sure," Hooper wrote to Austin on November 10, 1884, "that Roman letters, cut in with a deep V cut, would go better with the style of the building. He thinks it essential to the proper effect to keep that white band of stone 'rock-faced,' which he can do with a V cut letter, but not with a raised letter. He also objects to old English for his style of architecture. . . ." Having laid the question of lettering style to rest, it remained only to put off carving the inscription until spring. Hooper reported to Austin on December 10, 1884, that "Mr Richardson and Mr [John] Evans the carver" have postponed cutting the inscription "on account of uncertainty as to weather."

In the spring of 1885 Austin donated an additional $2,500 to paint the interior, and was told by Hooper on June 29, 1885, that the work would be finished by the fall.

Edward Austin's gifts for Austin Hall amounted to $140,500 (plus interest), as Hooper reminded him on June 18, 1885. This was a handsome donation for the Beacon Hill merchant who had not attended Harvard. At his death he overshadowed it with another half million dollars for scholarships.

Richardson received $9529.58 for his work. Hooper sent him his final payment on November 1, 1884 (the day after he told Austin he had closed the building account), "the balance due for commission & expenses at seven per cent on cost as agreed." He included the following statement:

Amount paid Norcross Bros. as per contract
(including furniture designed by H.H.R. *$134,788.75*
(including stone $112 & insurance $90.)

Surveying bill	*20.*
Shreve Crump & Low for Standards	*313.75*
Hollings — extra gas fitting &c	*128.37*
Evans & Tombs — carving fire-place — & "Austin Hall."	*886.06*
	136,136.93
Pd. H.H.R. at sundry dates	*$9364.20*
Bal. by check herewith	*165.38*

Grading &c was done by the College servants.

This remarkable cache of documents brings together the multiple participants — the donor Edward Austin, and the Harvard Corporation in the person of Edward W. Hooper; the contractor Norcross Brothers; the architect Richardson; and the stone carver John Evans. All had a hand in the process of decision-making that resulted in Austin Hall, but E.W. Hooper emerges as the all-important arbiter.

Sources: Harvard University Archives: Eliot Papers for 1885 and 1886, Hooper Correspondence (Copy Books) for 1880-1883 and 1883-1887, College Records, vol. 13, and a folder on Austin Hall; *Annual Report of the President and Treasurer of Harvard College, 1878-1879*, Cambridge, 1880, pp. 83-86.

24a. Elevation of South Front

Pencil, brown ink and wash on tracing paper; 15½ x 22½ in. Draughtsman. Unpublished. (AH-B27)

Draughted elevation of the first stage of the design, with asymmetrical plan and massing, two turrets (polygonal to left, round to right) and single-arched entry.

24b. Perspective of South Front

Brown ink and pencil with triple line border on heavy white paper; 35½ x 18⅛ in. (sheet torn and mended, with losses). Autograph and draughtsman. Unpublished.
Lent by the Harvard Law School (ø0.94.5)

Presentation perspective of a design developed from the elevation in no. 24a. The massing is the same, but details have been altered. HHR penciled in a change in the size of the squat chimney at the ridge, and unsatisfied with the overall proportions of the building, at the top sketched in pencil a thumbnail perspective with lower, more massive, ground-hugging proportions.

24g. Austin Hall. Study for Polychrome Stonework

153

24e. Austin Hall. Study for Polychrome Stonework

24c. Elevation of South Front

Pencil and gray wash on tracing paper; profile of capital in pencil upper right; 12 x 23¼ in. (sheet irregular). Draughtsman. Unpublished. (AH-B7)

Elevation study for a design rather close to the building as erected, except for the high central roof peak.

24d. Perspective of South Front

Brown ink on heavy paper; 31⅛ x 15½ in. Dated *1882* on chimney. Draughtsman. Unpublished.
Lent by the Harvard Law School (∅0.133.D)

Presentation perspective of the building nearly as erected. Changes still to occur include a date one year later on the existing chimney, colonnettes framing the window depressions and the mullions of the upper windows treated as colonnettes. It should be noted that even in this finished presentation drawing HHR's office makes no attempt to capture the quality of stonework.

24e-i. Studies for Polychrome Stonework

24e. Pencil, brown and black wash on linen; 13 x 10¼ in. Draughtsman. Unpublished. (AH-D131)

24f. Pencil, gray and terra-cotta wash on tracing paper; 8⅞ x 8⅞ in. Draughtsman. Unpublished. (AH-D103)
Written in pencil lower right: *Law School Studies.*

24g. Pencil, gray and terra-cotta wash on linen; 7⅝ x 6⅜ in. Draughtsman. Unpublished. (AH-D126)
Written in pencil lower right: *changed*

24h. Pencil, gray and terra-cotta wash on tracing paper; 9⅛ x 10⅛ in. Draughtsman. Unpublished. (AH-D130)

24i. Pencil and terra-cotta wash on buff paper; 13⅜ x 6½ in. (sheet irregular). Draughtsman. Unpublished. (AH-D132)

A series of studies of decorative polychrome exterior stonework.

LIBRARY BUILDINGS

Most of Richardson's libraries were designed to house not only books. They were in fact community cultural centers, containing bookroom, natural history museum, art museum and lecture space. They reflect the late nineteenth-century flowering of popular education in this country paralleled by the Chautauqua and other mass cultural movements. They also served as memorials to men who had helped build small-town America.

The library is one of the two building types by which Richardson is best known. This would surprise nineteenth-century members of the American Library Association who fought against the monumental bookrooms surrounded with tiered alcoves that form the core of Richardson's buildings. After the installation of the hidden metallic bookstack at Harvard's Gore Hall (Ware and Van Brunt, 1874-1877), certainly known to Richardson, such spatial posturing in library design was transferred from storage area to reading room (cf. Bates Hall in the Boston Public Library by McKim, Mead & White, 1888 *et seq.*).

25. Winn Memorial Library, Woburn, Massachusetts, 1876-1879

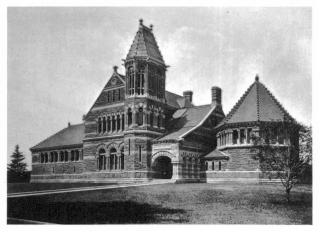

Photograph 1880's (HCL)

Charles Bowers Winn (1838-1875), a leather merchant, willed funds for a building to honor his father, Jonathan Bowers Winn (1811-1873), founder of the Woburn Public Library in the 1850's. Charles Winn's legacy was officially accepted by the town on February 17, 1876, and John Johnson, Parker L. Converse and Edward D. Hayden appointed executors.

Winn's will stipulated that the building house both books and "oil paintings," and that a competition be held to determine the architect. The competitors included Gambrill & Richardson, Cummings and Sears, Ware and Van Brunt, Peabody and Stearns, and Snell and Gregorson. Presentation drawings were prepared during 1876; by the end of the year Richardson was waiting impatiently for the result. On November 26 he wrote Olmsted that he had "heard nothing from Woburn"; on December 15 he had still heard "nothing positive from Woburn yet." The accepted design was published in *AABN*, March 3, 1877.

Working drawings were prepared immediately, for on May 2 the architect wrote Olmsted that he was "very busy getting estimates for Woburn." Norcross signed the contract for an initial sum of $71,625.50 on May 22. T.M. Clark superintended construction. John Evans carved the clock face above the reading room fireplace. The library was moving into its new quarters by October 1878, but the building was not opened to the public until May 1, 1879.

Sources: Olmsted Papers, General Correspondence, Library of Congress, Box 14; letters in possession of SBRA; *AABN*, II (March 3, 1877), 68; "The Woburn Public Library," *The Woburn Journal*, November 18, 1881; *Annual Reports of the Library Committee of the Town of Woburn*, 1875 *et seq.*; William R. Cutter, "A Model Village Library," *New England Magazine*, n.s. II (February 1890), 617-625.

25a. Presentation Plan

Black and red ink and light tan wash within triple-line border on stiff paper, with light pencil notation (red sticker pasted upper right); 21 x 35½ in. Draughtsman. Unpublished. (WML-A2)
Lettered in black ink at bottom: FIRST STORY PLAN
Signed in brown ink lower right: *Gambrill & Richardson*

Presentation, probably competition, drawing presented in the fall of 1876. The executed building closely follows this plan.

25b-c. Plans

25b. Black and blue inks and color washes on heavy linen-mounted paper (dimensioned in black and red ink); 27 x 46 in. Draughtsman. Unpublished. (WML-A5)

Lettered in black ink lower left: LIBRARY / AT / WOBURN MASS / FIRST STORY PLAN / SCALE ¼ IN = ONE FT.

NOTE	RED	INDICATES	BRICKWORK
	PURPLE	"	LONGMEADOW ASHLAR
	BLUE	"	CUT LONGMEADOW
	SIENNA	"	OHIO STONE
	YELLOW	"	WOODWORK

Signed in brown ink lower right: *John Johnson* } *Committee*
 Parker L. Converse } *of*
 E. D. Hayden } *Town of Woburn*

Lettered in ink on plan: room uses and interior finishes.
In pencil on verso: *Woburn Library / D.A.N.*

25c. Black and blue inks and color washes on heavy linen-mounted paper (dimensioned in black and red ink); 24⅞ x 42¾ in. (edges frayed). Draughtsman. Unpublished. (WML-A6)

Lettered in black ink lower left: LIBRARY / AT / WOBURN MASS / SCALE ¼ INCH = 1 FT. / GALLERY PLAN OF LIBRARY, and lower right: SECOND STORY PLAN / PLAN OF MUSEUM / THROUGH WINDOWS, and lower left:

NOTE	RED	INDICATES	BRICK WORK
	PURPLE	"	LONGMEADOW ASHLAR
	BLUE	"	CUT LONGMEADOW
	YELLOW	"	WOODWORK

Signed in ink lower right: *John Johnson* } *Committee*
 Parker L. Converse } *of*
 E.D. Hayden } *T of Woburn*

On verso: light sketches of shells.

25d. Elevations

Black and blue inks and polychrome washes on heavy linen-mounted paper (overlay of window grouping at left); 27⅜ x 46 in. (edges frayed and mended). Draughtsman. Unpublished. (WML-B5)

Lettered in black ink at bottom: WINN LIBRARY / AT / WOBURN MASS / SIDE ELEVATIONS / ¼ INCH SCALE, and in blue ink below basement windows: BLUE LINES ADDED AFTER DRAWING WAS SIGNED

Signed in ink lower right: *John Johnson* } *Committee*
 Parker L. Converse } *of*
 E.D. Hayden } *Town of Woburn*

Nos. 25b and 25d are part of the set of construction documents prepared during March, April and May 1877. Iron beams and angles are among the building materials.

25a. Winn Memorial Library. Presentation First Story Plan

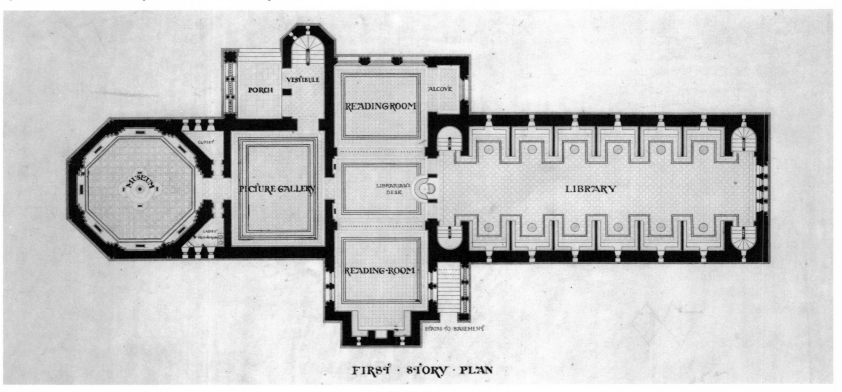

FIRST · STORY · PLAN

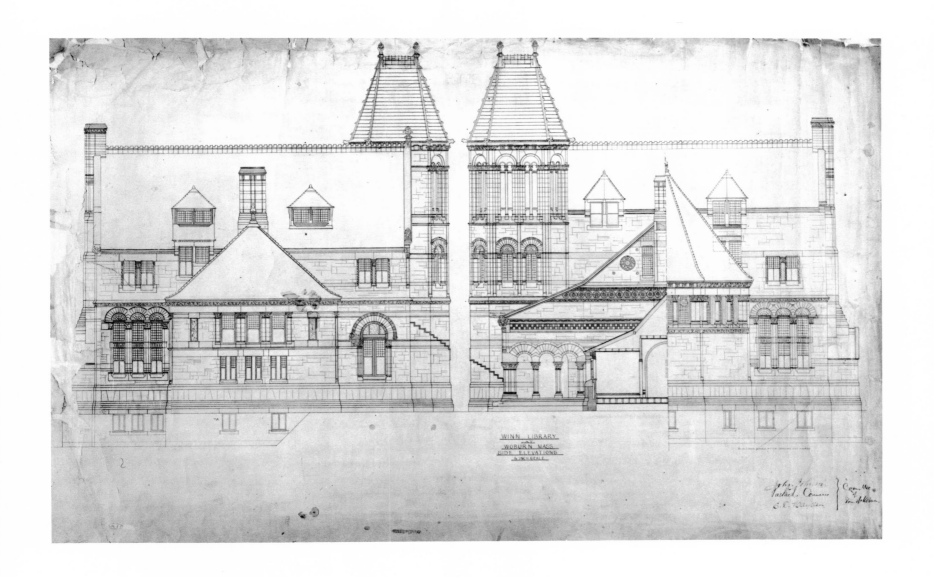

WINN LIBRARY
WOBURN MASS
SIDE ELEVATIONS
½ INCH SCALE

25d. Winn Memorial Libarary. Elevations

26. Crane Memorial Library, Quincy, Massachusetts, 1880-1882

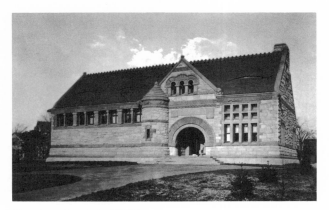

Photograph 1880's (HCL)

On February 20, 1880, Albert Crane of New York offered the town a library dedicated to his father, Thomas Crane (1803-1875), a New York dealer in Quincy granite. The Crane family picked the architect, perhaps at the suggestion of Charles Francis Adams, Jr., chairman of the Building Committee. On April 12, Crane, Richardson, Adams and the town's selectmen met in Quincy to discuss the architect's fee. Construction began in December.

On June 7, 1881, Richardson wrote Augustus Saint-Gaudens, asking him to make a "bronze medallion portrait [of Thomas Crane] to be placed in the wall over the mantel at the east end of the reading room. . . . The chimney stand [*sic*] at the end of the building & light comes in upon it from ample windows on the n. s. & w. The reading room and bookroom form really one large hall with but a light screen between. . . . The entire finish of the building is in yellow pine." Richardson forwarded the contract between Crane and Saint-Gaudens to the sculptor in December, but no portrait was executed.

The building was dedicated on May 30, 1882, with Richardson speaking briefly.

Sources: Saint-Gaudens Papers, Baker Library, Dartmouth College, Box 16; *Address of Charles Francis Adams, Jr. and Proceedings at the Dedication of the Crane Memorial Hall, at Quincy, Mass., May 30, 1882*, Cambridge, Mass., 1883 (a presentation copy is among the books from HHR's library preserved in the Frances Loeb Library, Gund Hall, Harvard Graduate School of Design); L. Draper Hill, Jr., *The Crane Library*, Quincy, 1962.

26a. Plan

Pencil and brown wash on tracing paper with light figuring and notations; 17½ x 24¼ in. Draughtsman. Hill, pl. [8]. (CLQ-A5)
Written in pencil at bottom: *Move this staircase / out farther — So / as to get some support for the arch*
Lettered in ink lower right: CRANE

One of a series produced between April and September 1880. Discussed by Hill as his second-stage plan. At this stage, a lecture hall was part of the program, and the bookstack was given a separate wing.

26b. Plan with Sketch of Elevation

Pencil and pale washes on tracing paper with light pencil figuring; 18½ x 29½ in. (sheet torn and mended; loss lower right). Autograph and draughtsman. Hill, pls. [5] - [6]. (CLQ-A6)
Lettered in pencil at bottom: FIRST FLOOR PLAN / SCALE ⅛ IN. = 1 FT., and in ink: CRANE

This is Hill's third-stage plan. The thumbnail perspective in soft pencil upper right is probably autograph, HHR here visualizing the three-dimensional effects of his assistant's layout. The projecting bookstack was absorbed into the mass of the building as finally built.

26c. Plan and Elevation

Pencil on engraved blue stationery with pencil notations; 7⅝ x 4⅞ in. Autograph. Unpublished. (formerly UNK-F25)
Written in pencil: *Paper 10c + 8c / lunch 10c + 5c / Fare 10.00 / See Norcross / about clock face & memorial / Write Olmsted-Gurney / & Bond / telegraph / Olmsted / Write Cheney / C. H. Dalton / Edmund Dwight / Rectory finish 3" wide*
Written in pencil on verso: *Sending stairs & description granite / Cols / Marble in Executive / Chamber(?) — shall / I Put any in / Desks & / Chairs for Com: / Eidlitz / Simpson [?] / See about fire / place in Ante room / for Lt Gov^r / Finish of Lt Gov- / rooms & Clerk / rooms- / Write Dorsheimer*

Sketch plan and elevation of a small library. The notes date the sheet about 1880: the Governor's Room at Albany bears that date (cat. no. 20); Dalton and Dwight were members of the Boston Park Board for whom Richardson designed the bridges in the Fens in 1880 (cat. no. 38); Trinity Rectory was finished in that year (cat. no. 5). The Crane was the only library Richardson designed between 1877 and 1883, so this sheet must relate to that commission.

Hill's arrangement of the series of preliminary plans shows the evolution of the design as a characteristic process of simplification. This newly identified scheme fits easily between his third- (here labelled 26b) and fourth-stage plans, making it the next to last recognized stage in the evolution. The stack wing has been eliminated, but the final overall rectangle in plan and the contained gable and tower in elevation have not yet appeared.

26d. Perspective

Pencil on engraved blue stationery; 4⅞ x 7¾ in. Autograph. Hill, pl. [7]; Hitchcock 1966, pl. 64. (CLQ-F1)
Written in pencil lower right: *Rear Quincy Library*

Hitchcock noted long ago the seventeenth-century character of the design shown here, as well as the fact that it could have been executed in wood as well as stone (no material is suggested). HHR's interest is in shapes and silhouette; the look of materials could not be rendered in such a sketch. This view of the building has been obscured by later additions.

26c. Crane Memorial Library. Sketch Plan and Elevation

27. Billings Memorial Library, University of Vermont, Burlington, 1883-1886 et seq.

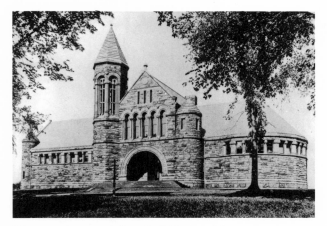

Photograph 1886 (Robert Hull Fleming Museum, University of Vermont)

The library was named for its donor, Frederick Billings (1823-1890; U. Vt. '44), lawyer and former president of the Northern Pacific Railroad. It was built to house the collection of some 12,000 volumes acquired by Billings for the University from the estate of George Perkins Marsh (1801-1882), scholar, congressman and U.S. Ambassador to Italy from 1861 until his death.

Billings' initial gift was $85,000; he eventually spent $150,000. Through President Matthew H. Buckham the donor played an active role in the design process. Richardson's Winn Memorial (cat. no. 25) was the model.

After consulting a number of architects, Billings chose Richardson in the spring of 1883. He wrote to President Buckham on May 17:

". . . For exterior and interior effect the Richardson idea seems to me superior to any other plan; — a parallelogram for the main library on the left — the Marsh Library on the right, and the interior for the working part, with a large open fire place, and spaces for portraits would be to my mind about the thing. For such a building really the proper thing to do is to employ Richardson.

"If we take the plan that Richardson submitted to us, and change that 'pepper-box' which he has in front into a clock tower, and put a graceful window in that North end, we will get about what you and I are thinking of

"On the whole, if you think you can control Richardson I am inclined to a meeting with him as you suggest."

Billings' hurry to get the building underway led to a long justification by the architect of his working method. On July 9, 1883, he dictated the following letter to the donor:

"I am very sorry you should feel uneasy with regard to the progress of the drawings for the Library. I assure you there is no just cause for any such feeling. I have from the first given the best part of my time and attention and my most careful thought to your building, and I have and shall urge the drawings along with as much rapidity as is consistent with good work. As I explained to Mr. Buckham . . . the work up to July 5th was purely a matter of design, which could not be unduly hurried without serious detriment to the the [*sic*] building as a work of art. Only I myself and one or two of my best draughtsmen could be employed in that work. Since then, the work being now almost entirely mechanical, I have put a large force of men on the drawings and they will be completed as rapidly as possible. . . .

"I consider one of the chief reasons why there is so much bad architecture in this country is overhaste in making the designs. We are too impatient to be willing to give the time and thought and careful consideration and reconsideration which is essential to the production of a work of art. But it were surely unwise to mar the design of a monument which is to last we hope for centuries

for the sake of beginning work a week or two earlier. I assure you I never have
undertaken the design of a building which has worked out so rapidly and
successfully as this has, and certainly none has received more constant attention.
Indeed it has been the chief work in my office since the time it was first put into
my hands. I should be very glad if you and Mr. Buckham could find the time
to come to Brookline, that you might see the drawings for the library and that I
might show you the careful and painstaking way in which I study and restudy
a design before beginning the working drawings, and which I am confident is
the only way in which good work is produced and to which I largely ascribe
my success.''

Construction by Norcross began in September with the final design still under
discussion. On February 16, 1884, for example, Richardson wrote Buckham
that he had been ''making some very careful studies for the tower and have
already put into Mr. Norcross' hands the greater number of all the full size
details necessary reserving for more study the upper part of large tower &
finials of small tower and turrets.'' The library was dedicated at Commencement
in June 1885.

Shepley, Rutan and Coolidge lengthened the building a year later and added a
rear wing in 1889, changing the proportions as well as the outline of the original
design. The building now serves as the University's student activities center.

Sources: Buckham Papers, University of Vermont Archives; *The Billings Library, The Gift to
the University of Vermont of Frederick Billings, H.H. Richardson Architect,* Boston [ca. 1888];
Richard H. Janson, ''Mr. Billings' Richardson Library,'' *University of Vermont Alumni Maga-
zine,* May 1963, pp. 8-10.

27a. Plan

Black ink, gray, terra-cotta, yellow and blue washes and pencil on heavy linen-
mounted paper; 33½ x 54 in. Draughtsman. Unpublished. (BIL-A1)
Lettered in black ink lower left: PLAN OF GALLERY FLOOR / THE BILLINGS LIBRARY /
BURLINGTON. VT / SCALE ¼ INCH = 1 FOOT, and at top: PLAN THROUGH WINDOWS
ABOVE SECOND FLOOR, and at bottom: PLAN OF LOGGIA ABOVE SECOND FLOOR

Presentation plan of the building as first proposed, with a bookroom seven
alcoves long. In a letter of September 3, 1883, HHR explains to Buckham that the
latter's idea (or Billings') to reduce the size and hence cost of the proposed
structure by narrowing it longitudinally would save very little. At some point the
decision was made to shorten the building; as originally erected the bookroom
was six bays long (cf. plan, Van Rensselaer, p. 79).

On this drawing materials are indicated by colors: gray, stone; terra-cotta,
brick; yellow, woodwork. Note the use of concealed iron beams around
stairways.

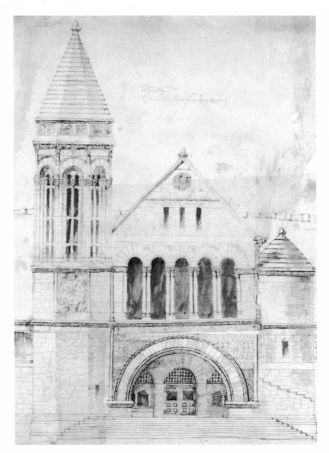

27b. Billings Memorial Library. Elevation Study

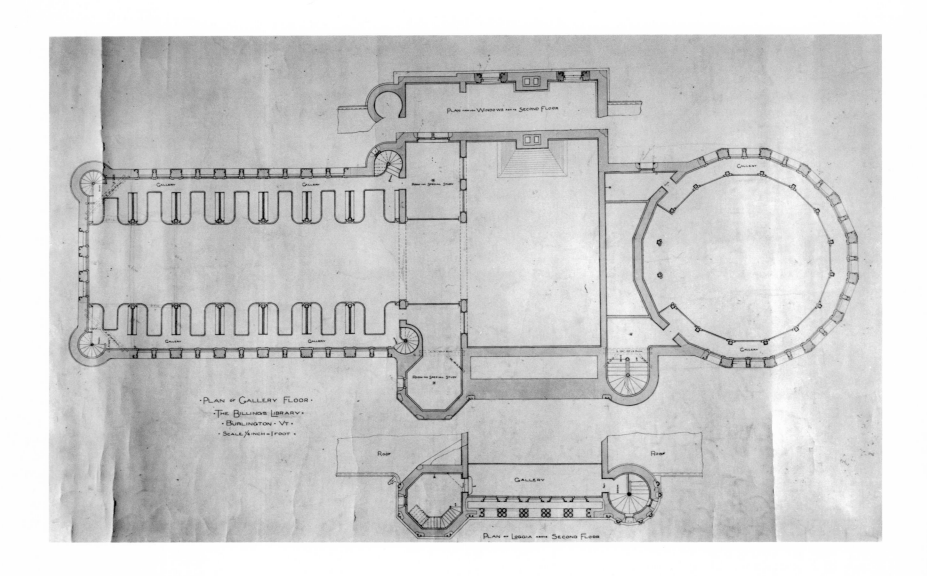

PLAN OF WINDOWS FOR THE SECOND FLOOR

ROOM FOR SPECIAL STUDY

GALLERY

GALLERY

GALLERY

GALLERY

GALLERY

ROOM FOR SPECIAL STUDY

GALLERY

GALLERY

· PLAN OF GALLERY FLOOR ·
· THE BILLINGS LIBRARY ·
· BURLINGTON · VT ·
· SCALE ⅛ INCH = 1 FOOT ·

ROOF

ROOF

GALLERY

PLAN OF LOGGIA ABOVE SECOND FLOOR

27b. Elevation

Brown ink on joined tracing paper; 23½ x 23 in. (irregular). Draughtsman. Unpublished. (BIL-D1)
Written in brown ink upper left corner: *Study for tower / for Library at / Burlington,* and above gable: *Study for Burlington Library*
Lettered inscription in brown ink above entrance arch: BILLINGS MEMORIAL LIBRARY, and in gable dated MDCCCLXXXIII

A study for a presentation drawing. This represents the building much as built except for minor changes (the clock on the tower was omitted in execution).

27c. Study for Interior Woodwork

Brown ink and pencil on joined tracing paper with correction on flap overlay; 18 x 7¾ in. Draughtsman. Unpublished. (BIL-E6)
Written in pencil on flap: *4 patterns / Balusters,* and in brown ink lower right: *Burlington Library / Book Room*

Study for elevation of a pier separating one tiered alcove from another. In the interior as executed, only the fireplace received elaborate carving. Note the characteristic coiled gas light fixture similar to those shown in the sketch (cat. no. 43m) and to those formerly in the Converse Library, Malden, and elsewhere.

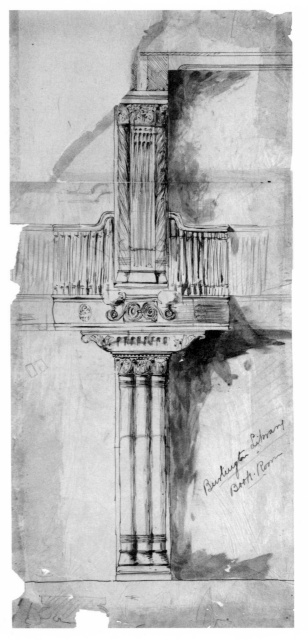

27c. Billings Memorial Library. Study for Interior Woodwork

28. Converse Memorial Library, Malden, Massachusetts, 1883-1885

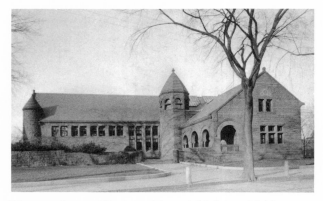

Photograph 1903 (Converse Memorial Library, Malden)

Van Rensselaer says the commission entered the office in August 1883. Olmsted and Richardson visited Malden to choose the site of the building in January 1884. It was dedicated on October 1, 1885.

Source: F.L. Olmsted, Jr. and Theodora Kimball, ed., *Frederick Law Olmsted, Landscape Architect, 1822-1903*, New York, 1970, p. 27.

28a. Presentation Elevation

Brown ink on heavy buff paper; 10⅜ x 20¾ in. Draughtsman? Unpublished. (MAL-B6)

Presentation drawing of the main elevation, altered in execution. The principal elements remained unchanged, although a corner stair turret was added to the west end of the bookroom, and the proportions of the building are taller than shown in this drawing. Most of the projected details were altered in construction: the grouping of the bookroom windows was abandoned in favor of a more continuous treatment; the reading room window was enlarged and divided differently; the corner colonnettes of the tower were omitted and the window design changed. Decorative stone patterns were added to the gable end facing Salem Street.

28b. Elevation

Black and blue ink with pencil notations on heavy linen-mounted paper (dimensioned in red and black ink); 25 x 38¼ in. Draughtsman. Unpublished. (MAL-B1)
Lettered in black ink upper left: CONVERSE MEMORIAL LIBRARY / MALDEN / MASS / NO. 5, and below: FRONT ELEVATION / SCALE ¼ INCH = 1 FOOT
Pencil notes: *Do This — Carved / HHR / July 15/85 / Not Contracted for*

Working drawing, much as built.

28c. Study for Carved "Griffin"

Pencil on tracing paper; 6¼ x 6¾ in. Draughtsman? Unpublished. (MAL-D9)

Nothing on the building corresponds exactly with this drawing of a fabulous winged beast with lion's head and amphibious tail, but it suggests the "griffin" found at the bottom of the long left rake of the front gable.

28d. Converse Memorial Library. Study for Carved Detail

28d. Study for Carved Detail

Pencil on tracing paper; 10½ x 9 in. Draughtsman? Unpublished. (MAL-D10)

Again, this exact carving is not present on the building, but it is very like the rich ornament of the entrance porch.

28e. Study for Decorative Carved Panel

Pencil on stiff blue paper; 10¼ x 7½ in. Draughtsman? Unpublished. (MAL-E1)
Lettered in pencil at bottom (later hand?): SKETCH FOR CARVING

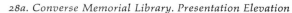

28a. Converse Memorial Library. Presentation Elevation

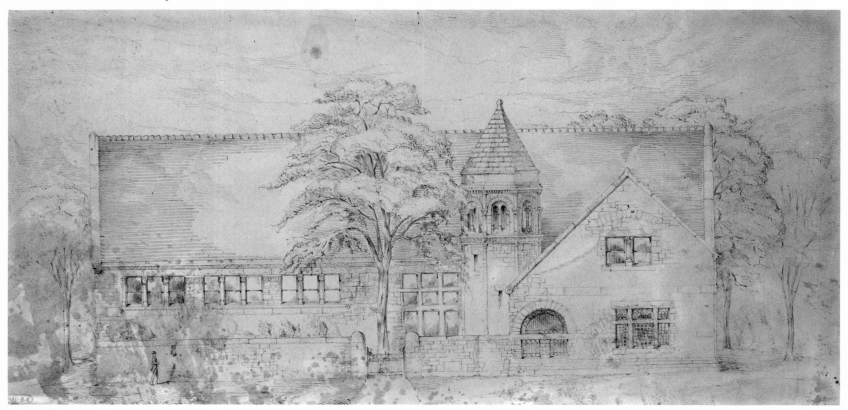

Between April 1883 and April 1884, fund-raising proceeded for a new home for the Y.M.A. Library and related institutions, while the library superintendent traveled to eastern cities "to confer with leading architects and to study the construction and arrangement of the best library buildings." With sufficient funds in hand, programs were sent to competing architects on April 16, 1884, for a building on a trapezoidal site to house the library, the Fine Arts Academy, the Society of Natural Sciences and the Buffalo Historical Society. This program was accompanied by a set of suggested plans, although it was emphasized that "the invention of architects shall be exercised upon the same problems without trammel or bias from these suggestions." The plans show a building in the shape of an asymmetrical letter A occupying the outside of the plot, with entrance, offices and reading rooms at the flattened point and book storage and galleries in the unequal wings. The most notable requirement of the program was for "a modified form of the book-stack system, as adopted in the library of Harvard University" (addition to Gore Hall, 1874-1877, by Ware and Van Brunt; with his new partner, Frank Howe, Van Brunt was invited to compete for the Buffalo library). Drawings were due on July 1, 1884, and the commission was awarded on the 11th. Richardson placed second to C.L.W. Eidlitz of New York, whose scheme closely followed the suggested plans. The finished building, brick and stone Romanesque, more irregular in massing than Richardson's contemporary work, with fireplaces in the spirit of Philadelphia's Frank Furness, opened as "The Buffalo Library" in March 1887.

Source: The Buffalo Library and Its Building, Buffalo, 1887.

29. Young Men's Association Library, Buffalo (project), 1884

29a. Plan

India ink over pencil on stiff white paper with pencil figuring; 17¾ x 11¾ in.
Autograph. Van Rensselaer, p. 83. (BL-A1)
Written in black ink in HHR's hand: room designations, and at bottom: *May 7.84* (with ink monogram?)

Study for vaulted ground floor. HHR shortened the long leg of the suggested A by moving the newspaper reading room toward the flattened point, and enclosing the courtyard with a narrow wing, thus achieving a characteristic compactness not found in either the suggested plans or Eidlitz's winning design.

29b. Elevations

Pencil and watercolor on watercolor paper; 13⅝ x 16⅜ in. Draughtsman. Unpublished. (BL-B1)

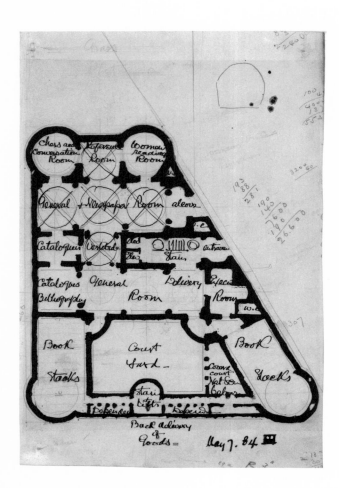

Alternative designs for the main front. The upper elevation is nearly identical to the design published in *AABN*, April 23, 1887 (the caption to the plate labels the design correctly, but in the list of illustrations on p. 199 it is called a design for the Young Men's *Christian* Association, an understandable slip which has caused some confusion). These elevations must be dated May-June 1884.

29c. Elevation

Pencil on watercolor paper; 7 x 12½ in. Draughtsman. Unpublished. (BL-B8)

Draughted rear elevation corresponding to the upper drawing in no. 29b.

On March 6, 1886, Richardson wrote to Shepley regarding the Hoyt Library project: "I am annoyed that I did not read the proofs of Saginaw specifications & that such a slip should have been made as the mention of the 'Middlesex Society Room' but after all it is not surprising we should now & then mix up libraries when we are building so many — It is not as bad as Street building the wrong church in the wrong village [Richardson is referring incorrectly to the legend about Street's English contemporary, G.G. Scott, who was said to build so many country churches he could not keep track of them]. . . . The longer they delay decision the better for us. You had better see Poole if you can, *not* in Chicago but in Saginaw — I am right about placing & facing the building — the southern sun on the porch & steps alone, all things considered, is enough to decide it. Stand solid on position as it is — I thought all their recommendations were suggestions."

The specifications Richardson mentions are contained in a 48-page booklet published to accompany his drawings. The proposal called for an ashlar exterior of "local magnesian limestone . . . laid in random-course, with horizontal beds and vertical joints . . . rock-face." The trim was to be rock-faced "Portage Entry red sandstone." It was planned to cover the main roofs with Akron [red] roof tiles.

One would have entered the library through a recessed stone porch giving access to the delivery room with bookroom to the right and reading room to the left. The bookroom was to be 45 by 38 by 14 feet high, "abundantly lighted by a great line of windows extending to the ceiling." The reading room was circular in plan, about 30 feet in diameter, extending through two stories, with an open timber ceiling. A monumental fireplace in the reading room would terminate the long axial vista through the library.

Richardson lost the commission to Van Brunt and Howe of Boston, whose Richardsonian building of bluish gray limestone trimmed with red sandstone was erected in 1887-1888.

The reason Saginaw rejected Richardson's proposal is suggested in his letter by the mention of Poole. William Frederick Poole (1821-1894) was then head of the Chicago Public Library but within months of accepting the task of forming the Newberry. In the same year he became president of both the American Historical Association and the American Library Association. Poole was Saginaw's consultant in the preparation of plans.

Poole had strong opinions about library architecture and had in fact just published a paper in the *Library Journal* on the small public library building. The librarian, he believed, should plan the building, after which the architect might cover its function with a picturesque exterior. He was a staunch advocate

30. Hoyt Library, (East) Saginaw, Michigan (project), 1886

of the departmentalized plan, with no monumental, towering, tier-ringed space as was so common in libraries of the mid-nineteenth century. His approach was strictly utilitarian: illumination and flexibility determined his scheme. The library was to be (in his paper of 1885) cruciform in plan to maximize window area, have side rather than sky light, and the reading room was to be lighted from the north. There were to be no alcoves or galleries in the bookroom. Interior partitioning was to be minimum. Beyond that, Poole liked exteriors of rubble or boulder walls.

Had Richardson known Poole better, he would never have made the mistake of thinking that the recommendations he received were mere suggestions. Van Brunt and Howe took them seriously; their reading room is in the north wing of the building.

Poole's rejection of Richardson's library project was not an *ad hoc* decision. He fought all Richardson's libraries on principle, as did the *Library Journal*, the mouthpiece of the American Library Association. The brief obituary of the architect published in the *Journal* mentions several of his suburban Boston libraries, "all of them beautiful buildings, though not all perfect as libraries."

But the *Journal* was just warming up in 1886. In 1888 it got into a squabble with the *AABN* about architects and libraries, a squabble that centered around SRC's Howard Memorial Library in New Orleans. The *Journal's* publication of the Howard drew the following reflection from its editor: "I think from our experience of architects' plans that we can safely say the architect is the natural enemy of the librarian." The type of Richardson building universally admired by twentieth-century architectural critics was condemned by the people who had to use it.

The Howard Library has a place in this discussion because the view of it published by the *Journal*, itself taken from *Harper's Weekly*, is in fact a view of the Hoyt Library project. According to *Harper's*, Charles T. Howard (1832–1885), a wealthy resident of New Orleans, decided sometime before his death to donate a public library to the city, "and his plans for it had been nearly completed." After his death his children continued the project as his memorial. "The design which had been selected by Mr. Howard, and which is seen in the illustration, is the work of the late H.H. Richardson . . . [whose death] occurred before the plans of Mr. Howard had taken definite shape, and the design, in consequence, is one which Mr. Richardson had not prepared with reference to this special project."

Harper's account is confusing. The elder Howard died on May 31, 1885; the Hoyt drawings would seem to date from early 1886. Perhaps the magazine intended to say that Howard's children accepted Richardson's rejected design

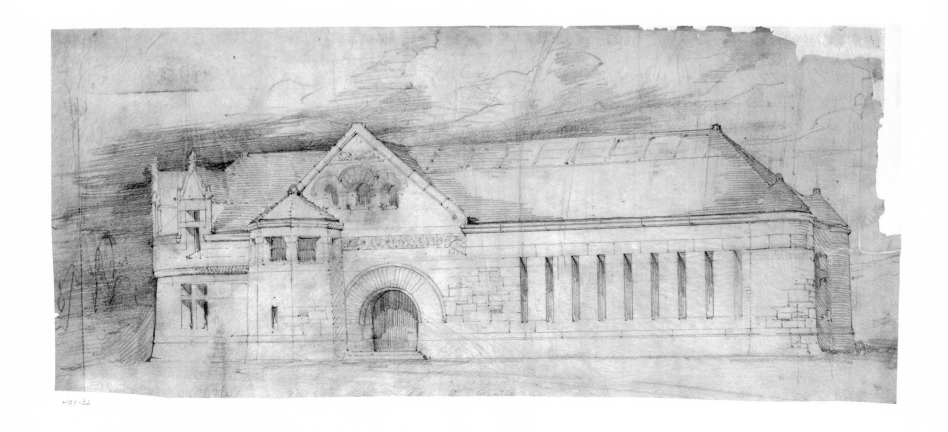

HOY-32

30b. Hoyt Library Project. Perspective

for the Hoyt, but that does not leave much space between a Saginaw rejection and the architect's own death. Nor does it take into account the specific statement that Howard had his plans nearly completed. Which came first, the Hoyt or the Howard, is not yet clarified.

They were erected simultaneously. The Howard, like Van Brunt's Hoyt, was built in 1887-1888 (and opened to the public on March 4, 1889) by Norcross Brothers under the supervision of Shepley, Rutan and Coolidge. One is tempted to say that they used the unwanted design for the Hoyt, just as they used the unwanted design for the Buffalo Arch at Stanford (cat. no. 36) at nearly the same time. It was a frugal New England firm.

Whatever the chronology of the design, there is no question that the Howard Library as built followed the drawings for the Hoyt, although it is doubled in size. It is two stories rather than one, with some minor decorative details and the reading room altered. Even the date inscribed above the entrance arch, MDCCCXXXVI, is that of the Saginaw project rather than the Howard design (1885?) or its execution (1887-1888).

Sources: Letter in possession of SBRA; H.H. Richardson, *The Hoyt Public Library, East Saginaw, Michigan,* Boston, n.d. (copy in HCL); W.L. Williamson, *William Frederick Poole and the Modern Library Movement,* New York, 1963, pp. 151 ff.; W.F. Poole, "Small Library Buildings," *Library Journal,* X (Sept.-Oct. 1885), 250 ff.; also *Library Journal,* XI-XIII (1886-1888), *passim; Harper's Weekly,* XXXII (Oct. 13, 1888), 775; *AABN,* XXIV (Oct. 13, 1888), 165.

30a. Preliminary Study for Elevation

Pencil on tracing paper; 6½ x 17⅝ in. Draughtsman. Unpublished. (HOY-B6)

30b. Perspective

Pencil on tracing paper; 10⅞ x 24 in. Draughtsman. Unpublished. (HOY-B2)

This corresponds to the drawing of the Howard Library published by *Harper's.*

RAILROAD COMMISSIONS

The commuter depot appeared as a new design problem after the Civil War as the suburbs became bedrooms, and business began to pile up in tall buildings downtown. The railroads then, like the highways now, were the thin connectors in modern schizophrenic life.

The depot is perhaps *the* most familiar Richardson building type. Here again the architect's reputation needs adjusting. Certainly, these stations form a significant portion of his work from 1880 onward, and certainly they had a very important impact upon the domestic architecture of Frank Lloyd Wright, but there were other architects who better deserve to be thought of in connection with the post-Civil War expansion of the railroad system. During the 1880's Richardson designed eleven stations, a freight house and the interior of one Pullman car. On the other hand, Frank Furness of Philadelphia in one five-year period (1879-1884) produced one hundred and twenty-five railroad buildings and alterations, remodeled a ferryboat and designed the interiors of seven sets of Pullman and parlor cars. That was for one railroad; during the same period he was working for other railroads as well.

31. Boston & Albany Railroad Station, Palmer, Massachusetts, 1881-1884

Photograph 1960's (HABS)

Commissions for Boston and Albany work presumably came to Richardson because of his friendship with Vice-President James A. Rumrill (Harvard '59) or Charles S. Sargent, a director of the Railroad (see Introduction).

The site at Palmer is a triangle formed by the junction of the main line (to Springfield) of the Boston & Albany and the New London & Norwich Railroads. Commissioned in August 1881, according to Van Rensselaer, it was being landscaped by F.L. Olmsted in the spring of 1884.

Sources: AABN, XXI (February 2, 1887); letters from Rumrill to Olmsted, Olmsted Papers, General Correspondence, Library of Congress, Box 18.

31a. Study for Plan

Brown ink over pencil on blue laid stationery; $7\frac{11}{16}$ x $4\frac{7}{8}$ in. Autograph. Unpublished. (formerly UNK-A3)
Written in brown ink in HHR's hand: room designations and notations.

Preliminary trapezoidal plan with tracks and rooms labeled. In this early scheme HHR divided men's and women's waiting rooms by a "Refreshments" area; the executed building is much larger and has a general waiting room and adjoining dining room. The surrounding porches are already indicated.

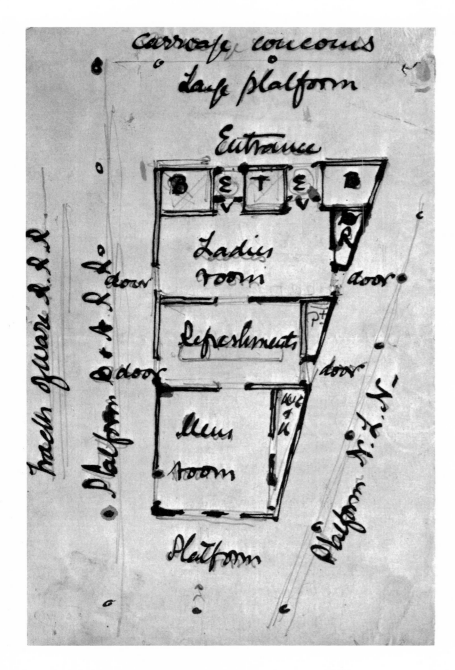

31a. Palmer Railroad Station. Study Plan

32. Old Colony Railroad Station and Freight House (the latter a project), North Easton, Massachusetts, 1881-1884

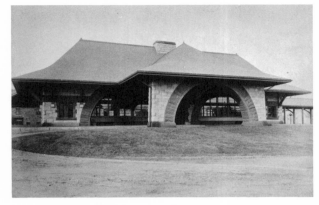

Photograph ca. 1890 (Boston Athenaeum)

F.L. Ames (see cat. no. 18) was an officer of the Old Colony Railroad. The station was commissioned in November 1881, according to Van Rensselaer. Olmsted was landscaping the grounds in 1884.

Sources: Olmsted Papers, General Correspondence, Library of Congress, Boxes 17 and 18; *AABN*, XXI (February 2, 1887); L. Homolka, "Richardson's North Easton," *Architectural Forum*, 124 (May 1966), 72 ff.

32a. Sketch Plan and Two Elevations

Pencil on blue laid stationery; 5¾ x 5⅛ in. Autograph. Unpublished. (formerly UNK-A4)

The final design resulted from the simplification of the plan and roof shown in these preliminary sketches.

32b. Sketch Plan

Brown ink over pencil on tracing paper; 6⅝ x 13 in. Autograph. Unpublished. (NES-A5)
Written in brown ink in HHR's hand: room designations.

Sketch plan of station showing circulation paths through the building from train to carriages.

32c. Elevation of Porte-Cochère

Pencil on tracing paper; 4¾ x 6⅛ in. Draughtsman? Unpublished. (NES-D1)

32d. Perspective

Pencil and brown ink on tracing paper; 4⅛ x 11¾ in. Autograph? Unpublished. (NES-F1)

Freehand view from the tracks of the station as erected. The sheds extending along the trackside have been removed.

32e. Plan

Black, red and blue ink, and brown, gray, terra-cotta and yellow wash on heavy white paper with pencil figuring; 26⅜ x 36½ in. (lower left corner torn away, mended). Draughtsman. Unpublished. (NES-A3)
Lettered in black ink at bottom: STATION AT NORTH EASTON / ¼ SCALE, and upper right: *No. 11*

Dimensioned construction drawing showing materials by color code: gray, stone; red, brick; yellow, wood.

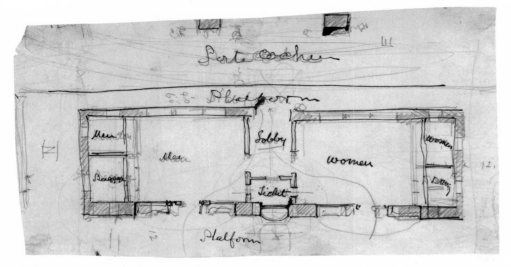

32b. North Easton Railroad Station. Sketch Plan

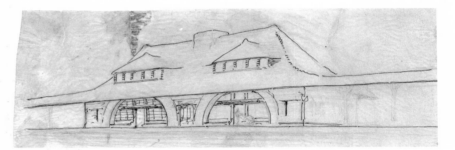

32d. North Easton Railroad Station. Trackside Perspective

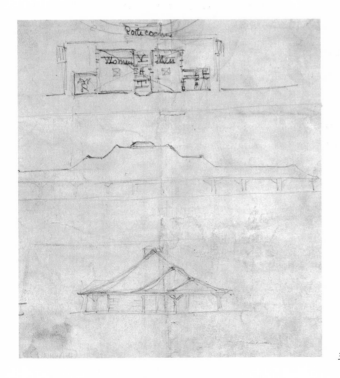

32a. North Easton Railroad Station. Sketch Plan and Elevations

179

32f. Trackside Elevation

Black ink and pencil on heavy white paper with red line labeled *level of rail;* 25 x 38 in. Draughtsman. Unpublished. (NES-B3)
Lettered in black ink upper left: STATION AT NORTH EASTON / ¼ SCALE, and at upper right: NO. 6, and at bottom: WEST ELEVATION, and above ticket window: NORTH 1882 / EASTON

Draughted trackside elevation as built.

32g. Elevation and Plan of Arched Entry

Black ink and pencil on linen; 24½ x 38¼ in. Draughtsman. Unpublished. (NES-E2)
Lettered in black ink upper left: NORTH EASTON STATION / DETAIL OF ARCHED WINDOW / ¾″ = 1 FOOT
Written in black ink upper right: *Copy 5-31-83 / No 7a*
Lettered in black ink above ticket window at right: NORTH 1883 / EASTON

Draughted details of arch and ticket windows on track side of station with partial plan below.

32h. Perspective of Freight House

Pencil with freehand border on tracing paper; 5¼ x 9½ in. Draughtsman? Unpublished. (NEF-F2)
Written in pencil in HHR's hand at bottom: *No. Easton Freight House*

The sketch shows a projected freight house south of the station. It was to be composed of a one-story gabled rectangle and a two-story cylinder, and built of stone and probably shingles.

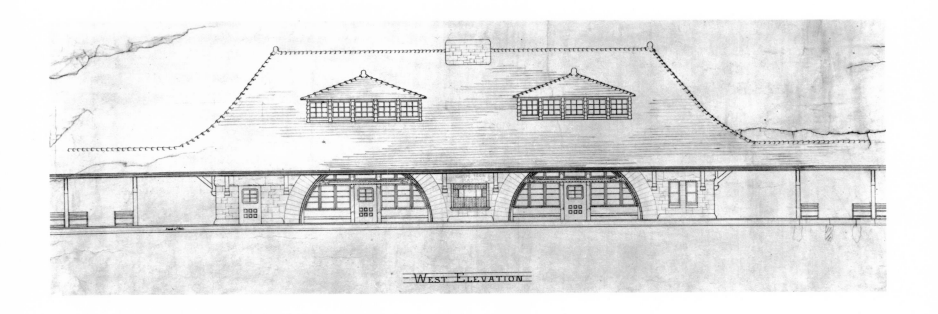

WEST ELEVATION

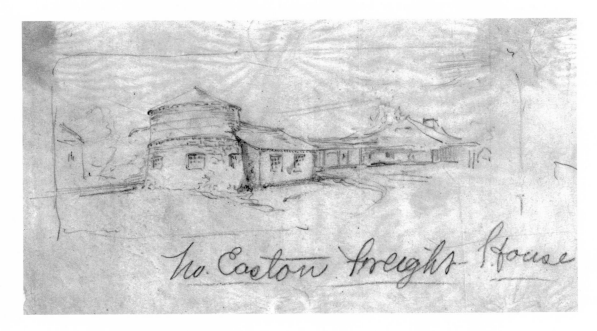

No. Easton Freight House

32f. North Easton Railroad Station.
Trackside Elevation

32h. North Easton Freight House Project.
Perspective Sketch

181

33. Private Pullman Car (project?), 1884?

Nothing has come to light about this Boston & Albany car since Hitchcock discussed it in 1936. He does not document the date of 1884.

33a. Plan

India and blue ink and pale red wash on watercolor paper; 14⅝ x 39½ in. Draughtsman. Unpublished. (PC-A2)
Lettered in black ink at bottom: FIRST STUDY FOR A PRIVATE CAR /SCALE ½ INCH = 1 FOOT

In this preliminary draughted plan there is no observation room-office forward; otherwise, it is much like the presumed second version in no. 33b. Additional partial plan showing conversion of dining room at night.

33b. Plan and Section

Brown and black ink on linen, mounted on board; 22⅛ x 40⅜ in. Draughtsman. Hitchcock 1966, fig. 96. (PC-A1)
Lettered in black ink lower right: B & A R.R. PRIVATE CAR

The plan now has an observation room at either end (one doubles as a business office). The staterooms in the center (not over the wheels) separate the kitchen and dining room.

33a. Pullman Car Plan

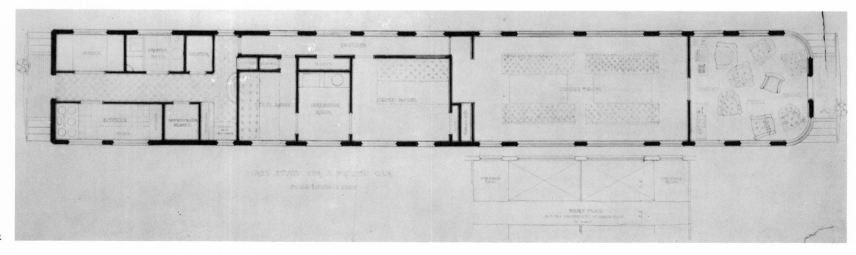

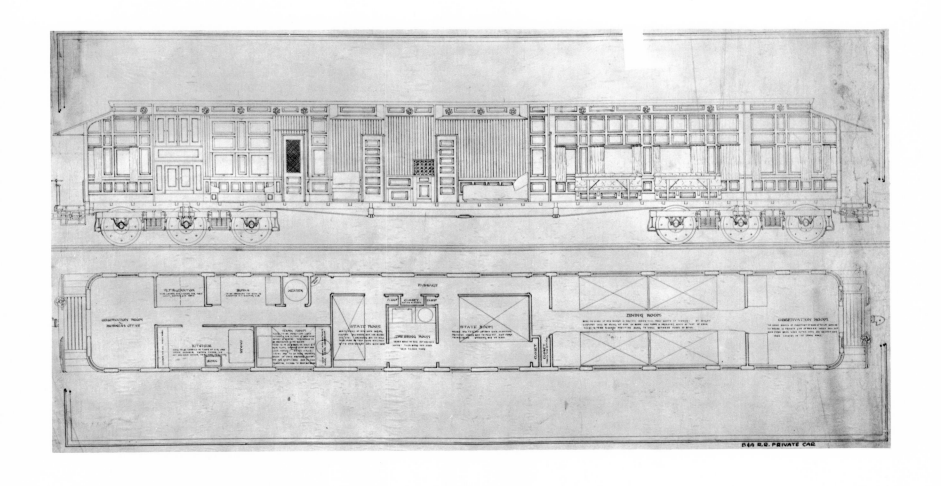

33b. Pullman Car Plan and Section

34. Unidentified Railroad Station

34a. Perspective

Pencil on tracing paper; 9 x 16½ in. (irregular). Draughtsman? Unpublished. (UNK-F16)

Written in pencil next to figure of baggageman: *Giant*

Sketch of a characteristic Richardsonian railway design with low stone walls and dominant roof. The comment refers to the oversized figure that is out of scale: a real Lincolnesque giant appears at the right.

34a. Unidentified Railroad Station. Perspective

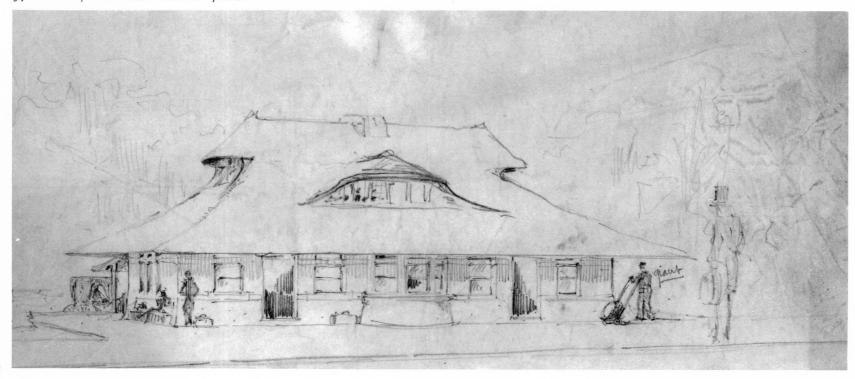

MISCELLANEOUS

"I'll plan anything a man wants," Richardson told
J.J. Glessner, "from a cathedral to a chicken coop."
He never got the chance to design the Chicago
grain elevator he wanted to create. But he did
study a substantial variety of other design problems
ranging from memorial tablet and drinking foun-
tain to a lighthouse and Civil War monument. The
latter category is of special interest: the fact that it
was dedicated to Union soldiers or sailors seemed
not to dampen the enthusiasm of this transplanted
Southerner.

35. George Minot Dexter Memorial (project?), Trinity Church, Boston, between 1873 and 1877

G.M. Dexter (1802-1872) was Senior Warden and an original member of the Building Committee of Trinity Church. At a special meeting held on November 28, 1872, the Wardens and Vestry recommended to the Proprietors that a "Tablet to his memory be placed on the walls of that 'new Trinity' to which he had already given so much." The Proprietors accepted the recommendation on December 18.

On October 21, 1877, Richardson wrote to Augustus Saint-Gaudens in Paris: "I . . . enclose tracing of frame for marble tablet. The frame is . . . to be made of wrought iron & brass and therefor [*sic*] I will not go into details unless you write for information — only that I think that the Brass part of frame need not be retouched by hand but simply cast — The price to wh: I am so far bound is $600 — Before doing anything about it please write me what it will cost Exclusive of duties, freight, insurance &c. Do you recall my design for a simple tablet for Mr. G.M. Dexter something like this

any design that would tell on the walls of Trinity placed say about (the head) eight feet high — with some simple ornament or cherub either side as at 'x' and inscription below."

The tablet shown in the sketches probably dates closer to 1873 than to 1877. In the latter year, Richardson designed another memorial, to the Rev. Henry E. Montgomery, for the Church of the Incarnation in New York City. It is an architectonic and plastic composition quite unlike the flat Dexter tablet, which must have been designed sometime earlier.

The G.M. Dexter memorial now on the east wall of the north transept of Trinity is a gray stone slab in the proportions shown in the sketches but without a portrait. The composition is asymmetrical; the low-relief cross and foliage are Pre-Raphaelite in design. No documentation concerning its execution has come to light.

Sources: Saint-Gaudens Papers, Baker Memorial Library, Dartmouth College, Box 16; *In Memoriam, George M. Dexter; obit Nov. 26, 1872* (copy in HCL); Church of the Incarnation, New York, Vestry Minutes, April 1876 to February 1878; J. Newton Perkins, *History of the Parish of the Incarnation, New York City, 1852-1912*, Poughkeepsie, N.Y., 1912, pp. 114-115.

35a-b. Variant Studies for Wall Tablet

35a. Pencil on watercolor paper; 4⅛ x 3⅜ in. Stanford White? Unpublished. (formerly UNK-F7)

35b. Pencil and colored washes on watercolor paper; 5⅛ x 8¼ in. Stanford White? Unpublished. (formerly UNK-F8)

Three studies for a memorial, that to the left in no. 36b bearing the name *Timothy Dexter*. In style and description these generally correspond to the memorial mentioned in HHR's letter to Saint-Gaudens. Only the name *Timothy* casts doubt on this attribution, but that can probably be explained by Richardson's or White's sense of humor. Timothy Dexter (1743-1806) was a wealthy eccentric of Newburyport, Massachusetts, given to self-aggrandisement and styling himself "Lord." The name on this drawing was certainly tongue-in-cheek; HHR's relations with the Trinity Building Committee were not always easy.

35b. Dexter Memorial Project. Study for Wall Tablet

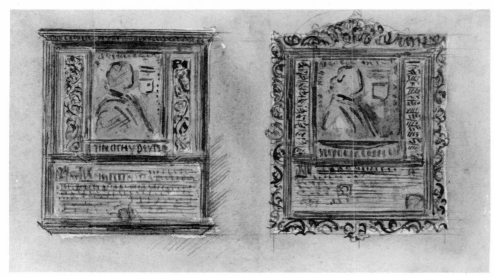

36. Civil War Memorial, Buffalo (project), 1874-1876

The Ladies Union Monument Association of Buffalo was incorporated in July 1874, with Miss Maria M. Love as its active vice-president. The Ladies petitioned the Park Commission, whose executive committee included William Dorsheimer (see cat. no. 20), for permission to erect a Civil War memorial in Niagara Square, just then being redesigned by F.L. Olmsted, consulting landscape architect to the Commission. Precisely how Richardson came to design the monument is not known, but the presence of Dorsheimer and Olmsted makes his intervention understandable.

By September 23, 1874, the architect was at work on a memorial in the form of an arch, and by December 6 had sent the drawings to Olmsted, who presented them as part of his scheme on December 15. Although the Park Commission approved the whole layout, the Ladies decided that any action on their part would be premature. The problem was money. Although Norcross had estimated the cost of the arch without sculpture to be in excess of $50,000, by July 1875, only $7,466.18 had been collected.

The project rested, presumably while additional monies accumulated, until early 1876, but by then men had infiltrated the Ladies Association, and despite Miss Love's resistance, alternative proposals were being considered. Richardson's arch was judged "too heavy — too much like a rail-road tunnel — too dark," according to Miss Love's letter to Olmsted of April 27. Nevertheless, during June plans were afoot to lay the cornerstone of the arch on the Nation's hundredth birthday. Although Richardson altered the design, perhaps several times, no start was made that summer. As late as August, however, the project was still under discussion, for on the 9th the architect wrote to Olmsted enclosing a new design in which "the prows are left off the turrets. I hope it will be in time . . . as I know it wd: help my cause for you to show it."

It did not. The documents in hand end here. Richardson's arch was never erected in Buffalo, but it did have two direct descendants. One, which stood in front of the main entrance to Stanford University until destroyed by earthquake in 1906, is close to the project of 1874. It was the work of Shepley, Rutan and Coolidge (1888 *et seq*.), and must stem directly from the Buffalo project, which they inherited. The other is the Washington Square Arch in New York City, erected in 1889 from the design of Stanford White. White was in the office of Gambrill & Richardson when the Buffalo project was being considered, and probably was the draughtsman of no. 36a. There can be little doubt that the Washington Square monument was directly inspired by the Buffalo Civil War Memorial.

On July 4, 1882, the cornerstone for the Buffalo Memorial was finally laid. It was neither an arch nor in Niagara Square. Dedicated in 1884 and located in

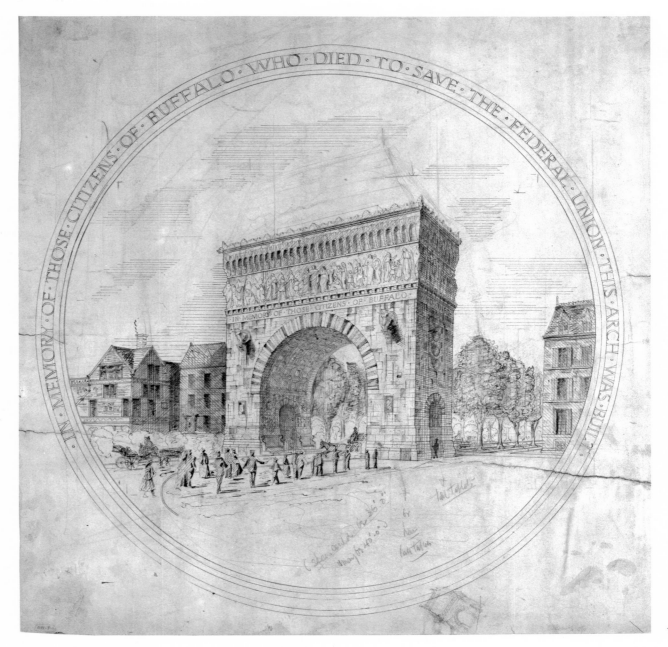

*36a. Buffalo Civil War
Memorial Project. Perspective*

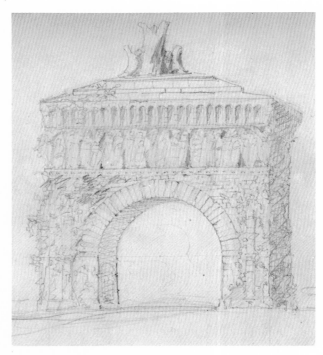

Buffalo Civil War Memorial Project. Perspective (Sketchbook, f. 31ʳ [see Appendix])

Lafayette Square, it was the work of architect George Keller and sculptor Casper Buberl. An 85-foot column surrounded by four uniformed figures and topped by a female of unknown designation, it cost $50,000. The monument eventually erected in Niagara Square is a central obelisk dedicated to the memory of William McKinley, assassinated in Buffalo in 1901.

Sources: Minute Book of the Ladies Union Monument Association in the Buffalo and Erie County Historical Society, Buffalo; Olmsted Papers, General Correspondence, Library of Congress, Boxes 12 and 14; letters in possession of SBRA; HHR's letter of August 9, 1876, Burnham Library, Chicago Art Institute; *Fifth Annual Report of the Buffalo Park Commissioners*, Buffalo, 1875; *Semi-Centennial Celebration of the City of Buffalo . . . Celebration of July 4th, in connection with laying of Corner Stone of Soldiers' and Sailors' Monument*, Buffalo, 1882.

36a. Perspective

Pencil and brown ink in circular border on watercolor paper; 21¾ x 21¼ in. Autograph and Stanford White? Hitchcock 1936, fig. 80 (detail). (ARC-F1)
Lettered in brown ink around border: IN MEMORY OF THOSE CITIZENS OF BUFFALO WHO DIED TO SAVE THE FEDERAL UNION THIS ARCH WAS BUILT
Written in pencil within circle: *Span could be 36' 0" / & may be 40' 0".* Other pencil notations and thumbnail perspective by HHR of arch with addition of mansard roof.

The buffalo heads in the spandrels relate this drawing to HHR's letter to Olmsted of December 6, 1874: "I tried hard for projections for your views and as you see have use[d] Buffaloes . . . freely — the estimated cost . . . is about $50,000 without the carving." In a second letter, dated the 9th, HHR mentions specifically "the figures in the frieze." He also mentions the figures of Brattle Square Church, the obvious parallel with his use here of frieze beneath machicolations. This evidence dates this drawing to the fall of 1874; it is perhaps the drawing presented by Olmsted in December. The draughtsmanship is not Richardson's. We know from letters that Stanford White worked on this project. There are preliminary sketches for this early design in HHR's hand in the Sketchbook (f. 31ʳ, see Appendix). Characteristically, White's rendering considerably lightens the heavy forms in HHR's drawing. A photograph of a rendering, now unlocated, of what must be a later (1876?) version of the design, is in the photo album at SBRA.

The commission for a gate lodge and garden house for "Langwater," F.L. Ames' North Easton estate, entered the office in March 1880, according to Van Rensselaer. It was finished by Norcross the next year.

Source: L. Homolka, "Richardson's North Easton," *Architectural Forum,* 124 (May 1966), 72 ff.

37a. Perspective

Brown ink on yellow tracing paper; 3 x 4½ in. (torn and mended at right). Draughtsman? Unpublished. (AGL-D3)

A small sketch showing the carriage entrance arch and tower on the road side. Much as built, except here the arch is flattened on top. HHR has not yet curved the eaves line in order to permit the arch to develop a full half circle. The eyelid in the roof above has not yet made an appearance.

37b. Perspective

Pencil on white paper; 3⅜ x 5½ in. Draughtsman. Unpublished. (AGL-F1)
Numbered in black ink upper right: *193*

A light sketch of the lodge from the southwest much as built. Like no. 37a, this closely corresponds to the photograph published in *The Ames Memorial Building, North Easton, Mass.,* Boston, 1886. Yet, both are preparatory. The well tower here corresponds to the design stage in no. 37c.

37c. Details of Well Tower

Pencil on white paper; 7½ x 6 in. (corners bevelled; torn and mended). Draughtsman? Unpublished. (AGL-D2)

Two studies by a master draughtsman of the well tower on the estate side of the lodge, very close to what was built. The round depressions of the parapet of the upper level were omitted in favor of massive rough-faced blocks; the arch supporting the eccentric balcony became cantilevered stones. Comparison of these drawings with the building suggests that many details were worked out as the rough stone building rose.

37. Gate Lodge, North Easton, Massachusetts, 1880-1881

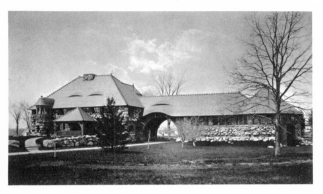

Photograph 1880's (HCL)

37c. Ames Gate Lodge. Studies for Well Tower

The client was the Boston Park Commission (Charles H. Dalton, chairman), but these structures came to Richardson through F.L. Olmsted, who was laying out the Fens. Two bridges are included: the Charlesgate West Bridge over railroad tracks, and the Boylston Street Bridge over water. Both first appear in preserved written documentation in letters from Olmsted to the engineer Joseph Davis and to Dalton dated January 24, 1880.

In his letter to Davis, Olmsted makes it clear that for the railroad bridge he wants girder construction beneath the roadbed. Years later, John C. Olmsted recalled that Richardson's part in the design was limited to "railings, lamps, etc." Advertisements for construction proposals were authorized by the Park Commission in April 1882. The bridge was pulled down in the mid-1960's.

The commission for the design of the Boylston Street Bridge entered Richardson's office in April 1880, according to Van Rensselaer. In the letters to Davis and Dalton, Olmsted stresses that the structure's key position makes it more an artistic than an engineering problem. He is undecided whether he wants a stone arch or a wooden bridge, but he does want to consult an architect. "But as to the Boylston Street Bridge," he wrote to Dalton in his characteristically uneconomical prose style, "I wish that you would consider whether you could not let me have Richardson's assistance?"

In a memorandum on the work in the Fens written in the early 1890's, Olmsted claimed large credit for his office in the design of the Boylston Street Bridge. A sheet with minute sketches of an arched span preserved by Olmsted Associates of Brookline and bearing the date December 1878, would seem to support him. John Olmsted was probably referring to this sheet when he wrote in 1898: ". . . the preliminary plan which I devised shows it just as it now is, with the exception of the projecting bays or tourelles and a blind arch in the northwest wing wall. All the curves . . . were accurately indicated on my design, and Mr. Richardson added the tourelles and arch and determined the . . . stone. . . ."

Construction of the foundation and abutments began in the fall of 1880, but work dragged on for what seems an extraordinary length of time for so small a structure. Richardson delivered "Plans of stonework for Boylston St. Arch" to the Commission in July 1881, but was asked to modify them. The contract for stonework was authorized in October 1881, but the Commission was still debating the choice of stone in December. The centering for the arch was taken down in November 1883, but the spandrels were not finished until 1884.

Source: Cynthia Zaitzevsky, "The Olmsted Firm and the Structures of the Boston Park System," *JSAH*, XXXII (May 1973), 167-174. I wish to thank Mrs. Zaitzevsky for permitting me access to unpublished material in her forthcoming Harvard doctoral dissertation on Olmsted's Boston work.

38. Bridges, Back Bay Fens, Boston, 1880-1884

Photographs 1963 (Jean Baer O'Gorman)

38e. Back Bay Fens Bridges. Detail of Stone Wall

38a-d. Elevations of Iron Bridges

38a. Pencil on tracing paper; 10¾ x 15 in. Draughtsman. Unpublished. (FB-B1) Written in pencil upper left: *Bridge on Back Bay Park*

38b. Pencil on tracing paper; 7¾ x 11¼ in. Draughtsman. Unpublished. (FB-B2)

38c. Pencil on tracing paper; 7½ x 10¼ in. Draughtsman. Unpublished. (FB-B3)

38d. Pencil on tracing paper; 6 x 9¼ in. Draughtsman. Unpublished. (FB-B4)

Four studies for the railway span: two iron trusses and two suspension bridges.

38e. Detail of Stone Wall

Pencil on tracing paper; 4⅞ x 9⅞ in. Draughtsman. Unpublished. (FB-B5)

Study of a blind segmental arch set into a random ashlar wall, perhaps for the "northwest wing wall," as mentioned by John Olmsted.

38f. Details of Metalwork

Pencil on tracing paper; 12¼ x 18¼ in. (irregular). Autograph? Unpublished. (FB-D1)
Written in pencil upper right: *Write D; / Irving & Casson / Albany St. / & / Cor Sudbury / & Portland*

Sketches for ornamental metal railing and light fixtures of the railway bridge. Detail of iron claw-shaped pinion at left.

38g. Perspective

Pencil and pale red wash on watercolor paper; 5½ x 21 in. Autograph? *Back Bay Boston: The City as a Work of Art*, Boston, Museum of Fine Arts, 1969 (exh. cat.), p. 113. (FB-F1)
Written in pencil lower left: *1ˢᵗ Club / dining room write Cheney / Telephone Hayden ED* [for the latter see cat. no. 25]
Numeral in black ink upper right: *19*

Preliminary panoramic sketch of an eight-arched stone road bridge, more extensive than built.

38f. Back Bay Fens Bridges. Details of Metalwork

38g. Back Bay Fens Bridges. Preliminary Panoramic Sketch

39. Robert Gould Shaw Monument, Boston (project), 1881, et seq.

The memorial to the white leader of black troops during the Civil War, killed in the assault on Fort Wagner, stands opposite the State House on Beacon Street at the edge of the Common. The work of the architect Stanford White and the sculptor Augustus Saint-Gaudens, it was dedicated in 1897.

The commission came to Saint-Gaudens through Richardson, and to Richardson from the economist Edward Atkinson (1827-1905), chairman of the memorial committee and a Brookline neighbor. Shaw had been a fellow member with Richardson of the Pierian Sodality at Harvard. On February 24, 1881, the architect wrote to Saint-Gaudens that he had "arranged about the Shaw Monument" and asked when he could come to Boston to meet the committee. On November 29, 1881, the sculptor wrote to Richardson that he had "seen Mr. Atkinson about the Shaw and . . . commenced to think about the tablet," which he wanted to discuss with Richardson.

Time meant little to Saint-Gaudens. The contract between sculptor and committee was not signed until February 23, 1884. Saint-Gaudens agreed to "execute a life size Memorial of stone and bronze . . . according to the sketch submitted . . . in April 1883, and to furnish and erect . . . such architectural work to be indicated by an architectural drawing of one fourth size satisfactory to this committee." The agreement gave him two years to finish; he added eleven to that provision. Meanwhile, Richardson died.

Sources: Saint-Gaudens Papers, Baker Library, Dartmouth College, Boxes 16 and 42; Edward Atkinson, "The Shaw Memorial and the Sculptor St. Gaudens," *The Century Magazine,* XXXII (May-October 1897), 176 ff.; A. Saint-Gaudens, *The Reminiscences,* New York, 1913, I, pp. 327 ff.; Harold F. Williamson, *Edward Atkinson,* Boston, 1934; S.T. Riley, "A Monument to Colonel Robert Gould Shaw," *Proceedings of the Massachusetts Historical Society,* LXXV (1963), 27-38.

39a. Elevation

Pencil on tracing paper with thumbnail perspective sketch at right; 14⅛ x 17 in. Draughtsman. Unpublished. (MON-B1)

The relief equestrian figure in an architectural frame that was eventually executed appears here in an early, simplified version. Shaw is isolated in the frame and there is an historiated frieze suggested beneath him. The detailing of the frame suggests White rather than Richardson. This drawing might have originated outside the office.

197

40. Castle Hill Lighthouse, Newport, Rhode Island (project), 1885-1886?

Hitchcock calls this the Agassiz Lighthouse. In 1874 the naturalist Alexander Agassiz (1835-1910) purchased the thirty-acre peninsula called Castle Hill on the eastern side of the entrance to Narragansett Bay at Newport. In the winter of 1874-1875 he built a summer house there, adding his famous laboratory in 1877.

Congress first appropriated money for a lighthouse on Castle Hill in 1875, and on August 4, 1886, again appropriated $10,000 for light and foghorn if a site could be obtained at no expense. The land was deeded by Agassiz to the government on June 10, 1887, provided that the "Light House and fog signal station shall be constructed upon plans and specifications agreed upon . . . and annexed hereto."

This information suggests that the lighthouse drawings are posthumous, but Van Rensselaer includes one sketch for it, always a sign that it was studied before Richardson's death. Agassiz could have approached the architect any time after 1875 for a design. We know he was thinking of Richardson in 1883, because Marian (Mrs. Henry) Adams says in a letter of April 22 of that year that "Alex [Agassiz] is anxious to buy a lot here [in Washington] and have Richardson build him a really simple cheap house."

The present Castle Hill Light was erected in 1889-1890; it is a granite tower based loosely on Richardson's design. The drawings mentioned in the 1887 conveyance await rediscovery in our National Archives.

Sources: "History of Castle Hill Light Station," *Rhode Island History*, 10 (October 1951), 103-108; W. Thoron, *The Letters of Mrs. Henry Adams*, Boston, 1936, p. 442.

40a. Perspective

Pencil on engraved blue stationery; 6 x 8 in. Autograph? Unpublished. (cf. Van Rensselaer, p. 110). (LH-B3)

40b-c. Perspective Studies with Plans

40b. Pencil on tracing paper; 13⅛ x 13¼ in. Initialed *H.W.* (Herbert Langford Warren?). Unpublished. (LH-A1)

40c. Pencil on tracing paper; 12⅝ x 9⅜ in. Initialed *H.W.* (Herbert Langford Warren?). Unpublished. (LH-A2)

The sketches show slight variations in details. There is the possibility that *H.W.* stands for "High Water," although Warren signed other drawings (for the Higginson House, cat. no. 7) with this combination.

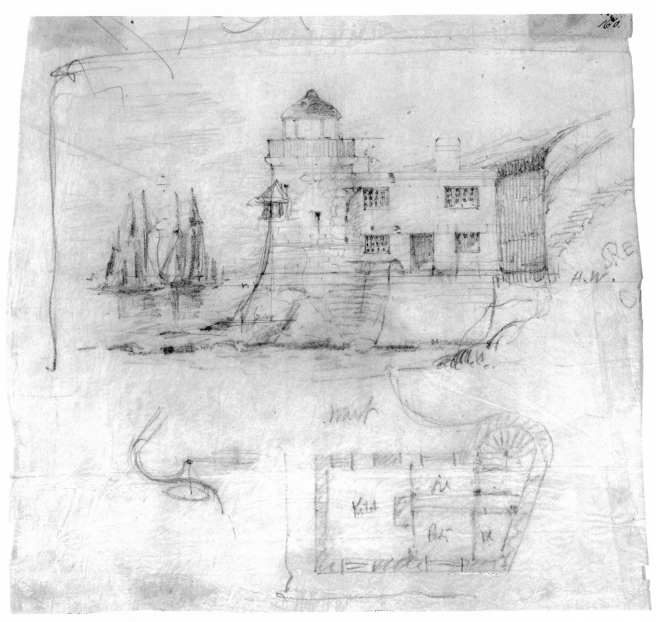

40b. Castle Hill Lighthouse Project. Perspective Study

41. "Mr. Tudor's Barn," Buzzard's Bay, Massachusetts?, 1887?

In the collection of the Boston Athenaeum are two drawings signed with the monogram of Frank I. Cooper, a draughtsman with both Richardson and with Shepley, Rutan and Coolidge. One, a variation on the Stoughton House in Cambridge, is labeled *Tudor*; the other, also a shingled design, is labeled *Sketch for Mr Tudors House / N° 1*. Neither is dated.

A ledger now in possession of SBRA contains an entry under date of September 8, 1887, for a house and stable at Buzzards Bay for F. Tudor, cost $12,500.

Source: "H.H.R. AND S.R. & C. RECEIPTS 1885-1889" (SBRA).

41a-b. Perspectives

41a. Pencil on engraved blue stationery; 7⅝ x 9¾ in. Charles A. Coolidge? Unpublished. (TB-F1)
Written in pencil below: *Mr Tudors Barn*
On verso: pencil sketch of head in profile with tall visored hat.

The engraved stationery usually signifies an autograph drawing, but this could be the hand of Charles Coolidge. There are a lightly sketched plan and an elevation at the bottom.

41b. Pencil on tracing paper; 8 x 11¼ in. Charles A. Coolidge? Unpublished. (TB-F2)
Written in pencil at bottom: *Mr Tudors Barn*
Noted on turret: *Bell*

The draughtsmanship, especially of the horse in the foreground, suggests Coolidge.

41a (detail). "Mr. Tudor's Barn." Perspective

42a. Plan

Pencil on engraved buff stationery; 8 x 11 in. Autograph? Unpublished. (UNK-A1)
Written in pencil above: *Preserve this*

 The handwriting and the draughtsmanship might be Charles A. Coolidge's. The purpose of the plan is not clear.

42b. Interior Perspective of a Concert Hall (surmounted by a Byzantine dome)

Brown ink on tracing paper; 11⅜ x 13¾ in. (irregular). Draughtsman. Unpublished. (UNK-E25)

42c. Ornamental Plaque with Rinceau-Entwined Date, 1880

Brown ink heightened with white on slate blue paper; 4 x 13¾ in. Draughtsman. Unpublished. (UNK-D7)

42d. Studies for Leaf Ornament for Capitals, Archivolts and Frieze

Pencil on yellow tracing paper; 17¾ x 13 in. Draughtsman. Unpublished. (UNK-D35)

42e. Study for Leaf Ornament

Brown ink over pencil on linen; 17⅛ x 13¾ in. Draughtsman. Unpublished. (UNK-D25)

42c. Ornamental Date Plaque

43cc. Design for Decorative Interlace

42. Unidentified Drawings

42e. Study for Leaf Ornament

201

DECORATIVE ARTS

As with so many English and American architects of the late nineteenth century, Richardson thought of buildings as total environments, and his job as incomplete until he had provided furniture, fixtures and accents: painting, sculpture and decorative glass. Here his collaboration became international, with the English group around William Morris joining the Frenchman Auguste Bartholdi and the Americans John La Farge, Augustus Saint-Gaudens and John Evans. From the Church of the Unity on, Richardson's office supplied furniture designs. How much of this came from the architect's own hand remains a question. No surviving drawing for furniture is indisputably holograph. In the 1880's, we know, he relied upon the designer Francis Bacon and the furniture maker A.H. Davenport (later Irving & Casson).

43. Decorative Arts

43a. Bookcase

Pencil on tracing paper; 8¼ x 12 in. Draughtsman. Unpublished. (UNK-E7)

Front and side elevations of a curtained bookcase. The flanking piers are composed of chamfered bases, banded colonnettes and winged lions holding curtain rod in mouth. Stylistically datable to the mid-70's.

43b. Sketches for Furnishings

Pencil on buff paper; 8½ x 11⅜ in. Draughtsman. Unpublished. (UNK-E10)

The various sketches on this sheet include a light standard to left, carved settee, scale figure to right, and either the back of a sideboard or an overmantel. Stylistically datable to the late 70's.

43c-e. Furniture for Senate Chamber, New York State Capitol

43c. Desk
Brown ink on tracing paper; 4½ x 4½ in. Draughtsman. Unpublished. (ASC-E3gg)
Written in brown ink: *1st Study for Desks in / Senate*

43d. Upholstered Armchair
Brown ink on tracing paper; 4⅞ x 3¾ in. Draughtsman. Unpublished. (ASC-E3ii)
Written in brown ink: *Study for Chair for Senate*

43e. Upholstered Armchair
Brown ink on tracing paper; 4⅝ x 4¾ in. Draughtsman. Van Rensselaer, p. 135 (ASC-E3hh)
Written in brown ink: *2nd Study for Chairs in Senate / Mahogany and red leather stamped with brown*

These perspective drawings for Senate Chamber furniture can be dated 1880-1881 (cat. no. 20). All the furniture in the building was custom-made on the premises.

43g. Sketch for Wooden Armchair for Converse Memorial Library

OPPOSITE P
43f. Sketch for Clock for Court of App New York State Ca

43f. Clock for Court of Appeals, New York State Capitol

Brown ink on tracing paper; 12½ x 6⅜ in. (irregular). Draughtsman? Roseberry, *The Capitol Story*, p. 67; *The Furniture of H.H. Richardson*, Boston, Museum of Fine Arts, 1962 (exh. cat.), cover ill. (ASC-E15d)

Preliminary sketch, to be dated 1880-1881. As constructed the clock is taller (154 inches) and more delicate with ornamentation of a Byzantine character. It is illustrated in *19th-Century America; Furniture and other Decorative Arts*, New York, The Metropolitan Museum of Art, 1970 (exh. cat.), no. 236.

43g. Wooden Armchair for the Converse Memorial Library, Malden, Massachusetts

Brown ink with partial freehand border on white paper; 8¼ x 5¼ in. Draughtsman. Unpublished. (cf. Van Rensselaer, p. 134). (MAL-E5)
Lettered in brown ink: SKETCH FOR / CHAIR

Dating from ca. 1884-1885 (see cat. no. 28).

43h-l. Furniture for Billings Memorial Library, Burlington, Vermont

43h. Wooden Armchairs
Brown ink on tracing paper; 5½ x 6½ in. Draughtsman. Unpublished. (BIL-E16)

43i. Wooden Annular Settee
Brown ink on tracing paper; 4¼ x 8¼ in. Draughtsman. Unpublished. (BIL-E17)

43j-k. Wooden Settees

43j. Brown ink on tracing paper; 4¼ x 5½ in. Draughtsman. Unpublished. (BIL-E18)

43k. Brown ink on tracing paper; 5 x 5¾ in. Draughtsman. Unpublished. (BIL-E19)

43l. Wooden Table
Brown ink with partial freehand border on tracing paper; 10½ x 10¼ in. Draughtsman. Unpublished. (BIL-E22)
Lettered in brown ink at top: BURLINGTON LIBRARY

These sketches must date ca. 1885, the year the library was dedicated (see cat. no. 27).

43m. Sketches for Gaslight Sconces

43m. Sconces

Pencil on blue stationery; 5½ x 4⅞ in. Autograph? Wendell D. Garrett *et al.*, *The Arts in America; The Nineteenth Century*, New York, 1969, p. 126. (UNK-E9)

Sketches for tubular gas fixtures similar to those used at the Converse and Billings Memorial Libraries (see no. 27c).

43n. Light Standards

Pencil on tracing paper; 11½ x 9½ in. (irregular). Draughtsman? Wendell D. Garrett *et al.*, *The Arts in America*, p. 126. (UNK-F4)

Four sparkling studies for wrought-iron gaslight standards intended for gate piers or stair newels.

43o-bb. Andirons for Austin Hall, Harvard University

43o. India ink on tracing paper; 9 x 7 in. Draughtsman. Unpublished. (AH-E29)

43p. Brown ink with partial freehand border on white stationery; 8½ x 5⅜ in. Draughtsman. Unpublished. (AH-E12)

43q. Pencil on white stationery; 8½ x 5⅜ in. Draughtsman. Unpublished. (AH-E13)

43r. Pencil on watercolor paper; 7¼ x 3⅞ in. Draughtsman. Unpublished. (AH-E14)

43s. Brown ink with partial freehand border on white stationery; 8½ x 5⅜ in. Draughtsman. Van Rensselaer, p. 132. (AH-E15)

43t. Brown ink with partial freehand border on white stationery; 8⅜ x 5⅜ in. Draughtsman. Unpublished. (AH-E16)
Lettered in brown ink: FIRE DOG / FOR / THE / HARVARD / LAW / SCHOOL

43u. Brown ink with partial freehand border on white stationery; 8½ x 5⅜ in. Draughtsman. Van Rensselaer, p. 133. (AH-E17)
Lettered in brown ink: ANDIRON / FOR / THE HARVARD / LAW / SCHOOL
Written in pencil at left: *Spirals / back & front*

43v. Pencil on tracing paper; 5¾ x 5⅛ in. Draughtsman. Unpublished. (AH-E18)
Written in pencil: *Boltheads*

sketch for Rowand Anderson

43 o. Sketch for Andiron for Austin Hall

43w. Brown ink and pencil on white stationery; 8½ x 5⅜ in. Draughtsman, with criticism by HHR? Van Rensselaer, p. 132. (AH-E19)
Written in ink: *Sketch for Round Andiron*
Written in pencil with pencil sketch: *like this*

43x. Brown ink on white stationery; 8½ x 5⅜ in. Draughtsman. Unpublished. (AH-E20)
Written in ink: *All one piece*

43y. Brown ink on tracing paper; 5½ x 4¼ in. Draughtsman. Unpublished. (AH-E21)
Written in ink: *Flat*

43z. Pencil on tracing paper; 5⅝ x 4 in. Draughtsman. Unpublished. (AH-E22)

43aa. Pencil on tracing paper; 6¼ x 6 in. Draughtsman. Unpublished. (AH-E23)

43bb. Pencil on tracing paper; 6 x 3⅞ in. Draughtsman. Unpublished. (AH-E28)

According to E.W. Hooper's letter to Edward Austin of October 1, 1884 (cat. no. 24), these studies must date ca. 1884-1885.

43cc. Decorative Interlace

Pencil on tracing paper; 2¼ x 2⅜ in. Draughtsman. Unpublished. (PCH-D77)

*43i. Sketch for Wooden Annular Settee
for Billings Memorial Library*

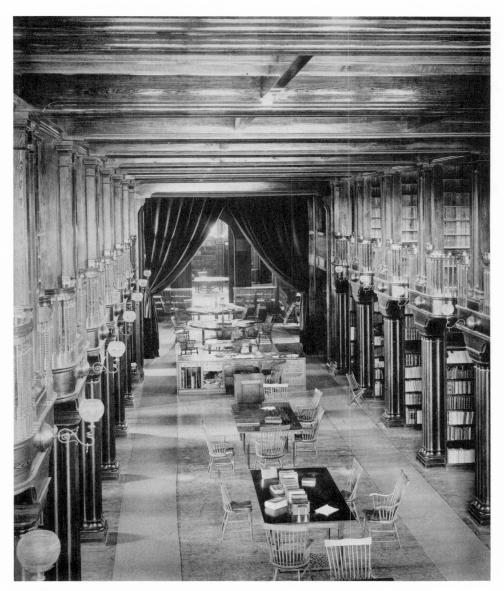

27. Billings Memorial Library,
University of Vermont. Bookroom

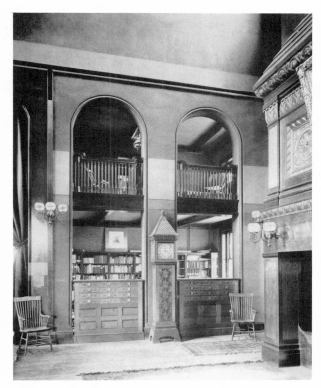

27. Billings Memorial Library,
University of Vermont. Detail of Interior

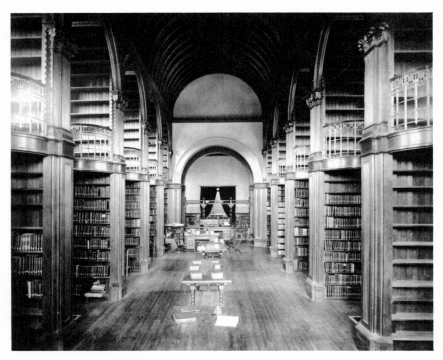

25. *Winn Memorial Library, Malden. Bookroom*

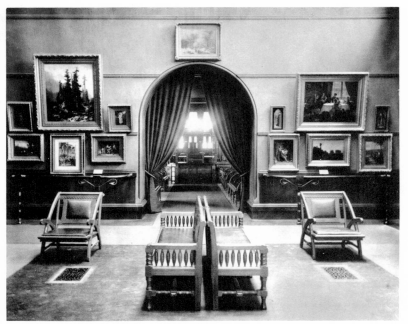

25. *Winn Memorial Library, Malden. Picture Gallery*

44. Autograph Sketchbook, 1869-1876

An album of sheets, 12 x 19¾ inches, bound in red morocco, gilt fillets. Pasted on f. 1ʳ is a pencil note signed *HRS* (Henry Richardson Shepley) and dated June 17, 1958: *This is a sketch book of H.H. Richardson . . . It was used between 1869 & 75. . . .*

Henry R. Shepley's description seems correct, except that the dates should be 1869-1876, and it should be noted that the drawings appear in it as now bound in more or less chronological order. It seems that sometime after 1876 Richardson abandoned sketchbook studies in favor of the familiar thumbnail sketches on blue or buff stationery.

Folio numbers are a recent addition; those sheets not listed below are blank.

Lent by Joseph P. Richardson.

2ᵛ Light pencil sketches: a) elevation of lower part of a tower with arch at base; b) plan of a; c) front elevation of a chapel. Pencil note: *to have drinking fountains at 4 angles / a little off from tower & [] with / buttresses — perhaps a stair tower / to avoid any ecclesiastical character / & depend upon simple & monumental effects. / Make useful if possible portion of tower for store room of [] &c &c / Memorial tablet [] near base / Castelated [?] top ??*

 For the tower see f. 25ʳ; for the chapel see f. 3ʳ.

3ʳ Light pencil sketches: a) elevation of chapel; b) two plans for a public building (?); c) miscellaneous. Pencil notes:
a) *Oct 12 [?] 1869 / Crowninshield has begun piling & wants Specifications — Well [] before latter — / [] working on Dorsheimer piazza — Charles / framing Rye Church drawing — Meyer made miserable study for Naragansett Chapel / Clark working on plans for Mrs. R. S. Fay Boston / Wm. P. Van Rensselaer called about Rye church — / [?] & F. Sturges & Ross were in — Hitchcock called & paid $100 —*
b) *Gave / Meyer — 50¢ — / Oct. 12. 1869 — / R. T. Ford wants me to go to Rhinebeck to see about altering a house —*
c) *Came down / in a boat. / I saw Mr & Mrs Higgins. / Rode up with Mr & Mrs Dun [?]. / Called in evening at Lawrence / Fay called in evening.*

d) *Library 30 x 40 — / Laboratory — one story [] / Philosophical apparatus — / Lecture rooms about 30 x 40 / 10 school rooms to hold 50 scholars each —*
e) *Why not have recitation room / merely to recite in — How can it / be otherwise — Must write to Mayor Blake —*
f) *If I drew [] / I would use [] / [] / But patience can / make a good draughtsman / not an architect — The greatest fault of the french school / is in the great skill of color[ing?] / form is sacrificed to color / I am [] — Have sent Bill to [] / [] for $800 —*

 The chapel sketched here and on f. 2ᵛ could be either for Rye or Narragansett; neither is known. Notes d and e, and perhaps the plans for a public building, refer to the Worcester High School, commissioned in November 1869; James B. Blake was Mayor of Worcester 1866-December 1870. See also ff. 4ʳ, 5ʳ and 7ʳ. Crowninshield is Benjamin W. Crowninshield for whom Richardson designed a house in the Back Bay (hence pilings) after April 1868. Dorsheimer is William Dorsheimer for whom Richardson designed a Buffalo house after October 1868. Charles could be Charles Rutan, who joined Richardson in 1869, or Charles McKim, who joined the office a little later. Meyer is unidentified. Clark is Theodore Minot Clark, until the late 70's one of Richardson's most important assistants. Fay, Van Rensselaer, the Sturgeses, Ross, Hitchcock, Ford, the Duns [?] and the Higginses are yet to be identified.

3ᵛ Small, light pencil drawing of seated figure. Architectural decoration.

4ʳ Pencil sketches: a) portion of a plan (stairhall); b) decorative details.
 These definitely relate to the Worcester High School. See ff. 3ʳ, 5ʳ and 7ʳ.

4ᵛ Pencil sketches: standing female figures; female bust.

5ʳ Pencil sketches: a) elevation of a church; b) part of a plan (pencil note: *Nichols / Nichols*); c) two outline elevations, domestic in scale, related to b; d) lower part of a tower with arched entry at base; e) perspective of upper part of a tower; f) plans and elevation of base of a tower (pencil notes: *Base pedestal semicircular / thus ! ? / Bronze inlaid — base —*; arithmetical pencil calculations.

The upper part of the tower suggests Brattle Square Church, commissioned in July 1870. There are scale plans for a house for the Hon. A.P. Nichols, Buffalo, N.Y. in HCL (APN-A1). The church remains unidentified.

6ʳ Pencil sketches: plans for a town house; assorted dimensions in pencil.

7ʳ Pencil sketches, one reinforced with ink: figures, capitals and grotesques. Pencil notes: a) *March 7ᵗʰ· 1870 — Monday Julia still at Cambridge — Boys eye better from last / accounts — Jula well — Suffer'd badly from pain in right side — the night between Saturday & Sunday — This morning severe snow storm / will not go to City — Reading Macaulay: Hist: High School at Worcester roof unsatisfactory — To add clause to all specifications — as follows / that contractors are to call for drawings from the architect only as such drawings are required / for the purpose of the work — that is that architect / shall only be required to furnish drawings (full size) / a reasonable time before the building of work set forth / in drawings — Architects should not be made / the convenience of contractors —*

Julia was his wife, Julia Gorham Hayden Richardson; her family lived in Cambridge. The boy could at this date be only John Cole Hayden Richardson, the oldest son. The oldest child, Julia Hayden Richardson, was called Jula (see f. 23ʳ). Richardson was living on Staten Island, so inclement weather would prevent his commuting to his Manhattan office. Macaulay is Thomas Babington Macaulay (see f. 30ʳ).

8ʳ Sketches: a) pencil plan and elevation of large public building; b) superimposed in brown ink, elevation of a small public building. Note in brown ink over pencil: *Dining Hall / w. c. female / w. c. male / dressing room female / dressing room male / stairs / Hat room & coat room / Bar room / wine room / []*. Arithmetical pencil calculations.

Sketch a and the list of rooms may refer to a large casino. The ink elevation reminds one of the project for the Brookline Town Hall, 1870, although it is for a smaller building. See ill. p. 21.

9ʳ Small, light pencil sketches of arches.

9ᵛ Pencil sketches: details of f. 10ʳ; arithmetical pencil calculations.

10ʳ Sketches in brown ink over pencil: elevation, plan and details of a wooden gate, domestic in scale, with male figure.

11ʳ Pencil sketch of unidentified plan (?).

12ʳ Pencil sketches: two study plans for a cruciform church. Pencil note: *In main nave we have 104 pews 5 persons / each.* Dimensional pencil figures.

Studies for Brattle Square Church; must predate July 1870. See f. 13ʳ.

13ʳ Pencil sketches: a) study for a candelabra type fountain; b) perspective of corner of a courtyard (?); c) plan of a cruciform church with porch and asymmetrical tower. Various calculations in pencil.

The church is Brattle Square; this sheet follows f. 12ʳ chronologically. The other sketches have not been identified.

13ᵛ Sketches in pencil and brown ink: a) section through a church (?); b) profile of the top of a tower.

Presumably still Brattle Square Church.

14ʳ Pencil sketches: plans for a town house.

15ʳ Pencil sketches: a) section through a church with open truss roof; b) partial elevation of a church with large bull's-eye window.

Presumably still Brattle Square Church.

16ʳ Pencil sketches: plans, elevation, thumbnail study for a large public building with pavilions connected around a courtyard. Pencil note: *I prefer Dʳ Grays system — / that is large wards connecting / with iron [?] corridors or galleries it is / more economical — the classification is / as select & privacy as great & the / promenading galleries or loggia / of Dʳ Gray are incomparably / superior to the parlor of 1ˢᵗ floor as in Dʳ B[]'s —*

First study for the Buffalo State Hospital. See letter from Julia Richardson to her mother, December 12, 1869 (now in the Archives of American Art): "Hal is going away this week too — He expects to go to Buffalo — Did you known that he met Dr. Grey [sic] of Utica about the Insane Asylum" Dr. Joseph P. Gray consulted in the design which, as built, followed the plan developed by Samuel Sloan and Dr. T. S. Kirkbride, published in the latter's *Hospitals for the Insane*, Philadelphia, 1st ed. (?), 1854; 2nd, illustrated, ed., 1880. The doctor whose name begins with *B* remain unidentified. According to Hitchcock, Richardson's plan was adopted on August 25, 1870, but construction of the multi-part complex extended through the decade.

17ʳ Pencil sketches: plan, elevations, perspective and details of a large public building.

The Buffalo State Hospital. This sheet chronologically follows f. 16ʳ, but the Kirkbride plan has not yet appeared.

18ʳ Pencil sketches: a) undecipherable drawing and note in French; b) detail of a spire; c) profile of a resting lion outlined in brown ink; d) heraldic device; e) perspective of a tower with open pointed arcade below and note: *Cardinal duprat / ministre de Fʳ Iᵉʳ / Juilly / 16ᵉᵐ / from Viollet*; f) end of a stone wall, with standing figure outlined with brown ink.

19ʳ Pencil sketches: studies for chamfered wood trusses. Pencil note: *There will be [].*

20ʳ Pencil sketches: a) elevation of a towered public building; b) light alternate design for a; c) sketches of figure crowning tower.

Principal elevation of the Hampden County Court House, Springfield, a commission that came to Richardson in July 1871, as the result of a competition.

21ʳ Pencil sketch: plan of a large cruciform public building. Pencil note:

> 2ᵈ Story —
> Governors Private office 18 x 24 — 1
> w. c. & []
> Governors Rep 18 x 18 2
> Education Commission room 18 x 24 3
> R[] . 18 x 18 4
> Agricultural Com 18 x 18 5
> Secretary of State 18 x 24 6
> Clerk . 18 x 18 7

A study plan for Richardson's entry in the competition for the Connecticut State Capitol, which he lost (see Charles Price in *Perspecta*, 1965).

21ᵛ Pencil note: *Sh: the Speakers room open from Assembly Directly / Ditto clerk* —

See f. 21ʳ and f. 22ʳ.

22ʳ Pencil sketches: partial plan studies for large public building, with pencil calculations. Pencil note: *Room for Speaker & / Clerk.*

See f. 21ʳ and f. 21ᵛ.

22ᵛ Ink and pencil sketches: roof plan and projected perspective of a house.

See f. 23ʳ.

23ʳ Sketches, pencil, ink and ink over pencil: a) plan of a house with polygonal corner tower; b) plan of a house with piazza; c) elevation of b; d) alternate elevations for b-c; e) sketch of a part of a church (?). Pencil notes: *Sept 30* —, and

> *Hayden* —
>
> | *1 blue cloth suit* | | |
> | *Jacket, Waistcoat & Kilt* | } | *20* |
> | *Brown* | | |
> | *1 over coat with* | } | *18* |
> | *fur Collar cuffs & pockets* | | |
> | *1 Grey Kilt* | } | *6* |
> | *4 White Shirts* | } | *12* |

Inscribed in ink in HHR's hand:

> *Sch* [?] *J. C. H. R.*
> *H. H. R. jr.* } *H. H. R.*
> *J. H. R.* *&*
> *M. H. R.* *J. G. R.*

The unidentified house with the piazza also appears on f. 22ᵛ. Hayden is John Cole Hayden Richardson, born April 17, 1869. His initials lead the inked inscription, followed by Henry Hyslop Richardson, born September 30, 1872; Julia Hayden Richardson, born November 25, 1867; and Mary Houghton Richardson, born February 9, 1871. These were the first four of the six children born to the architect and his wife, whose initials are to the right. The coincidence of Henry Hyslop's birthdate and the date at the top of the sheet suggests the birth of the fourth child as the reason for the genealogy. Was Richardson designing on this sheet a house to replace that on Staten Island? With the commission for Trinity Church in hand, was he thinking of moving in 1872, as he did indeed in 1874?

24ʳ Pencil sketches: a) demonstration of perspective construction; b) studies for a multi-gabled house; c) mantelpiece; d) clock tower with arch at bottom; e) decorative frieze. Arithmetical pencil calculations.

The clock tower is related to that on f. 2ᵛ, f. 25ʳ, f. 26ʳ and f. 27ʳ. Nothing else is identifiable.

25ʳ Pencil sketches: plan, elevations and details of a clock tower with arch below; plan of track intersection.

A photograph of the finished project now in the large photo album at SBRA proves these to be studies for the tower of a Boston & Albany station. Its location, date and fate are not known.

26ʳ Pencil sketches: elevations and sketches of a clock tower.

See f. 25ʳ.

27ʳ Pencil sketches: a) lower part of a clock tower; b) studies for spandrel decorations.

See f. 25ʳ.

28ʳ Pencil sketches: a) roof plan, elevation and section of a house; b) plan and elevation studies of a church; c) studies for solomonic columns and other decorative details; d) unidentified plan; e) unidentified sketches. Arithmetical pencil calculations.

The church is Trinity Church, Buffalo, a project of 1872-1873. Nothing else has been identified.

29ʳ Pencil sketches: various plans for a cruciform church. Pencil note: *Trinity*. Arithmetical pencil calculations.

See cat. no. 1.

30ʳ Pencil sketch: ornamental mantelpiece (inscribed LAON MONOY). Pencil notes: a) LAON; b) SPIRO SPERO; c) *Chesterfield letters / Burton Anatomy of Melancholy / Gaudts* [?] *Physique* — / *Macaulay's England / Stanhope's Queen Anne / Bryants Homer / Ruskins Painting.*

31ʳ Pencil sketches: three studies for a triumphal arch. Arithmetical calculations. Note: *Buffalo Arch.*

See cat. no. 36.

31ᵛ Pencil sketch: plan of a house.

Watts Sherman House, Newport, R. I., commissioned in September 1874. See following leaves, and cat. no. 11.

32ʳ Pencil note: *Specification / Description — / The building is to be irregular in shape — the main part — / —— x —— feet outside measurement exclusive of bays; Bays included / —— x —— feet. The two principal entrances / are upon the West side with a Porte cochere and / on the East side or seaview side opening upon the / terrace. The servants entrance is into the Basement on West side & —— with flights of stone steps thereto — / There is to be a terrace not covered from N.E. corner along the entire East front & extending as far as Drawing Room bay on South side varying in width as shown on plan / — [cf. f. 31ᵛ] —— feet on East side & narrow around / Library bay & on South side. The walls of the first story are to be of the local stone such as the wall which encloses Mʳ Wetmores place on —— Avenue is built of with —— / trimming, sills & lintels, quoins — the ashlar / to be Random course work with horizontal / beds & vertical finish. The remainder of / the building above the stone work is to be of / wood construction.*

Roofs shingled except as may hereafter be / specified to be trimmed. The underpinning entrance / step, servants entrance platform, pedestal to / porte cochere of ——.

chimney tops of brick.

Basement is to be finished and divided into /

33ʳ *Kitchen —— x —— feet. Laundry —— x —— feet — / Servants Hall —— x —— feet. Store room — Boot / room, w. c., cold closet, Ice closet, / Entries and back stair & elevator — Cellar proper / Contains wine cellar: the Furnace / set in brickwork and coal bins.*

Principal Story

The Principal Story is to be subdivided as / follows. Vestibule —— x —— feet. / Hall 18' x 32' — with large fireplace — / Drawing room 16' x 20' with square bay 6 x —— with fireplace / Library 16' x 16' with —— bay 6' x 16' — / with fireplace. Dining room 18' x 24' with / fireplace bay 6' x 12'. Principal Stair / leading from vestibule with balcony / from first landing overlooking the Hall. [In margin: Stair for / guests from / 2 to attic / story —] Back Hall opening from vestibule with / back stair case & elevator — Butlers / pantry, serving room & water closet.

Second Story

The second story is to be subdivided into staircase / Hall, lighted by windows on the west outer wall. / Four master bedrooms, [] dressing rooms, —— closets / two bath rooms & 2 water closets. The N.W. corner / is lower by —— steps than the rest of 2 story / & is subdivided into two bedrooms for servants / with back stairs Hall. Elevator, closet, w. c &c &c.

34ʳ ### Attic —

In the attic there is one guest chamber with closet / & dressing room &c. Guest Stairway Hall — / Bedroom for servants —— closets — with / trunk rooms, linen closets, stairs, lift & c —

Height of Stories

Cellar
Basement
Main House 1ˢᵗ Story
North west corner — 1ˢᵗ story
2ⁿᵈ Story — Main
" " — N. W. corner
Attic

Excavations —

Dig out for the basement story for the / foundations, areas, drains, floors, and all / other work requisite [marginal: Coal slides / &c &c] — Beat down to a solid / consistence the ground forming the beds of the / trenches for receiving the foundations of walls, / piers, fireplaces and after they are in / to fill in & ram down the ground with / wooden drummers. [marginal: excavate for / cesspool — / separate contract.] Level up & do such other rough groundwork as may be necessary for / forming the sectional ground lines / shown upon the drawings. In basement /

34ᵛ *ashes & drain around all walls —*

35ʳ *no earth is to be left nearer than 9 inches / to any floor or other timbers — such cavities to be / filled in with ashes or clean gravel — / Leave the ground altogether free from all useless / soil or other materials / Excavation for all the walls & piers to be at / —— feet below the level of Basement / floor.*

Bail out or pump out and remove all soil / & water that may fall into the excavations from drains, springs, or rain, cesspools or otherwise / and see that the trenches are well drained / before any masonwork is done in them —

Drains —

Provide and lay all the drains indicated / upon the cellar plan, from the different / soil & wash pipes to the outside of wall / & thence to the cesspool — and from the / foot of the different rain water conductors / to the cistern

or elsewhere, as the case may be. / They are to be of the best glazed earth-
en pipe / of the size indicated, laid with even / inclination, joints set in
cement, connections / made with regular branches or turns, thoroughly /
cemented, and all carefully brushed out — / all connections with pipes &
the leaders from / conductors are to be made by regular / quarter turns of
the same glazed pipe. / The digging for the drains to be done / by the
proprietor —

36ʳ Foundations —

For all areas & walls & fireplaces & piers lay / at the bottom of the trenches
properly / prepared 6" of concrete composed of / pure hydraulic cement &
clean coarse gravel / or broken stone spread uniformly, and / well rammed
down — cement to be used / in such quantities as may be directed — [mar-
ginal: Foundation / for steps — / entrance to / main house / & area steps —]
Then lay the footing courses of ——— stone / laid crosswise in the trenches /
carefully bedded in cement with close / joints, no stone to have less than 8
inches / projection on each side of the foundation / -wall which rests on
it — / Fill in & ram solidly with good gravel / [] under and about all
foundation / areas, drains cesspools & coal slides [marginal: cesspools /
separate.] / On the footing build of ——— stone the / foundations as shown
on plans carefully / laid in one half cement and one half lime / & sand
mortar of the best quality. / The foundation for all interior walls or piers /
to extend only the under side of basement / floor — all partitions & piers
in basement / to be wooden —
Build foundation for Porte cochere post / & all other foundations shown
as necessary as / above specified —

36ᵛ Brick around / windows — arches / &c &c . . .

37ʳ Specification
 for
 W. Watts Sherman Stable

Description —
The building is to be of wood, with local stone basement walls / and
shingled roof and [small outline sketch] in plan — the main part / 25 x 34
containing carriage room & harness room with / servants rooms above (one
living room & four bed rooms) / the stable proper is 18 x 26 with 5 stalls
and Hay loft &c &c / above — The basement is only excavated sufficiently
to prevent / dry rot — The manure pit is place[d] on the S. end of stable — /
for height of stones see plans —

 Leaves 31ᵛ through 37ʳ contain a sketch plan and incomplete draft speci-
fications for the William Watts Sherman House and Stable at Newport.

37ᵛ In pencil: The following notes are taken from / a report made by a com-
mittee consisting / of Mʳ Olmsted, Dʳ Harris, Mʳ Trowbridge and / myself
appointed by the Staten Island Improvement Comm to report upon the /
sanitary conditions of the Island and / the benefit to be derived from drain-

age / I propose giving such facts, as I think will / be most interesting
without entering into / a medical dicussion of the dif. theories of the / causes
of malaria for which I depend on the medical member of our club. / as may
promote discussion among our medical friends present.

38ʳ-48ʳ Pencil notes based upon pp. 31 ff. of the report cited in footnote 80 of
the introductory essay.

49ʳ Pencil sketches: plan studies for a house. Glued onto page: [Harvard
University] Class Day ticket for June 20th, 1879.
 The plan seems related to the Watts Sherman House (see f. 31ᵛ).

49ᵛ Pencil sketch: an unidentified circular labyrinth (?). See f. 50ᵛ.

50ʳ Pencil sketches: Roof plans, plans and elevations of a house.
 Watts Sherman again. The elevations are not as finally built.

50ᵛ Pencil sketches: an unidentified labyrinth (?). See f. 49ᵛ.

51ʳ Pencil sketches: a) plan studies for a house; b) sketch elevation of a
church tower. Arithmetical pencil calculations.
 The house is the Watts Sherman again (see f. 50ʳ); the tower is the Sala-
manca-inspired design for Trinity Church, established in April 1874 (see
cat. no. 1).

51ᵛ Pencil sketch: a labyrinth (?). Arithmetical pencil calculations.

52ʳ Pencil sketches: plan and elevation of a commercial block.
 Early study for the Cheney Building, Hartford, commissioned in Septem-
ber 1875 (see cat. no. 17; and ff. 53ʳ-56ʳ).

53ʳ Pencil sketch: study for ground floor elevation of a commercial block; the
Cheney Building.

54ʳ Pencil sketches: elevation studies for a commercial block; the Cheney
Building.

55ʳ Pencil sketches: perspective and detail of a commercial block; the Cheney
Building.

56ʳ Pencil sketch: sketch plan of a large commercial block; the Cheney Building.

56ᵛ Arithmetical pencil calculations.

57ʳ Pencil notes and calculations: May 27 — 1875 / Work done on Trinity . . .
Trinity Church, Boston (see cat. no. 1).

58ʳ Pencil sketch: elevation of a tall, narrow commercial block; arithmetical
pencil calculations.
 The Hayden Building, Boston, erected in 1875 (see Cynthia Zaitzevsky
in JSAH, May 1973).

215

58ᵛ Arithmetical pencil calculations.

59ʳ Pencil sketches: plans, outline elevation of a house. Perhaps studies for the Blake House of 1874.

60ʳ Pencil doodles, block plans and notes: a) *Flats for F. H. Harris* (the name repeated several times); b) *F. L. W. R.* (the initials repeated several times); c) *Flats for Springfield.*

 The Harris Flats for Springfield, if that is how we should read it, are otherwise unrecorded. F. L. W. R. was the architect's youngest child, Frederick Leopold William Richardson, born July 10, 1876, during progress of the work on the Albany State Capitol and named for Richardson's collaborators on that project: Frederick Law Olmsted, Leopold Eidlitz and William Dorsheimer (see cat. no. 20).

60ᵛ Pencil sketches for a long, low nave church; ink over pencil perspective of a different ecclesiastical design.

The pencil design remains unidentified. The pen perspective relates to f. 61ʳ.

61ʳ Pencil sketches: elevation studies for a church.

 These might relate to the "Competitive Design for a Village Church" published in the *New York Sketch Book*, II, 1875.

61ᵛ Arithmetical pencil calculations.

62ʳ Sketches in brown ink over pencil for a church with plan and elevation. Arithmetical pencil calculations.

 For the church, see f. 61ʳ. See ill. p. 19.

63ʳ Pencil sketches: plan studies for a house.

INDEX